To Г. Е.
 Immensely loved, sorely missed, an inspiration always.

Contents

Contributors

Atholl Anderson

Archaeology and Natural History
Research School of Pacific and Asian Studies
Australian National University
Canberra ACT 0200, Australia
Atholl.Anderson@anu.edu.au

Anthony Bonanno

Department of Classics and Archaeology
University of Malta
Msida MSD 2080, Malta
anthony.bonanno@um.edu.mt

Elena Flavia Castagnino Berlinghieri

Università degli Studi di Catania, Italy
Soprintendenza ai Beni Culturali e Ambientali di Siracusa, Italy
elfcb@tiscali.it

Helen Dawson

Classical and Archaeological Studies
University of Kent
Canterbury CT2 7NZ
Kent, UK
helen.dawson@uclmail.net

Stašo Forenbaher

Institute for Anthropological Research
Gajeva 32
HR-10000 Zagreb, Croatia
staso.forenbaher@zg.htnet.hr

Chris Gosden

School of Archaeology
University of Oxford
36 Beaumont Street
Oxford OX1 2PG, UK
chris.gosden@arch.ox.ac.uk

Timothy Kaiser

Lakehead University
500 University Avenue,
Orillia, Ontario L3V 0B9, Canada
tkaiser@lakeheadu.ca

Nellie Phoca-Cosmetatou

Leverhulme Centre for Human Evolutionary Studies
Department of Archaeology and Anthropology
University of Cambridge
Fitzwilliam Street
Cambridge CB2 1QH, UK
nehp100@cam.ac.uk

Alan Simmons

Department of Anthropology
University of Nevada, Las Vegas
Las Vegas, Nevada 89154, USA
simmonsa@unlv.nevada.edu

List of Figures

List of Tables

Acknowledgements

This volume has had a long gestation. The first seeds were planted at the session I organised at the 8th Annual Meeting of the European Association of Archaeologists (EAA) at Thessaloniki, Greece in 2002, entitled *Initial occupation of small island groups in theory and practice*. The emphasis on small islands and island groups still pervades the present volume. A wide variety of papers were presented, ranging from the Pacific, the Mediterranean and the Channel Islands by Eva Rosenstock, Alan Simmons, Bryon Bass, Robert Tykot, Heather Sebire, Christophe Sand, Frederique Valentin/ Ivana Pranjic/ Anne DiPiazza, and myself. Thanks are due to all speakers for making the session an interesting and inspiring one. The decision was subsequently taken to produce a volume on a more narrow and focused theme on the Mediterranean rather than stemming directly from the conference proceedings.

Papers were subsequently commissioned, some quite soon after the conference whilst others much more recently. All contributions have been peer reviewed anonymously, and prior to final submission checked and updated by their authors. Over these years, a number of colleagues have provided support, advice, comments, suggestions and inspiration; some very kindly offered to review the various papers in the volume. They include Graeme Barker, John Bennet, Emma Blake, Cypian Broodbank, John Cherry, Simon Davis, Yannis Galanakis, Reuben Grima, Julie Hamilton, Snježana Karavanić, Caroline Malone, Preston Miracle, Peter Mitchell, Jennifer Moody, Lucia Nixon, Victor Paz, Mark Pearce, Paul Rainbird, John Robb, Derek Roe, Carlo Tozzi, Robin Skeates, Simon Stoddart, Nicholas Vella, Ruth Whitehouse, Todd Whitelaw and three anonymous referees. I wish to particularly thank Bernard Knapp for helpful and supportive discussions on the format and framework of the volume in its early stages. As editors of the Series, Barry Cunliffe and Chris Gosden, provided advice and support to see the volume to fruition. Last, but by no means least, I would like to thank all contributors for their collaboration. The editorial work was completed during my stay at the University of Arizona as a Visiting Scholar; thanks are due to Mary Stiner for her hospitality and to the Foundation for Education and European Culture (IPEP) for financing my visit and the final publication.

Siena, July 2011

Introduction:
The first Mediterranean islanders

Nellie Phoca-Cosmetatou

The present volume examines the characteristics of the initial occupation of the Mediterranean islands. The emphasis is on the better understanding of the mechanisms, strategies, cultural contingencies and social alliances that enabled the consolidation of a permanent human presence on the islands. There is a focus on small islands, which can present increased demands on people to adapt and survive due to their more marginal environments, and on islands where recent research has led to a reassessment of the date and character of initial occupation.

After a brief overview of some recent trends in Island Archaeology research, this introduction will focus on the two main themes of the present volume. The first one deals with the concept of occupation, as defined in the context of the wider process and multiple phases of island colonisation. The second theme concerns the strategies and mechanisms people adopted in colonising and settling in the new and demanding environments of the various Mediterranean islands.

Trends in island archaeology

Island Archaeology is coming of age. Excavations and surveys on islands continue to abound, but it is the proliferation of books and specialist journals that suggests it now constitutes a distinctive sub-field of Archaeology (e.g. Broodbank 2000; Constantakopoulou 2007; Fitzpatrick and Erlandson 2006; Fitzpatrick *et al.* 2007; Knapp 2008; Lätsch 2005). Islands exert a strong fascination. They form distinct geographical entities, separated from other landmasses by sea. At the same time they are dynamic places of social and cultural change and loci of widespread interaction. Their study has become central to our understanding of major issues in human evolution and behaviour, including the spread of humans around the world, the origins of modern humans and the development of cultural complexity (Erlandson and Fitzpatrick 2006).

Approaches to islands and Island Archaeology have undergone a number of shifts. Notions of islands as laboratories for the study of the mechanisms of cultural change in human societies are still discussed but largely discarded (Clark and Terrell 1978; Evans 1973; see discussions in Broodbank 2000; Rainbird 2007; Spriggs 2008; Terrell *et al.* 1997). Concepts from island biogeography (MacArthur and Wilson 1967), with a focus on the geographical properties of islands such as their size, configuration and distance from other landmasses, continue to be applied in a more critical manner, thus avoiding environmental determinism (see discussion in Keegan and Diamond 1987; also Broodbank 2000; Fitzpatrick *et al.* 2007; Knapp 2008). In this manner they can provide a framework in which to assess the available archaeological evidence (Cherry 1990, 2004; Dawson 2008), as has been done in proposing that the colonisation of Crete was purposeful and targeted (Broodbank and Strasser 1991).

Recent research has emphasised an increasingly social outlook. A more integrated archaeological approach to islands has been adopted, taking into account their perceptions by people in the past, recognising that the physical boundaries of islands need not necessarily be equated with any social and cultural ones, which can be defined by the ways the inhabitants perceive and define their own society. One example is Mauritius which, despite being far removed geographically, is not isolated in a cultural sense, since a mix of people and ethnicities inhabit the island (Eriksen 1993). An opposite one is prehistoric Malta which, despite the existence of earlier contacts with the outside world, became isolated in its later prehistory as a result of internal social change and of islanders deliberately creating their own island identity (Robb 2001).

Although notions of isolation, separation and remoteness are used and emphasised less than their opposites of connectivity, integration and contact, there is still a lot of debate in Island Archaeology studies on just how isolated islands really are, both in a geographical and cultural sense. Although islands can be separate geographical entities, recent research has been emphasising that isolation and interaction should be considered as ends of a continuum (Erlandson 2008), that land, sea and society are mutually constructed (Lape 2004) and, thus, that isolation is a relative phenomenon in that insularity is historically contingent and socially constructed (Broodbank 2008; Fitzpatrick and Anderson 2008; Knapp 2008, 17-18; Terrell 2008a). Horden and Purcell (2000) have focused on the fragmentation, interaction and coherence between the 'microregions' that constitute the Mediterranean. To the claims of some that islands are 'not given geographical entities' (Rainbird 1999) but are 'just ideas' (Robb 2001) created by the society itself, others have replied by stating, as a reaction, that 'islands *are* isolated' (Keegan 1999, emphasis in original). Terrell (1999) has stated, correctly, that 'although I would wager that no archaeologist genuinely thinks islands are isolated, they sometimes write as if they were'. Irwin (1992, 206) has commented that 'Polynesian society was commonly less insular than its islands'. Contacts between islands and with the mainland would have been part of any island identity.

The complex interplay between geography and culture has been termed 'the dynamic nature of insularity' (Broodbank 1999a). In his seminal book, Broodbank (2000) argues that insularity, social interactions and island identities are culturally constructed and need not fit with geographical boundaries, given that the sea should not be seen as isolating but rather as binding the islands (Gosden and Pavlides 1994). As a consequence, the ideal unit of analysis need not be a single island just because it is bound by the sea. Broodbank proposes the need for an 'archaeology of the sea' (2000, 34) in conjunction with that of the land, that incorporates its dynamic use. Building on the concept of 'seascapes' defined by Gosden and Pavlides (1994), and on recent archaeological approaches to landscape, he introduced the term 'islandscapes'. It embraces both the island landscapes and seascapes, incorporating people's perceptions and use of the land and sea.

Rainbird (1999, 2007) argues for 'an archaeology of the sea that incorporates the land rather than only merges with an 'archaeology of the land'' (Rainbird 2007, 45), thus reducing the prominence of the islands and the land (for critiques see Fitzpatrick 2004; Terrell 2008b). Although debate continues on such issues as isolation vs. interaction, boundedness vs. boundlessness, a common underlying theme of most recent work has been 'the interplay between insularity, identity, human settlement and maritime interaction' (Knapp and Blake 2005, 10). The sea can act as both a barrier and a 'corridor for movement' (Robb and Farr 2005, 26), both connecting and dividing (Horden and Purcell 2000; Knapp and Blake 2005). As Fitzpatrick and

Anderson (2008) note, different levels of connection and separation existed between islanders in the past and these levels were due to varying environmental and socio-cultural conditions.

Initial occupation

The primary focus of the present volume is on the initial occupation of the islands, in the sense of consolidation of permanent human presence, though it not necessarily be a long-lived one. Island colonisation is a long process. Consisting of multiple phases, it is not a directional one. Cherry (1990) made the important distinction between *occupation* and *utilisation*. *Occupation* implies that the island formed the residential focus for the human group living there; not necessarily a year-round occupation but one which was centred on the island, in economic, social and habitation terms. *Utilisation*, on the other hand, implies shorter-term visits to the island, for the purpose of exploitation of particular resources by human groups whose residential base is elsewhere.

There are a number of issues pertinent to defining the phases of colonisation. The first one relates to the number and types of stages defined. The two that Cherry proposed form important distinctions. They have been further elaborated and broken down into in-between stages, such as discovery, exploration, visitation, settlement and establishment (e.g. Broodbank 2000; Graves and Addison 1995; Irwin 1992), with subsequent clarifications added, such as seasonal settlement, year-round utilisation, place- or resource-focused occupation (Dawson 2008). In his recent overview, Broodbank (2006) discusses human presence on the Mediterranean islands within the wider context of the emergence of 'maritime activity' in an attempt to be more encompassing of different types of activities and stages of colonisation.

The second issue relates to the extent of overlap and distinction between these stages. Incorporating all possible permutations into the above definitions is problematic as many past uses of islands might not be best described by any one term. For example, deliberate short visits and an unsuccessful occupation are both characterised by their brevity, but they are very different in the intent, organisation and knowledge involved (Broodbank 2000). The occurrence, nature and duration of the various phases can be variable for each island or island group. Thirdly, apart from definition issues, there is that of archaeological visibility. Not all phases of human occupation and utilisation may be visible archaeologically, and some might leave similar signatures, as in the example just given.

Disentangling island colonisation, in the sense of when and whence people came to occupy particular islands and the routes followed in these travels, has been widespread. The focus of such studies has been aspects such as wind and sea currents, land visibility, cultural affinities with the mainland and/or other islands (Broodbank 1999b; Broodbank and Strasser 1991; Cherry 1981; Irwin 1992; Keegan 1995). These are, of course, fundamental issues in understanding the nature of island livelihoods, and in recognising the relevance of the character of the societies which are likely to have provided the colonists (Davis 2001). The importance of such studies, both in relation to our knowledge of specific islands and to wider archaeological considerations, cannot be overemphasised.

Another concern within Island Archaeology has been with the establishment and elaboration of settlement, as seen in the 'emergence of civilisation' on the islands, usually at a later date; examples include the Cycladic civilisation (Renfrew 1972), the Maltese temples (Evans 1977; Stoddart *et al.* 1993) and the Easter Island civilisation (Bahn and Flenley 1992; McCoy 1979).

The period of early occupation of the islands, in a sense the period between these two transitions of initial colonisation and cultural elaboration, has been relatively overlooked and understudied, at least in terms of what it stands for, rather than what it leads to. I would like to suggest, however, that this period should not be seen simply as a 'prelude' (*sensu* Clark 1980) to any later developments, but should be studied in its own right for what it tells us about human settlement in these regions. It consists of an exploration of the livelihoods of the first settlers on the islands, how they survived in the new conditions they faced, how – and if – they might have changed and adapted their mode of life, such as subsistence strategies, social alliances, long-distance contacts, to suit the new and particular conditions they encountered on the islands.

Survival strategies: marginality and interconnectedness

Successful colonisation of new and unfamiliar landscapes requires an effective process of 'landscape learning' (Meltzer 2003; Rockman 2003). Rockman (2003, 12) defines the term landscape learning as 'the social response to situations in which there is both a lack of knowledge of the distribution of natural resources in a region and a lack of access to previously acquired knowledge about that distribution'. Meltzer (2003, 226) identifies the learning about the 'routes' for moving across space, the climatic 'regimes' and the 'resources' available in the new and unfamiliar landscapes colonised as being of crucial importance. Rockman (2003) emphasises that knowledge about the new environment includes not only information about locations but also about the limitations on resources such as population carrying capacity, and the social meanings ascribed to the landscape. Colonisers bring with them prior knowledge, based on the landscape they came from. This knowledge is subsequently transformed based on the discoveries, geographical, technological and social, the new inhabitants make in their new home (Hardesty 2003). However, the more people rely on pre-existing knowledge and the less they modify and adapt it to fit with their new setting, the greater risk they run of making the wrong decisions which can have disastrous results on their colonisation success (Blanton 2003; Meltzer 2003).

The ideas behind landscape learning have great relevance to the colonisation and initial occupation of islands (Anderson 2003). There are three aspects I want to focus on. The first is that many of the ideas have been developed for colonisation taking place in landscapes mainly devoid of other human groups (e.g. Meltzer 2003, 223). Island occupation, on the other hand, often occurred in situations where people were familiar with these environments, albeit having been exploiting them in different guises. Models of island colonisation, as discussed in the previous section, are sophisticated in that they break down the process of colonisation into a number of phases. Landscape learning thus becomes a gradual process operating on different levels for each stage. For example, visitation and utilisation of islands require knowledge of technological means, seafaring and resource identification. Permanent settlement requires knowledge and understanding of the opportunities and limitations of the region and a more critical application of pre-existing knowledge on resource utilisation. Social knowledge is built and modified at each stage as use and familiarity with the landscape changes.

The second issue is that landscape learning is important even if does not operate on a blank canvas. Meltzer (2003, 233) notes that 'obviously, those agricultural groups who are travelling with food resources – 'transported landscapes' Kirch (1997, 218) calls them – can dispense with much of the learning process'. I would argue that this is not necessarily the case.

Such transport also includes the transport of pre-existing knowledge and, as mentioned above, an uncritical use of it could greatly jeopardise the success of settlement. Such transport of food resources and pre-existing knowledge took place in the Mediterranean islands. Although visited and utilised by foragers during the Pleistocene and early Holocene, they were only settled on a more permanent basis by agricultural groups predominantly during the Neolithic period, transporting the domestic stock to the islands.

The third issue relates to the particular physical attributes of islands that make landscape learning more pertinent in such a setting. Meltzer (2003, 223) notes that 'the greatest effort in information acquisition should occur in patchy environments that vary temporally and in large scale'. The physical characteristics of islands make them not only patchy but also geographically constricted and separate landmasses. These two key concepts, of constriction and separation, are of prime importance in our understanding of the nature of island adaptations and island livelihoods. They are especially relevant to small islands rather than to large and self-contained ones. The latter have been labelled 'matchbox continents' (Held 1989) due to their environmental and social carrying capacity, often comparable to that of the mainland.

The physical constriction of islands means that they can be marginal environments. Marginality, the state of being at the edge, peripheral and with low returns, has been defined as being either environmental, when the environment's carrying capacity is the limiting factor, economic, when the subsistence strategy employed is not best adapted to the given environment, or socio-political, when human groups are isolated (Coles and Mills 1998; Mondini and Muñoz 2004). Marginal environments are, thus, more demanding for humans to exploit. Islands, in particular, provide a limited range, diversity and quantity of resources, able only to sustain low species diversity (Whittaker 1998). With such low productivity and restricted resources, islands constitute fragile environments posing risks to human occupation. This is particularly the case in small islands where the risk of crop failure and famine is even greater (Cherry 1987). As Keegan and Diamond (1987, 77) note, 'the riskiest stage in colonisation, that is, the stage at which the population runs the greatest risk of extinction, is the first, when a small number of individuals reaches an uninhabited island'. This is especially relevant in attempts to establish a first occupation and settlement, rather than in cases of short-term visits.

A number of responses to marginal conditions have been recognised, including economic and social innovations, such as changes in resources exploited, storage, redistribution; adoption of new technologies and intensification in resource exploitation; as well as changes in settlement patterns, including both mobility and abandonment (Coles and Mills 1998). Cherry (1981), based on Halstead (1981), has proposed four strategies which would have been available to human groups specifically living on marginal and small islands. These are, firstly, an increase in resource diversification, both of domesticated and wild resources; secondly, an increase in storage; thirdly, an increase in exchange, trading and, thus, of alliance networks; and finally, increased mobility and changes in settlement and group sizes. Halstead (2008) has elaborated further on the last point, arguing that the smaller, shorter-lived and more dispersed settlements in marginal areas facilitated and rendered essential regional exchanges. He thus considers the maintenance of distant social relationships, rather than changes in subsistence patterns, to hold the key to the successful colonisation of marginal areas.

Terrell (1986) has also suggested similar mechanisms which are adopted by people so as to survive on small islands where, because of the constricted physical space and higher population densities, 'the pressures of social life must be far more inescapable' (ibid., 180). He envisages people responding to such conditions in two major ways. Primarily, there is a

greater reliance on social networks, people keeping closer ties, both of an economic and social nature, with other human groups near and far. Secondly, there is a much greater tolerance for difference and diversity in the behaviour of the members of the social group; as he notes, 'this flexibility is adaptive for it allows people to adjust easily to the demands of an environment that can change rapidly at any moment' (ibid., 182). He identified three key concepts, not necessarily mutually exclusive, which characterise people's lives in such environments: avoidance, competition and co-operation (ibid., 211). These three concepts find close parallels in the strategies proposed by Cherry and Halstead: mobility and extended social ties, changes in settlement location and changes in social group sizes all constitute means of dealing with social and ecological pressures, and all involve some degree of avoidance, competition and co-operation.

Hence, given the unpredictability and risk of island environments, keeping alive alliance networks, social obligations and reciprocity in times of need between far-flung distant groups would have been paramount in ensuring the success of any permanent occupation (Davis 2001). It is precisely under such conditions that the interconnectedness and interdependence of human communities on the islands gain increased importance and relevance. Islands might be self-contained in ecological terms (Whittaker 1998) but need not have been so for human societies, which would have needed to keep in contact with other communities for access both to resources and to mates. As discussed above, isolation can well be relative.

The first Mediterranean islanders

The Mediterranean islands form the principal geographical focus and the background against which the above issues will be explored. They do not form part of an extended island group, like so many of the Pacific and Caribbean islands, nor does their study form part of a single archaeological tradition. Except for the few works in which the Mediterranean islands have been examined collectively (e.g. Cherry 1981, 1990; Patton 1996), most have been dealt with in separate research agendas. This is in contrast to the larger number of works dealing with the Caribbean (e.g. Keegan 1992, 1995; Wilson 1997) and the Pacific (e.g. Allen *et al.* 1977; Denoon 1997; Irwin 1992; Spriggs 1997; Terrell 1986) often in their entirety, so far as this is possible.

The Mediterranean is composed of many separate seas, such as the Aegean, the Adriatic and the Tyrrhenian, containing separate island groups in different configurations and sizes. Land, either in the form of mainland or islands, can be seen from a large proportion of the sea, and thus no island is completely isolated (Cherry 2004). The islands were occupied by human groups coming from the mainland who would, accordingly, have had to adapt to the newly encountered conditions.

The history of the colonisation of the Mediterranean islands has recently been informatively and comprehensively presented by Broodbank (2006) as part of his discussion of the overall emergence of maritime activity in the Mediterranean. Substantive seafaring activity primarily in the eastern Mediterranean is first dated to the Younger Dryas. It then takes off from the early Holocene onwards. Early traces of visits to the islands, in the form of isolated, sporadic and short-lived sites but indicative of seafaring and knowledge of the islands, include the site of Akrotiri-*Aetokremnos* on Cyprus (Simmons 1999); the cave of Cyclops on Yioura (Sampson 2008a) and the open-air site of Maroulas on Kythnos (Sampson 2008b) in the Aegean, and the presence of Melian obsidian at Franchthi cave on mainland Greece (Perlès

2003). Mesolithic sites have also been recovered on the larger islands of Corsica and Sardinia (Costa *et al.* 2003). This integrated role of the sea in hunter-gatherer landscapes has succinctly been denoted by the term 'foraging seascapes' (Barker 2005, 47), highlighting the role of the sea connecting people across the Mediterranean from the beginning of the Holocene.

It is to the Neolithic period that longer term, often permanent, settlement, is dated. Broodbank notes (2006, 214) that this is part of the spread of Neolithic practices that took place along a south European maritime route. Some islands, located at great distances from the mainland such as Crete, were occupied early in the Neolithic as part of purposeful migrations (Broodbank and Strasser 1991). Others, including the Cyclades and the Balearics, were occupied later, during the Late Neolithic and Early Bronze Age respectively. Absolute dates differ, of course, depending on the island examined, but range mainly from the 7th to the 3rd millennium BC. Although recent research is finding traces of early visits and utilisation of the islands, the Mediterranean islands are quite unique in having a time lag between the presence of farmers on the mainland and their subsequent occupation; this is true especially for the small islands and less so for the large ones (Vigne 1999). This situation raises questions as to the nature, purposefulness, technological and social prerequisites required for their colonisation and for ensuring a successful settlement (Cherry 2004; Phoca-Cosmetatou 2008). Explanations such as the innovation of polished stone axes used as woodworking tools to build boats big enough to transport the required domesticates for a successful occupation on the islands (Strasser 2003) provide a focus on technological prerequisites and can account for the timing but not necessarily for the characteristics of early occupation.

The themes and issues of initial occupation and survival strategies are particular relevant and meaningful in a Neolithic context. The term 'Neolithic' is here used in an economic sense, rather than as a chronological marker; it involves a mode of subsistence which is based on what people produce, through the cultivation of plants and the raising of domestic animals, and not primarily on gathering what nature provides. Within the framework of such an economy one could envisage people having a higher degree of control and manipulation of the environment, in the widest sense of the word, which could have played an important role in facilitating and enabling any successful occupation. Moreover, a Neolithic economy is one involving quite small groups of people 'going it alone', with or without their social networks, but without the backing and support of any state or larger political unit. And it is precisely within such an economic and social context that the following papers will explore the nature of the first occupation of the various islands although, as will become clear, this nature differed widely from one island to another.

Overview of the volume

The papers in the volume are ordered geographically, moving from the eastern to the western Mediterranean. They cover Cyprus, the Cyclades, Palagruža, the Aeolian islands and Malta (a paper on the Balearics was to have been included in this volume but unfortunately had to be withdrawn at the last moment). These case studies are prefaced by an overview on the colonisation of the Mediterranean islands, and followed by two commentaries.

Dawson provides a starting point and a framework for the subsequent island examples. Through a comparison of the dates of colonisation of 145 islands across the Mediterranean, she presents a theoretical overview of the state of knowledge on the timing and pace of island colonisation across the Mediterranean. She uses a biogeographical approach in a critical

manner to highlight examples and rates of island colonisation that do not fit with biogeograph-ical predictions. She proceeds to discuss the various phases of island colonisation, such as visitation, utilisation, exploration and settlement. She concludes that the Neolithic was the key period for the permanent settlement of the Mediterranean islands and distance was an obvious concern to the settlers. At the same time, there was a lot of variability in the timing and type of colonisation of the various islands.

Cyprus is of key importance in our understanding of the initial occupation of the Mediterranean islands for recent finds over the last 20 years are altering markedly the timing and nature of the colonisation of the island, as Simmons discusses. The timing of the first occupation of Cyprus has been pushed back in time by almost 2000 years to the 8th millennium BC (Cypro-PPNA/B) with intimations of a pre-Neolithic human presence stretching back to the 11th millennium BC. Simmons presents a history of the colonisation and occupation of Cyprus that is multi-faceted and economically complex, as seen archaeologically through a variety of site types and locations and the early control, if not domestication, of animals. As a framework for understanding people's movements and adaptations he places emphasis on cultural identi-ties, and suggests that the early inhabitants of Cyprus were retreating from the cultural changes taking place on the mainland. It is only with the subsequent Khirokitia phase that the inhabi-tants of the island created their own, more separate, island identity.

The Cycladic islands also demonstrate a long period of knowledge and visits since the late Upper Palaeolithic but permanent settlements appear only in the Late Neolithic, despite a well established Neolithic on the mainland 2000 years earlier. Phoca-Cosmetatou assesses this delay through an examination of the nature and character of the occupation of the islands and the livelihoods of the people. With a specific emphasis on the economy from the site of Ftelia on the island of Mykonos, she demonstrates that although pottery styles and luxury items, in particular, indicate long-distance contacts, the study of economic and subsistence variables, on the other hand, suggest a more insular existence.

Palagruža is a small islet in the middle of Adriatic Sea. It had been an island even during the Last Glacial Maximum 20,000 years ago, and presumably a landmark in navigation across the Adriatic. It brings into relief the demands and requirements of island occupation as in this case archaeological remains do not necessarily demonstrate a human presence. The finds from the Early Neolithic are very few. Forenbaher and Kaiser critically assess this archaeological evidence and the role of Palagruža in Neolithic navigation, as well as the symbolic and cultural appropriation of the sea.

Lipari was a source of obsidian and thus constituted a draw for early mariners and an important reason for its occupation during the Neolithic period. Castagnino Berlinghieri presents an overview of the archaeological evidence, both architectural and economic, together with an assessment of prehistoric navigation skills. She proposes that, because of its obsidian sources, Lipari formed the central focus for communities from other islands that visited the island, and that its inhabitants were very much tied to their land.

An opposing picture is drawn for Malta, though it has also some parallels with Cyprus. In his discussion of the early occupation of the island, Bonanno makes a distinction between the cultural identities of the early settlers, who emphasised their origin, links and connections with Sicily during the first 1000 years (5th millennium BC) by replicating Sicily's settlement patterns and keeping trade links alive, and the complete break in ceramic repertoire in the 4th millennium BC, which, although could be indicative of a change in population, it could also be seen as a change in the island's cultural trajectory.

In his comparison of the colonisation of the Mediterranean and Pacific islands, Anderson raises a number of theoretical issues on the limiting and enabling factors, the role of seafaring technology and climate change, and notions of identity, remoteness and construction of social landscapes. He focuses on the great difference in the geographical scales of the two regions and what that means in terms of remoteness, isolation and connectivity. The Mediterranean is more land-locked, its islands located relatively close to the mainland and thus creates a more coherent entity enabling a wide web of possible interactions. In contrast, the Pacific is more elusive and vast, islands are more remote and isolated, and cultural connections are more constrained in the possible routes they can follow along island groups. Longer distances hinder opportunities for long-term processes of discovery and utilisation to predate establishment, as has been argued and demonstrated for Mediterranean islands. Remoteness affected cultural trajectories, seafaring voyages and island identities. Anderson concludes by arguing that although sharing methodological and theoretical concerns, island landscapes differ greatly around the world, and they each create a unique theatre for human social interactions.

These conclusions are mirrored in the volume's postscript provided by Gosden. Taking a temporal comparative perspective, Gosden notes that the notion of a pan-Mediterranean cultural sphere is a result of trade and connections dating from the Bronze Age onwards. He argues that, in contrast, the initial occupation of the Mediterranean islands took place within a framework of more localised cultural spheres, in a series of 'small words' centring around particular geographical regions and island groups. He further argues that cultural identities were being created in the process of establishment on the islands. Embodied intelligence, practice and action, collaboration, creation and transfer of knowledge played key roles in enabling seafaring, mobility, island colonisation and occupation as well as constituting and creating past identities.

The ideas expressed in these latter two commentaries throw into relief the multi-layered and multi-dimensional theatre provided by the Mediterranean. It is hoped that the entire volume similarly draws attention to the complexities of island occupation in this region. The notion of fluid group identities created through practice in the 'small worlds' of the Neolithic highlights the necessity of an emphasis on the process of occupation and consolidation of island inhabitation, which is precisely the focus of the current volume.

References

ALLEN, J., GOLSON, J. and JONES, R. (eds.) 1977: *Sunda and Sahul: prehistoric studies in Southeast Asia, Melanesia and Australia* (Canberra).

ANDERSON, A. 2003: Entering uncharted waters: models of initial colonization in Polynesia. In Rockman, M. and Steele, J. (eds.), *Colonization of unfamiliar landscapes: the archaeology of adaptation* (London), 169-189.

BAHN, P.G. and FLENLEY, J. 1992: *Easter Island Earth Island: a message from our past for the future of our planet* (London).

BARKER, G. 2005: Agriculture, pastoralism, and Mediterranean landscapes in Prehistory. In Blake, E. and Knapp, A.B. (eds.), *The archaeology of Mediterranean prehistory* (Oxford), 46-76.

BLANTON, D.B. 2003: The weather is fine, wish you were here, because I'm the last one alive: "learning" the environment in the English New World colonies. In Rockman, M. and Steele, J. (eds.), *Colonization of unfamiliar landscapes: the archaeology of adaptation* (London), 190-200.

BROODBANK, C. 1999a: The insularity of island archaeologists: comment on Rainbird's 'Islands out of time'. *Journal of Mediterranean Archaeology* 12 (2), 235-239.

BROODBANK, C. 1999b: Colonization and configuration in the insular Neolithic of the Aegean. In Halstead, P. (ed.), *Neolithic society in Greece* (Sheffield, Sheffield Studies in Aegean Archaeology 2), 15-41.

BROODBANK, C. 2000: *An island archaeology of the early Cyclades* (Cambridge).

BROODBANK, C. 2006: The origins and early development of Mediterranean maritime activity. *Journal of Mediterranean Archaeology* 19 (2), 199-230.

BROODBANK, C. 2008: Not waving but drowning. *Journal of Island & Coastal Archaeology* 3, 72-76.

BROODBANK, C. and STRASSER, T.F. 1991: Migrant farmers and the Neolithic colonization of Crete. *Antiquity* 65, 233-245.

CHERRY, J.F. 1981: Pattern and process in the earliest colonization of the Mediterranean islands. *Proceedings of the Prehistoric Society* 47, 41-68.

CHERRY, J.F. 1987: Island origins: the early prehistoric Cyclades. In Cunliffe, B. (ed.), *Origins: the roots of European civilisation* (London), 16-29.

CHERRY, J.F. 1990: The first colonisation of the Mediterranean islands: a review of recent research. *Journal of Mediterranean Archaeology* 3, 145-221.

CHERRY, J.F. 2004: Mediterranean island prehistory: what's different and what's new? In Fitzpatrick, S.M. (ed.), *Voyages of discovery: the archaeology of islands* (Westport), 233-248.

CLARK, J.G.D. 1980: *Mesolithic prelude* (Edinburgh).

CLARK, J.T. and TERRELL, J.E. 1978: Archaeology in Oceania. *Annual Review of Anthropology* 7, 293-319.

COLES, G. and MILLS, C.M. 1998: Clinging on for grim life: an introduction to marginality as a archaeological issue. In Mills, C.M. and Coles, G. (eds.), *Life on the edge: human settlement and marginality* (Oxford), vii-xii.

CONSTANTAKOPOULOU, C. 2007: *The dance of the islands: insularity, networks, the Athenian Empire, and the Aegean world* (Oxford).

COSTA, L., VIGNE, J.-D., BOCHERENS, H., DESSE-BERSET, N., HEINZ, C., DE LANFRANCHI, F., MAGDELEINE, J., RUAS, M.-P., THIEBAULT, S. and TOZZI, C. 2003: Early settlement on Tyrrhenian islands (8th millennium cal. BC): Mesolithic adaptation to local resources in Corsica and northern Sardinia. In Larsson, L., Kindgren, H., Knutsson, D., Loeffler, D. and Åkerlund, A. (eds.), *Mesolithic on the move* (Oxford), 3-10.

DAVIS, J.L. 2001: Review of Aegean prehistory I: the islands of the Aegean. In Cullen, T. (ed.), *Aegean Prehistory: a review* (Boston, American Journal of Archaeology Supplement 1), 19-94.

DAWSON, H.S. 2008: Unravelling "mystery" and process from the prehistoric colonisation and abandonment of the Mediterranean islands. In Conolly, J. and Campbell, M. (eds.), *Comparative island archaeologies: proceedings of the International Conference, University of Auckland, New Zealand 8th-11th December 2004* (Oxford, BAR International Series 1829), 105-133.

DENOON, D. (ed.) 1997: *The Cambridge history of the Pacific islanders* (Cambridge).

ERIKSEN, T.H. 1993: In which sense do cultural islands exist? *Social Anthropology* 1, 133-147.

ERLANDSON, J.M. 2008: Isolation, interaction, and island archaeology. *Journal of Island & Coastal Archaeology* 3, 83-86.

ERLANDSON, J.M. and FITZPATRICK, S.M. 2006: Oceans, islands, and coasts: current perspectives on the role of the sea in human prehistory. *Journal of Island & Coastal Archaeology* 1 (1), 5-32.

EVANS, J.D. 1973: Islands as laboratories for the study of culture process. In Renfrew, A.C. (ed.), *The explanation of culture change* (London), 517-520.

EVANS, J.D. 1977: Island archaeology in the Mediterranean: problems and opportunities. *World Archaeology* 9, 12-26.

FITZPATRICK, S.M. 2004: Synthesizing island archaeology. In Fitzpatrick, S.M. (ed.), *Voyages of discovery: the archaeology of islands* (Westport), 3-18.

FITZPATRICK, S.M. and ANDERSON, A. 2008: Islands of isolation: archaeology and the power of aquatic perimeters. *Journal of Island & Coastal Archaeology* 3, 4-16.

FITZPATRICK, S.M. and ERLANDSON, J.M. 2006: The archaeology of islands and coastlines. *Journal of Island & Coastal Archaeology* 1 (1), 1-3.

FITZPATRICK, S.M., ERLANDSON, J.M., ANDERSON, A. and KIRCH, P.V. 2007: Straw boat and the proverbial sea: a response to "Island archaeology: in search of a new horizon". *Island Studies Journal* 2 (2), 229-238.

GOSDEN, C. and PAVLIDES, C. 1994: Are islands insular? Landscape vs. seascape in the case of the Arawe islands. *Archaeology in Oceania* 29, 162-171.

GRAVES, M. and ADDISON, D. 1995: The Polynesian settlement of the Hawaiian archipelago: integrating models and methods in archaeological interpretation. *World Archaeology* 26, 380-399.

HALSTEAD, P. 1981: From determinism to uncertainty: social storage and the rise of the Minoan palace. In Sheridan, A. and Bailey, G.N. (eds.), *Economic archaeology: towards an integration of ecological and social approaches* (Oxford, BAR International Series 96), 187-213.

HALSTEAD, P. 2008: Between a rock and a hard place: coping with marginal colonisation in the later Neolithic and early Bronze Age of Crete and the Aegean. In Isaakidou, V. and Tomkins, P. (eds.), *Escaping the labyrinth: the Cretan Neolithic in context* (Oxford, Sheffield Studies in Aegean Archaeology, 8), 229-257.

HARDESTY, D.L. 2003: Mining rushes and landscape learning in the modern world. In Rockman, M. and Steele, J. (eds.), *Colonization of unfamiliar landscapes: the archaeology of adaptation* (London), 81-95.

HELD, S.O. 1989: Colonization cycles on Cyprus, 1: the biogeographic and palaeontological foundations of early prehistoric settlement. *Report of the Department of Antiquities, Cyprus (Nicosia)* 1989, 7-28.

HORDEN, P. and PURCELL, N. 2000: *The corrupting sea: a study of Mediterranean history* (Oxford).

IRWIN, G. 1992: *The prehistoric exploration and colonisation of the Pacific* (Cambridge).

KEEGAN, W.F. 1992: *The people who discovered Columbus: the prehistory of the Bahamas* (Gainesville).

KEEGAN, W.F. 1995: Modelling dispersal in the prehistoric West Indies. *World Archaeology* 26, 400-420.

KEEGAN, W.F. 1999: Comment on Paul Rainbird, 'Islands out of time: towards a critique of island archaeology'. *Journal of Mediterranean Archaeology* 12 (2), 255-258.

KEEGAN, W.F. and DIAMOND, J.M. 1987: Colonisation of islands by humans: a biogeographical perspective. In Schiffer, M.B. (ed.), *Advances in archaeological method and theory, vol. 10* (New York), 49-92.

KIRCH, P.V. 1997: *The Lapita people: ancestors of the Oceanic World* (Cambridge).

KNAPP, A.B. 2008: *Prehistoric and protohistoric Cyprus: identity, insularity, and connectivity* (Oxford).

KNAPP, A.B. and BLAKE, E. 2005: Prehistory in the Mediterranean: the connecting and corrupting sea. In Blake, E. and Knapp, A.B. (eds.), *The archaeology of Mediterranean prehistory* (Oxford), 1-23.

LAPE, P.V. 2004: The isolation metaphor in island archaeology. In Fitzpatrick, S.M. (ed.), *Voyages of discovery: the archaeology of islands* (Westport), 223-232.

LÄTSCH, F. 2005: *Insularität und Gesellschaft in der Antike: Untersuchungen zur Auswirkung der Insellage auf die Gesellschaftsentwicklung* (Stuttgart).

MACARTHUR, R.H. and WILSON, E.O. 1967: *The theory of island biogeography* (Princeton).

McCOY, P.C. 1979: Easter Island. In Jennings, J.D. (ed.), *The prehistory of Polynesia* (Cambridge), 135-166.

MELTZER, D.J. 2003: Lessons in landscape learning. In Rockman, M. and Steele, J. (eds.), *Colonization of unfamiliar landscapes: the archaeology of adaptation* (London), 222-241.

MONDINI, M. and MUÑOZ, S. 2004: Behavioural variability in the so-called marginal areas from a zooarchaeological perspective: an introduction. In Mondini, M., Muñoz, S. and Wickler, S. (eds.), *Colonisation, migration and marginal areas* (Oxford), 42-45.

PATTON, M. 1996: *Islands in time: island sociogeography and Mediterranean prehistory* (London).

PERLÈS, C. 2003: The Mesolithic at Franchthi: an overview of the data and problems. In Galanidou, N. and Perlès, C. (eds.), *The Greek Mesolithic: problems and perspectives* (London), 79-89.

PHOCA-COSMETATOU, N. 2008: Economy and occupation in the Cyclades during the Late Neolithic: the example of Ftelia, Mykonos. In Brodie, N.J., Doole, J., Gavalas, G. and Renfrew, A.C. (eds.), *Horizon: a colloquium on the prehistory of the Cyclades* (Cambridge), 37-41.

RAINBIRD, P. 1999: Islands out of time: towards a critique of island archaeology. *Journal of Mediterranean Archaeology* 12 (2), 216-234.

RAINBIRD, P. 2007: *The archaeology of islands* (Cambridge).

RENFREW, A.C. 1972: *The emergence of civilisation: the Cyclades and the Aegean in the third millennium BC* (London).

ROBB, J. 2001: Island identities: ritual, travel and the creation of difference in Neolithic Malta. *European Journal of Archaeology* 4 (2), 175-202.

ROBB, J. and FARR, R.H. 2005: Substances in motion: Neolithic Mediterranean "trade". In Blake, E. and Knapp, A.B. (eds.), *The archaeology of Mediterranean prehistory* (Oxford), 24-45.

ROCKMAN, M. 2003: Knowledge and learning in the archaeology of colonization. In Rockman, M. and Steele, J. (eds.), *Colonization of unfamiliar landscapes: the archaeology of adaptation* (London), 3-24.

SAMPSON, A. (ed.) 2008a: *The cave of Cyclops: Mesolithic and Neolithic networks in the Northern Aegean, Greece: 1. Intra-site analysis, local industries, and regional site distribution* (Philadelphia).

SAMPSON, A. 2008b: The Mesolithic settlement and cemetery of Maroulas on Kythnos. In Brodie, N.J., Doole, J., Gavalas, G. and Renfrew, A.C. (eds.), *Horizon: a colloquium on the prehistory of the Cyclades* (Cambridge), 13-17.

SIMMONS, A.H. 1999: *Faunal extinction in an island society: pygmy hippopotamus hunters in Cyprus* (New York).

SPRIGGS, M. 1997: *The island Melanesians* (Oxford).

SPRIGGS, M. 2008: Are islands islands? Some thoughts on the history of chalk and cheese. In Clark, G., Leach, F. and O'Connor, S. (eds.), *Islands of inquiry: colonisation, seafaring and the archaeology of maritime landscapes (Terra Australis 29)* (Canberra), 211-226.

STODDART, S., BONANNO, A., GOUDER, T., MALONE, C. and TRUMP, D. 1993: Cult in an island society: prehistoric Malta in the Tarxien period. *Cambridge Archaeological Journal* 3, 3-19.

STRASSER, T.F. 2003: The subtleties of the seas: thoughts on Mediterranean island biogeography. *Mediterranean Archaeology and Archaeometry* 3 (2), 5-15.

TERRELL, J.E. 1986: *Prehistory in the Pacific islands* (Cambridge).

TERRELL, J.E. 1999: Comment on Paul Rainbird, 'Islands out of time: towards a critique of island archaeology'. *Journal of Mediterranean Archaeology* 12 (2), 240-245.

TERRELL, J.E. 2008a: Islands and the average Joe. *Journal of Island & Coastal Archaeology* 3 (1), 77-82.

TERRELL, J.E. 2008b: Book review essay: the archaeology of islands (Paul Rainbird 2007, Cambridge University Press). *Journal of Island & Coastal Archaeology* 3, 154-158.

TERRELL, J.E., HUNT, T.L. and GOSDEN, C. 1997: The dimensions of social life in the Pacific: human diversity and the myth of the primitive isolate. *Current Anthropology* 38, 155-195.

VIGNE, J.-D. 1999: The large 'true' Mediterranean islands as a model for the Holocene human impact on the European vertebrate fauna? Recent data and new reflections. In Benecke, N. (ed.), *The Holocene history of the European vertebrate faunas: modern aspects of research* (Rahden, Archäologie in Eurasien 6), 295-322.

WHITTAKER, R.J. 1998: *Island biogeography: ecology, evolution and conservation* (Oxford).

WILSON, S.M. (ed.) 1997: *The indigenous people of the Caribbean* (Gainesville).

Island colonisation:
settling the Neolithic question

Helen Dawson

Introduction

The settlement of the Mediterranean islands is closely tied to the Neolithic period. Sedentism and demographic growth have been traditionally invoked to explain the increasing need for space in the Neolithic and the colonisation of marginal space, including the intensified frequentation and settlement of islands. The increase in archaeological data, also for the pre-Neolithic period, combined with changes in archaeologists' theoretical orientations, has contributed to major changes in relation to the concept of insularity, heralding a new phase in Mediterranean island studies. The emphasis has shifted towards concepts of agency and cultural interaction.

Different kinds of human activity on islands can now be better qualified than in the past, although the degree to which they can be distinguished in the field is variable. Cherry (1981) first systematised the earliest available colonisation data (by which he meant permanent settlement) for the Mediterranean islands and put forward a biogeographical explanation for their patterns of occupation based on an analysis of environmental parameters. New finds from the Mediterranean islands mean that studies of colonisation on the grand geographical scale have to be carried out with caution, as the picture may change. As sites earlier than the Neolithic are increasingly emerging, particularly in the eastern Mediterranean, the initial utilisation of the islands, sometimes amounting to their seasonal occupation, is being pushed backwards. In many cases the gap between this initial phase and the subsequent permanent occupation of the islands is being reduced, though there is generally agreement over the fact that different human groups were involved in the two phases (e.g. Broodbank 2000, 110; Ramis *et al.* 2002, 19). The wealth of new data also means that we can now follow more closely the long-term development of island cultures, factoring in abandonment and recolonisation (Dawson 2005).

It is significant that some of Cherry's (1981, 1990) key observations have withstood the test of time, even with the new finds. Having repeated Cherry's analysis by including the new data that have become available in the meantime (Dawson 2005, chapter 5), the results confirm that biogeographical variables are still relevant to the initial permanent occupation of the islands in the Neolithic. However, the islands' subsequent development (in the Bronze and Iron Ages) diverges increasingly from biogeographical predictions; nor does biogeography fully explain the earliest pattern of island visitation (as it involves some far-away islands). Cherry emphasised there was variability in the pattern of islands colonised, i.e. islands that were not colonised in spite of being large and close to the mainland, and referred to this as 'noise' (1990, 199). By this he meant 'anomalies, or colonisation events not following general models', which he attributed mainly to the patchiness of current knowledge (ibid.). This noise remains (Cherry 2004), in spite of recent discoveries in the intervening decades, and it is therefore high time we readdressed the issue.

Island colonisation

The fundamental question to be asked, before we can begin to understand Neolithic patterns of island settlement, is: what constitutes colonisation? The term is often overcharged with connotations of a well-planned venture endowed by a degree of permanence (cf. Roman *coloniae*). The difficulty of identifying these features in prehistory is all the more apparent given that even for the classical archaeologist the definition is not straightforward. Moscati (1968, 101; 1988, 49), for example, considered Greek colonisation to be pristine as its main concern was land, a prerequisite for the development of the first urban settlements (*contra* Osborne 1997, 268). Phoenician colonies, on the other hand, were 'mere factories', mainly involved in trade activities, entailing little interaction with the local populations and no cultural assimilation (Whittaker 1974, 75).

Elsewhere, I put forward this definition of colonisation: 'a physical and mental appropriation of space, as humans carry out activities that allow them to set themselves up in a geographical area and possibly lay claims over it' (Dawson 2004-6, 37). The definition is deliberately general (cf. similar definitions by Gosden 1993, 24 and Broodbank 2000, 110), as its main objective is to highlight that the equation colonisation=settlement is restrictive. Instead, it emphasises that colonisation encompasses different activities, all requiring different degrees of adaptation to island environments. These should, where possible, be qualified temporally and spatially, e.g. 'seasonal' settlement, 'year-round' utilisation, 'place-focused' or 'resource-focused' occupation, etc. (Dawson 2004-6, 36).

In the Pacific context, Anderson has observed that in general it is likely that discovery coincided with settlement (2003, 173); while Graves and Addison (1995, 387) have pointed out that colonisation (i.e. 'the placement of human populations on discovered islands') does not necessarily lead to 'establishment'. By contrast, in the Mediterranean context, non-settlement-related activities (e.g. visitation and utilisation) are pigeonholed either as being preliminary to settlement or as being unsuccessful, as the ultimate goal must be settlement (e.g. Guerrero 2001, 140). The vastly superior distances separating islands in the Pacific as opposed to the Mediterranean justify this attitude only in part (Dawson 2008), as there is no obvious

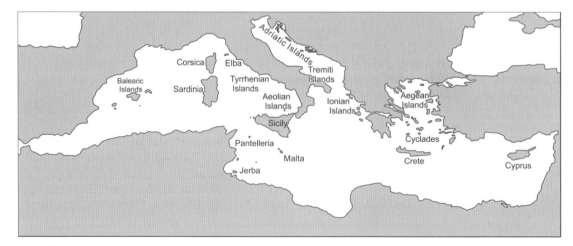

Figure 2.1: Island groups mentioned in the text

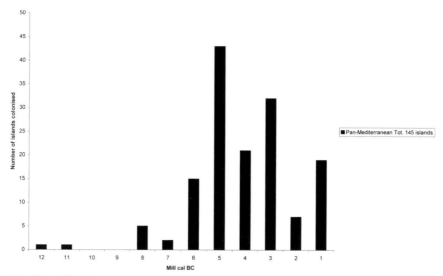

Figure 2.2: Overall colonisation rates for the entire Mediterranean (Dawson 2005)

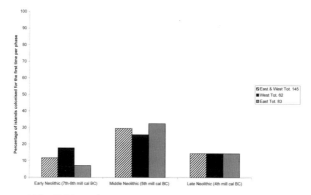

Figure 2.3: Phases of Neolithic colonisation (Dawson 2005)

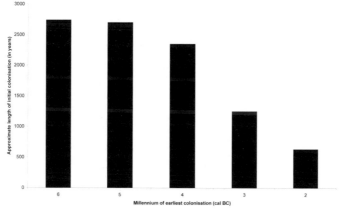

Figure 2.4: Initial occupation decreases with later colonisation (Dawson 2004-6, 40)

reason why a similar strategy of utilisation of island resources without the establishment of populations should not have occurred also in the Mediterranean, where shorter distances would have made it all the more feasible (Figure 2.1).

When the entire corpus of colonisation data from the Mediterranean islands (now amounting to at least 145 islands, see Tables 2.1 and 2.2, all dates are calibrated) is analysed, the Neolithic emerges as the principal period when the islands came to be inhabited permanently (Figure 2.2).

The evidence has been reviewed in detail elsewhere (Dawson 2005, 2004-6, 2008), therefore only three key observations are made here, which will be discussed in turn:

1. The Neolithic should not be viewed as a monolithic phase, as it is clear that rates of colonisation varied during this period (Figure 2.3);
2. What distinguishes Neolithic colonisation is that islands settled in this period experienced longer periods of occupation than islands settled in later periods (Figure 2.4);
3. The overall pattern of island colonisation is not one of steady occupation of available land (cf. a 'wave of advance'), but rather a more random process, reflecting a more peripatetic trajectory.

The pan-Mediterranean record: new data, new patterns?

Cherry's (1981) original dataset was predominantly eastern Mediterranean, as he investigated 79 islands in the eastern Mediterranean and 35 in the western Mediterranean. The database has now grown and in the present review it includes just over 40 additional islands or 145 islands in total (83 in the eastern and 62 in the western Mediterranean), reflecting a considerable rise in research in the west. The data (Figure 2.5) confirm the general trends noted by Cherry: islands were colonised incrementally, apparently confirming a gradual and continuous

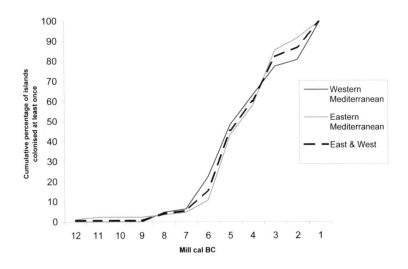

Figure 2.5: Cumulative colonisation plot (Dawson 2005)

Table 2.1 Western and central Mediterranean island data (millennium of first colonisation cal BC; distance to nearest mainland km; size sq km)

	Name	Mill 1st Col.	Dist. NM	Size
1.	Corsica	8	87	8722
2.	Brac	8	5.5	395
3.	Sardinia	8	205	24089
4.	San Domino	6	25	1.5
5.	Palagruza	6	130	0.3
6.	Korcula	6	34.5	276
7.	Lipari	6	30.2	37.6
8.	Salina	6	42.9	26.8
9.	Hvar	6	4.1	299
10.	Susac	6	80	4.6
11.	Vis	6	23.6	90.3
12.	Filicudi	6	46.6	9.5
13.	Malta	6	80	246
14.	Gozo	6	65	67
15.	Capri	5	5	10
16.	Elba	5	10	220
17.	Lampedusa	5	210	20.2
18.	Giglio	5	22	15
19.	Giannutri	5	14	3
20.	Solta	5	7.7	588
21.	Pianosa	5	50	10
22.	Iles Planes	5	5	n/a
23.	Habibas	5	11	0.4
24.	Rachgoun	5	2	n/a
25.	Ile du Roi (Chaffarinas)	5	11	n/a
26.	Ile d'Isabelle (Chaffarinas)	5	11	n/a
27.	Ile du Congres (Chaffarinas)	5	11	n/a
28.	Zembra	5	10	3.9
29.	Kuriate	5	16	12
30.	Ustica	5	53	8
31.	Panarea	5	42	3.4
32.	Levanzo	4	15	7
33.	Favignana	4	17	19.4
34.	Marettimo	4	30	12
35.	Ischia	4	11	46
36.	Lastovo	4	25	49
37.	Palmarola	4	1.4	32
38.	Ponza	4	33	12
39.	Zannone	4	27	4
40.	Pianosa (Tremiti)	4	35	0.11
41.	Pantelleria	3	102	83
42.	Stromboli	3	56.2	12.6
43.	Sv Klement	3	5.6	3
44.	Scedro	3	6.7	7.5
45.	Svetac	3	47.6	4.3
46.	Majorca	3	167	3740
47.	Menorca	3	200	702
48.	Alicudi	2	87.5	5.2
49.	Ibiza	2	86	541
50.	Formentera	2	95	82
51.	San Nicola	1	25	0.5
52.	Kopiste	1	87	1
53.	Mjlet	1	18	98.6
54.	Comino	1	70	2.6
55.	Bisevo	1	27.8	5.8
56.	Cabrera	1	175	13
57.	Conejera	1	178	18
58.	Linosa	1	19	5.4
59.	Montecristo	1	10	63
60.	Djerba	1	2.5	568
61.	Chergui (Iles Kerkenna)	1	25	69
62.	Gharbi (Iles Kerkenna)	1	25	n/a

Table 2.2 Eastern Mediterranean island data (millennium of first colonisation cal BC; distance to nearest mainland km; size sq km)

	Name	Mill 1st Col.	Dist. NM	Size
1.	Lemnos	12?	62	478
2.	Cyprus	11	60	9251
3.	Gioura	8	70	20
4.	Kythnos	8	39	100
5.	Crete	7	102	8259
6.	Alonissos	6	43	65
7.	Kyra Panagia	6	59	25
8.	Skyros	6	33	210
9.	Thasos	6	7	380
10.	Lefkas	6	0.5	303
11.	Corfu	5	5	593
12.	Amorgos	5	105	124
13.	Andros	5	55	380
14.	Astypalaia	5	79	97
15.	Chios	5	11	842
16.	Giali	5	18	9
17.	Kalymnos	5	18	93
18.	Karpathos	5	93	301
19.	Kasos	5	140	69
20.	Kos	5	5	290
21.	Kythera	5	15	280
22.	Leros	5	32	53
23.	Lesbos	5	12	1633
24.	Mykonos	5	112	86
25.	Naxos	5	132	430
26.	Paros/Antiparos	5	115	196
27.	Psara	5	67	40
28.	Rhodes	5	19	1400
29.	Salamis	5	0.5	96
30.	Samos	5	5	477
31.	Saria	5	85	21
32.	Symi	5	8	38
33.	Thera	5	180	76
34.	Tilos	5	20	63
35.	Ithaca	5	30	96
36.	Kephalonia	5	38	781
37.	Despotiko	5	112	8
38.	Aegina	4	21	83
39.	Alimnia	4	40	7
40.	Chalki	4	47	28
41.	Gavdos	4	192	30
42.	Kea	4	22	131
43.	Melos	4	105	151
44.	Samothraki	4	37	178
45.	Meganisi	4	9	20
46.	Siphnos	4	85	74
47.	Syros	4	75	85
48.	Zakynthos	4	18	402
49.	Delos	3	112	3
50.	Dokos	3	2	20
51.	Erymonisia	3	n/a	n/a
52.	Idra	3	6	50
53.	Imbros (Gokceada)	3	16	279
54.	Ios	3	147	109
55.	Keros	3	145	15
56.	Kimolos	3	106	36
57.	Kouphonisia	3	160	6
58.	Makronisos	3	3	18
59.	Pholegandros	3	131	32
60.	Poros	3	0.5	23
61.	Sikinos	3	140	35
62.	Spetses	3	2	22

Table 2.2 Eastern Mediterranean island data (millennium of first colonisation cal BC; distance to nearest mainland km; size sq km) (continued)

	Name	Mill 1st Col.	Dist. NM	Size
63.	Tenedos (Bozcaada)	3	19	42
64.	Donoussa	3	140	14
65.	Heraklia	3	155	18
66.	Schinoussa	3	157	9
67.	Tinos	3	82	195
68.	Nysiros	3	17	37
69.	Reneia	3	105	14
70.	Seriphos	3	62	75
71.	Anafi	2	152	40
72.	Lipsoi	2	37	17
73.	Patmos	2	48	34
74.	Skopelos	2	22	97
75.	Therassia	2	178	9
76.	Marsa Island	2	1	7
77.	Antikythera	1	63	20
78.	Arkos	1	10	5
79.	Atokos	1	8	5
80.	Castellorizo	1	5	10
81.	Ikaria	1	47	256
82.	Kalamos	1	2	25
83.	Skiathos	1	4	50

infilling of available land, which, generally speaking, was faster in the western than in the eastern Mediterranean, at least until the late-4th to early-3rd millennium cal BC. The temporal origins of colonisation have since been pushed back in both east and west, and there is a reduction in the colonisation time lag noticed by Cherry between the two areas (between the 7th-6th and the early-3rd millennia cal BC), which is mainly the result of a set of earlier dates that have become available from the eastern Mediterranean (Cyprus and the Aegean islands).

In the western Mediterranean (Figure 2.6; Table 2.1), the data show that, excluding the islands that were colonised at low sea levels, when land bridges or much narrower gaps probably existed (e.g. Sicily and Brac), the first western islands to be colonised are still the larger islands (Sardinia and Corsica). There is evidence of human settlement on the small island of San Domino (Tremiti, in the Adriatic) from the 7th or possibly 6th millennium cal BC, when the other Tremiti islands were perhaps frequented (Fumo 1980). The Tremiti islands are very small (in the order of one sq km) and less than 30 km away from the nearest mainland (SE Italy). Colonisers however also ventured further away at this time, up to c. 130 km in the case of Palagruža in the central Adriatic (although this journey could be broken up into two 50 km-stretches from either the Italian or Croatian side, via Pianosa or Susač) (Bass 1998; Kaiser and Forenbaher 1999). All the other islands colonised during this millennium lie less than 80 km away from the nearest mainland and most belong in the 10-100 sq km bracket (with a few smaller and larger exceptions). The islands colonised in the 5th millennium are generally close to the nearest mainland (less than 60 km), with one remote exception (Lampedusa, south of Sicily). A range of sizes is represented, with the islands colonised during this period falling in the <1 to 600 sq km bracket. In the 4th millennium, the islands colonised are all smaller than 100 sq km and less than 40 km away from the nearest mainland. In the 3rd millennium, most islands colonised are very small (smaller than 10 sq km), and between 10 and 100 km from the nearest mainland (with the notable exception of the two Balearics) (Ramis and Alcover 2001, Ramis *et al.* 2002). A few more

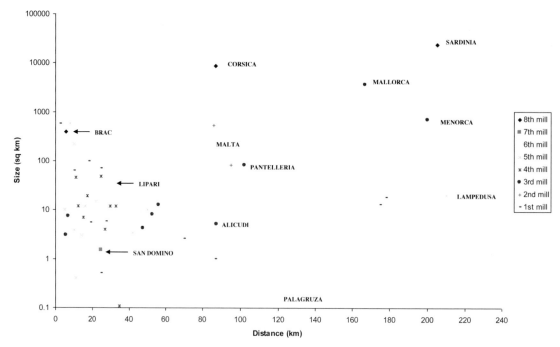

Figure 2.6: Western Mediterranean: colonisation scatter-plot showing islands colonised during each millennium cal BC (Dawson 2005)

islands were colonised for the first time in the 2nd and the 1st millennia, when there appears to be no spatial patterning in the islands occupied, although the islands are generally small (less than 20 sq km). In the 1st millennium, some lie close to larger islands previously occupied (e.g. Comino, Kopiste, Conejera, Cabrera), perhaps reflecting the filling-up of remaining empty space or possibly requirements linked to specific functional uses (e.g. ritual spaces, cf. Palagruža).

For the eastern Mediterranean (Figure 2.7; Table 2.2), some of the overall processes and patterns first noted by Cherry can still be recognised but, as mentioned, the new data indicate a strong increase in colonisation after the 6th millennium (particularly in the 5th and 4th millennia). The earliest colonisation is documented on the largest of the islands, Cyprus. The island's earliest colonisation has been dated to the 11th millennium cal BC, as found at Akrotiri-*Aetokremnos* (Simmons 1999) and possibly as early as the 12th millennium at the recently discovered sites of Nissi Beach and Aspros (Ammerman and Noller 2005; Ammerman *et al.* 2006, 2007). It should be noted that there is lack of consensus on whether this initial phase of human presence represents actual colonisation of the island, with Simmons (1999, 43) arguing that it was a failed experiment and Ammerman and Noller (2005) challenging the notion that it amounted to occupation. Settlement on Cyprus became more permanent in the 9th millennium (Guilaine *et al.* 1995, 1996; Peltenburg 2003; Peltenburg *et al.* 2001a, 2001b). An early date has recently been put forward for the island of Lemnos, in the north-eastern Aegean, where the site of Ouriakos, near Louri beach, is being excavated by Efstratiou, who has interpreted it as a hunter-gatherer and fishing site and dated it to the 12th

millennium BC. The site reports could not be consulted by the time of this paper going to press, but the site has been in the media spotlight (e.g. Balaskas 2009). In the 9th-8th millennium, further evidence comes from Gioura and Kythnos, two small islands in the Aegean (in the northern Sporadhes and Cyclades respectively). These may not be isolated instances, as further evidence still awaiting systematic investigation has apparently been found on several islets around Gioura (Davis *et al.* 2001, 79). In the 7th millennium cal BC, and the 6th in particular, a few larger islands were colonised (e.g. Skyros and Thasos), which, excluding Crete, all lie less than 60 km from the nearest mainland. Crete is an anomaly, being a large island with apparently no pre-Neolithic evidence, though future fieldwork may well rectify this. The recent announcement of Palaeolithic finds on Crete dated to 130,000 years BP (Strasser *et al.* 2010) is a groundbreaking discovery but is perhaps not surprising in the context of increasingly earlier evidence for seafaring emerging from the Mediterranean and other recent claims of Palaeolithic material on Crete and neighbouring Gavdos (Kopaka and Matzanas 2009; Mortensen 2008). Nonetheless, the lengthy gap between this initial colonisation and the Neolithic occupation of Crete indicates that the first colonisers either died out or abandoned the island. On the other hand, Neolithic colonisation in the 5th millennium seems to be all-pervasive, with islands colonised regardless of distance (up to 180 km from the

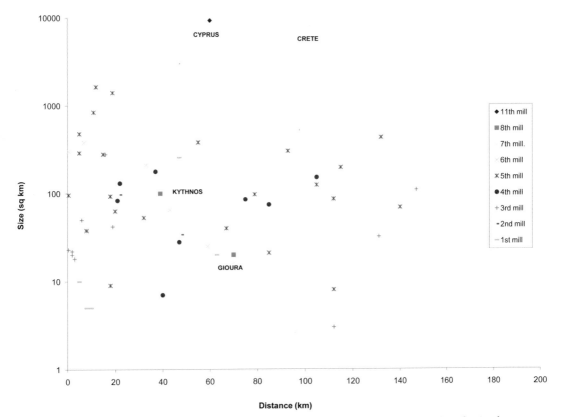

Figure 2.7: Eastern Mediterranean: colonisation scatter-plot showing islands colonised during each millennium cal BC (Dawson 2005)

nearest mainland, e.g. Thera, which is accessible from the mainland via other islands). The same pattern holds roughly for the 4th millennium (e.g. Gavdos, which is close to Crete), while for the 3rd and 2nd millennia, most islands colonised fall below the 100 sq km threshold, with two exceptions (Imbros and Tinos), and again distance appears not to be a hindrance to their colonisation (with each island lying up to 150 km away via intervening stepping-stone islands). There is little spatial patterning of note for the 1st millennium, but the islands colonised are at the lower end of the size scale.

Some interesting conclusions can be made based on the above:

1. There is increasing evidence for pre-Neolithic human presence on the islands: Cyprus is the most notable case, but some small (true) islands in the Aegean were also colonised as early as the Mesolithic.
2. Overall, island colonisation in the western Mediterranean took place at a steadier and faster pace than in the eastern Mediterranean, at least initially, though the time lag noticed by Cherry in 1981 has been considerably reduced, with colonisation in the east following that in the west closely in the Middle to Late Neolithic and surpassing it during the Final Neolithic-Early Bronze Age transition.
3. There is a higher number of islands colonised in the Early and Middle Neolithic, or between the 7th and 4th millennia, than previously seen. The Neolithic, as opposed to the Bronze Age, is overall the key period for island colonisation.
4. Overall, spatial patterning appears to be more prominent in the west than in the east. This may be due to geographical differences already noted by Cherry (1981, 63) (e.g. large islands in the west acting as 'mainlands').

Patton (1996, 59) created a histogram of colonisation data, which he used to identify distinct waves of colonisation. This was an important move away from the prevailing representation of colonisation, which until then had been cumulative or linear and promulgated

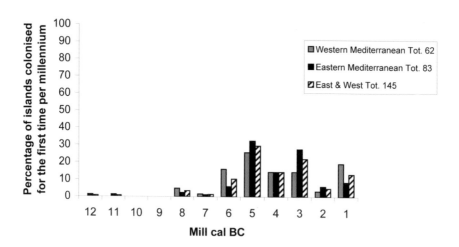

Figure 2.8: Rates of islands colonised during each millennium in the eastern and western Mediterranean (Dawson 2005)

colonisation as a 'wave of advance'. Patton used the graph only to make some very general points about pan-Mediterranean patterns of colonisation and did not explore the implications of his observations on a regional scale. Cherry (1997, 501, 503), who praised Patton's contribution as being the 'first book-length Mediterranean-wide treatment of the subject', also heavily criticised his cyclical socio-geographical model. Patton (1996, 62), however, did make the important point that the evidence for island colonisation indicates that this was an irregular rather than smooth process of spatial infilling.

Unlike cumulative plots, Patton's histogram was non-cumulative, and therefore, rather than adding the number of islands colonised in the previous millennium to the following, it only accounted for how many new colonisation events took place during each millennium. The same data used in Figure 2.5 are represented graphically as a bar chart (Figure 2.8) rather than a curve. This allows us to compare rates of colonisation between millennia and to identify distinct waves of colonisation. When viewed this way, the colonisation pattern for the eastern Mediterranean displays two distinct peaks, in the 5th and the 3rd millennia cal BC; in the western Mediterranean, colonisation also peaked in the 5th millennium with another small peak in the 1st millennium cal BC.

Testing island biogeography

Cherry's model for explaining island colonisation drew strongly on biogeography, which sought to explain why and how species occupy certain islands and thrive there, and offered island archaeologists some ready-made frameworks. Applying the same framework to human dispersal, however, has proved more problematic, and the application of the laws of biogeography to the study of human culture has resulted in the 'noise' noticed by Cherry. In its simplest incarnation, island biogeography uses variables such as island area and distance in order to calculate an island's 'biogeographic ranking' (BGR) (MacArthur and Wilson 1967). This gives an indication of the likelihood that an island will be colonised and that, once there, a colonising population will survive. Biogeographical studies of maritime movement rely by necessity on a set of simplifications, such as visibility indices (Patton 1996, 45), target-distance (T/D) ratios (Held 1989, 13), and longest single voyage (LSV) (Patton 1996, 40). Such categories, however, are removed from any true experience of navigation. Island archaeologists, on the other hand, are increasingly accepting that 'insularity was a social construction' (Lull *et al.* 2002, 124) and archaeological colonisation models have been modified accordingly (e.g. Broodbank 2000). As a result, biogeography's predictive power is under fire, but its potential for the analysis of colonisation trends is still appealing, as it uses simple observations based on island size and distance parameters. An example of how this type of analysis can be carried out is given below (for a detailed explanation of how different size and distance parameters were selected see Dawson 2005).

Most western Mediterranean islands colonised in the 5th millennium lie close to the mainland (less than 20 km), whereas, in the east, this number is balanced out by a similar number of islands that lie over 20 km away, though they are mostly large islands (larger than 50 sq km). In the western Mediterranean, most nearby islands (both large and small) were colonised during the Neolithic. Distant islands, even if large, were not targeted in this period. In the eastern Mediterranean, most large islands were colonised between the Neolithic and Bronze Age (5th-3rd millennia) regardless of distance.

In the eastern Mediterranean, far-away islands (>100 km from the nearest mainland) were

Table 2.3 Eastern Mediterranean islands: biogeographical characteristics

IONIAN	Size	Dist NM
Corfu	593	5
Ithaca	96	30
Kalamos	25	2
Kephalonia	781	38
Lefkas	303	0.5
Meganisi	20	9
Zakynthos	402	18
Average	317	15

SW AEGEAN	Size	Dist NM
Aegina	83	21
Poros	23	0.5
Salamis	96	0.5
Idra	50	6
Dokos	20	2
Spetses	22	2
Kythera	280	15
Antikythera	20	63
Atokos	5	8
Average	66.5	13

NORTHERN SPORADHES	Size	Dist NM
Skiathos	50	4
Skopelos	97	22
Alonissos	65	43
Kyra Panagia	25	59
Gioura	20	70
Skyros	210	33
Average	78	38.5

CYCLADES	Size	Dist NM
Andros	380	55
Tinos	195	82
Mykonos	86	112
Reneia	14	105
Schinoussa	9	157
Delos	3	112
Despotiko	8	112
Donoussa	14	140
Heraklia	18	155
Syros	85	75
Makronisos	18	3
Kea	131	22
Keros	15	145
Kimolos	36	106
Kouphonisia	6	160
Kythnos	100	39
Seriphos	75	62
Siphnos	74	85
Melos	151	105
Paros	196	115
Naxos	430	132
Amorgos	124	105
Ios	109	147
Sikinos	35	140
Pholegandros	32	131
Thera	76	180
Therassia	9	178
Anafi	40	152
Average	85	107

SE AEGEAN	Size	Dist NM
Samos	477	5
Ikaria	256	47
Patmos	34	48
Arkos	5	10
Lipsoi	17	37
Leros	53	32
Kalymnos	93	18
Kos	290	5
Astypalaia	97	80
Castellorizo	10	5
Giali	9	18
Nysiros	37	17
Tilos	63	20
Symi	38	8
Rhodes	1400	19
Chalki	28	47
Alimnia	7	40
Saria	21	85
Karpathos	301	93
Kasos	69	140
Average	165	39

NE AEGEAN	Size	Dist NM
Thasos	380	7
Samothraki	178	37
Imbros	279	16
Tenedos	42	19
Lemnos	478	62
Lesbos	1633	12
Psara	40	67
Chios	842	11
Average	374	29

Table 2.4 Biogeographic ranking of six island groups

Island group	Average size (sq km)	Average distance NM*	BGR**
IONIAN	317	15	21.13
NE AEGEAN	374	29	12.89
SW AEGEAN	66.5	13	5.11
SE AEGEAN	165	39	4.23
N SPORADHES	78	38.5	2.02
CYCLADES	85	107	0.79

* Average distance to Nearest Mainland in km
** Overall BGR: Biogeographical ranking=average size/average distance (without stepping stone effect).
Islands with higher BGR should be colonised earlier.

colonised mostly in the 3rd millennium (Early Bronze Age), usually via stepping-stone islands, and in the context of extensive trading networks. The same is true in the western Mediterranean. The exceptions are the islands of Susač and Filicudi, both of which were colonised earlier and were easily reached via stepping-stone islands colonised at roughly the same time.

Therefore, in conclusion, most small and far-away islands were colonised from the Early Bronze Age onwards, whereas the colonisation of small close-by islands took place gradually from the 5th millennium onwards. Identifying possible causes behind such large-scale geographical patterns does not seem a viable approach; instead, when this type of analysis is carried out at the regional scale, more localised patterns can be compared with the general trends described above, and underlying processes identified more effectively.

Northern and central Tyrrhenian islands. When the earliest known colonisation dates for the islands are plotted (Figure 2.9), it is evident that they were mostly occupied in the 5th-4th millennium cal BC (data from several sources, see Dawson 2004-6). There is a significant temporal gap between the colonisation of the larger islands, Sardinia and Corsica, and the remaining ten small islands, with no islands colonised between the 8th and the 5th millen-

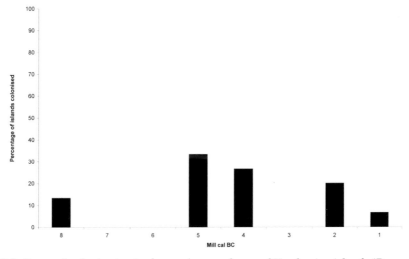

Figure 2.9: Rates of colonisation in the northern and central Tyrrhenian islands (Dawson 2005)

nium and between the 4th and the 2nd millennium cal BC. Colonisation in this island group was therefore not a smooth progression, but the two larger islands absorbed the colonisation momentum. On the basis of current knowledge, the island of Montecristo was the last one in the group to be occupied in the 1st millennium cal BC.

Southern Tyrrhenian: the Aeolian islands. There are seven islands in this group, Sicily's largest satellite archipelago, located c. 40 km north-east of its coast. The islands have been thoroughly investigated since the 1950s (Bernabò Brea 1957; Bernabò Brea and Cavalier 1980; Castagnino Berlinghieri 2002). Initial colonisation involved the three islands of Lipari, Salina, and Filicudi (with Lipari slightly earlier than the others). Figure 2.10 shows phases of human occupation: by incorporating both abandonment and recolonisation data, it displays, in percentage, how many of the seven islands were occupied at the same time. Lipari was the only island to be continuously occupied, while the other islands were abandoned at different times. There was a reduction in the overall occupation in the archipelago during the 4th millennium, an increase in the 3rd, and drastic nucleation in the 1st millennium cal BC, when only the Lipari acropolis was inhabited. Biogeography fails to explain why Vulcano, the island closest to Sicily, was never permanently settled; nor does it explain expansion and contraction within the archipelago overall. Instead, the anomalies have socio-cultural explanations.

Dalmatian islands. Of the several hundreds of islands stringed along the eastern shore of the Adriatic, only fourteen have been archaeologically investigated and are considered in this study (the data are derived from Bass 1998 and Gaffney *et al.* 1997). The islands' average size is 130 sq km, and their average distance from the Croatian coast is 40.5 km. When their colonisation histories are analysed, it emerges that there was a steady increase in the number of islands colonised from the 8th to the 6th millennium, and a slight drop in the 5th and 4th millennia cal BC. The Middle Bronze Age (2nd millennium cal BC) saw no islands being

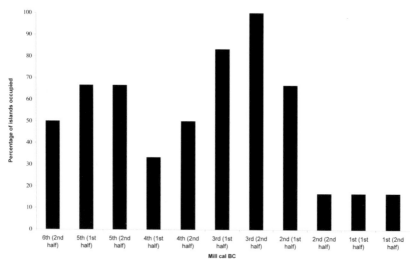

Figure 2.10: Aeolian Islands (Southern Tyrrhenian): percentage of islands occupied at any given time (Dawson 2005)

colonised. Colonisation resumed in the 1st millennium BC. The islands' steady infill may reflect the relative ease with which the islands can be reached from the mainland. The lack of island colonisation in the 2nd millennium has been linked by Gaffney *et al.* (1997) to settlement processes on the mainland during the same period.

The Cyclades. A total of 29 Cycladic islands have been considered (the data are derived from Broodbank 2000). The islands' average size is 85 sq km, and their average distance from the nearest mainland is 107 km, though the islands are in reach of each other. If the early and short-lived colonisation of Kythnos is not included, the colonisation of the Cyclades began in the 5th millennium, and involved some of the largest islands in the archipelago (e.g. Naxos). The main period for colonisation was however the 3rd millennium cal BC, when 17 (c. 60%) of the islands were colonised for the first time. Colonisation continued, at lower rates, up to the 1st millennium cal BC.

The late colonisation of the Cyclades is striking when the geography of the islands is considered: amongst the Cycladic islands colonised in the Early Bronze Age are Ios (109 sq km), Kythnos (100 sq km), and Pholegandros (32 sq km). While it may not be surprising that Ios was not settled earlier, in view of its distance from the mainland (147 km), it is striking that there is no evidence of human presence on Kythnos from the 8th to the 3rd millennium cal BC, when the island was recolonised. Kythnos falls within the category of Cherry's (1981, 52) 'larger littoral islands' (39 km from the mainland). Only Pholegandros, in this respect, satisfies biogeographical expectations, being both in the lower size range and further away from the mainland (131 km).

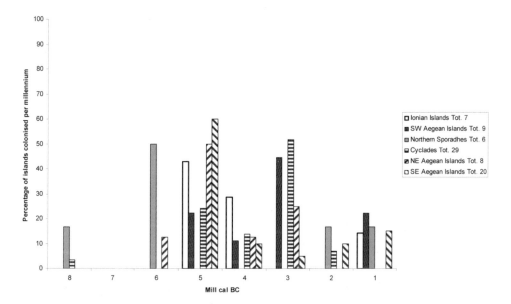

Note: at the time of going to press, a new site on Lemnos (NE Aegean islands) had been identified and provisionally dated to the 12th millennium BC

Figure 2.11: Comparing rates of colonisation in six eastern Mediterranean island groups (Dawson 2005)

Aegean and Ionian islands. When the colonisation histories of six eastern Mediterranean island groups are shown side-by-side (data from Broodbank 1999), several observations can be made (Tables 2.3 and 2.4; Figure 2.11). No single period was key to the colonisation of all island groups, but three periods appear to be prominent. The northern Sporadhes, the north-eastern Aegean islands, the south-eastern Aegean islands, and the Cyclades all experienced, albeit at different times, a colonisation peak (with 50% or more of the islands colonised in a single phase). This was the 6th millennium for the northern Sporadhes, the 5th for the Ionian, south-eastern and north-eastern Aegean islands, and the 3rd for the Cyclades and the south-western Aegean islands. In the case of the northern Sporadhes (if the isolated 'colonisation' of Gioura in the 8th millennium is excluded) and the south-eastern Aegean, colonisation actually began with such peaks (i.e. an initial surge). The northern Sporadhes, which have a low biogeographic ranking, display a long colonisation hiatus from the 6th to the 2nd millennium cal BC (in all the other groups, such gaps are usually in the order of a thousand years). The Ionian islands, which have the highest biogeographic ranking, were colonised mostly in the 5th and 4th millennia. The Cyclades experienced cyclical rates of colonisation, which paralleled closely those of the south-western Aegean islands in the 5th-3rd millennia. Rates of colonisation in the north-eastern and south-western Aegean islands were also cyclical, and both groups experienced peaks in the 5th and 3rd millennia and troughs in the 4th and 2nd millennia.

Variability in island colonisation

When viewed overall, the data indicate that the Neolithic was the main period for island colonisation, though the trend was one of irregular rather than steady occupation. Evans was among the first to link island colonisation to the 'Neolithisation' of the whole Mediterranean basin: although his focus was west-Mediterranean (having worked extensively on Malta), also on the basis of his work on Crete, he claimed that 'most Mediterranean islands were first settled at a fairly early stage in the Neolithic' (1977, 14). He argued that, most likely, the islands would have been reached by populations living on the nearest land, following the 'wave of advance' pattern envisaged by Ammerman and Cavalli-Sforza (1973, 1979).

In the current review of the data, the link between island settlement and the spread of agriculture is reflected, for example, by increased colonisation in the Neolithic in the northern and central Tyrrhenian islands. Other islands, however, such as the Dalmatian islands, experienced an actual reduction in the number of islands colonised in the 5th millennium, or were colonised altogether much later than the inception of farming on nearby mainlands (especially in the western Mediterranean, e.g. the Spanish islands). Anthony's (1997) 'leapfrogging' model of prehistoric migration and van Andel and Runnels' (1995) 'jump dispersal' model provide useful explanations for these archaeological gaps. Zilhão (2000, 170-171) also envisaged a modified wave of advance model, involving a punctuated series of events (cf. Fiedel and Anthony 2003), rather than a continuous and gradual process of demic colonisation. In these models, economic pressure is not the only reason why colonising groups may have moved. Zilhão (2000, 173) argued, on the basis of archaeological and ethnohistorical data of the colonisation of the Pacific islands, that social reasons must have been involved. He believed that, as in the Pacific, a 'pioneer ethic' was behind the rapid spread of a Neolithic way of life along the coasts of the western Mediterranean. It seems that the implementation of a variety of strategies was the key to ensuring continuous human presence in environments with limited resources.

Good examples of the integration of different subsistence traditions come from the Dalmatian islands. The cave site of Vela Spilja on the Dalmatian island of Korčula revealed Neolithic deposits (early impressed wares), radiocarbon-dated to the very end of the 7th millennium cal BC, that included the bones of tunny, dolphin, and sea-bream (Bass 1998, 46). Similar strategies are attested at coastal mainland sites, such as Pupićina Peć (Miracle 1997) and Vižula (Chapman and Müller 1990). These sites indicate that different cultural traditions coexisted for some time. A number of researchers have commented on the fact that humans introduced both domesticated and wild species to the Mediterranean islands, before, during, and after the Neolithic (Vigne 1998, 65-67; Peltenburg *et al.* 2001a, 46).

The migration models discussed so far highlight the fact that colonisation involved a variety of activities, some purposeful, others serendipitous: demographic growth, sedentism, and a preference for certain types of land are but a few of the reasons that may have prompted the search for new territories. Neolithic colonisation involved a complex set of processes.

The simple fact that island groups with similar geographical configurations and biogeographical ranking did not experience the same rates of colonisation is a clear sign of the limitations of a biogeographical approach. Cultural strategies, developed in order to cope with different island environments, but increasingly in response to events in the islanders' wider world, had more to do with island life than biogeography by itself can account for. The absence of people is the fundamental drawback of biogeographical analysis. But even when a more agency-based approach is taken, there remain some problems. Different groups of people have been traditionally associated with specific types of activities, depending on whether they were hunter-gatherers, farmers, or traders, but as already mentioned, there are several examples in the archaeological record of overlaps between the categories, arising from the benefits of composite resource strategies. On the other hand, human activity on islands has traditionally received the headings of visitation, utilisation, occupation, and establishment. The underlying assumption is that they are discrete phases following each other chronologically and that reaching an island is harder than living there or that, once established, social mechanisms ensured the survival of colonies. As a result, abandonment and recolonisation have received little systematic attention in island-related literature. The phases are arbitrary constructs: 'repeated visitation' in a Neolithic context could, for example, amount to 'occupation' in a Mesolithic context. Indeed it seems that human activity on islands has been excessively polarised between these extremes, without paying due credit to hybrid strategies. The following examples challenge this teleological view of colonisation.

Visitation/ utilisation. One of the classic examples of visitation is for the utilisation of a resource. Five Mediterranean islands produced the bulk of obsidian used in prehistoric times (Melos, Lipari, Palmarola, Pantelleria, and Sardinia), while Palagruža and the Tremiti islands had good-quality chert sources. Other islands had metal resources, e.g. Kythnos and Siphnos in the Cyclades produced copper, silver, and lead, which were exploited in the Early Bronze Age and possibly the Final Neolithic (Broodbank 2000, 79-80, fig. 19). Evidence for mineral exploitation activity relies on extensive chipping floors or other signs that mining took place on the islands, or on indirect evidence (i.e. material found elsewhere that can be traced back to the islands). There are no known built structures contemporary with the early phases of obsidian exploitation from Melos, Lipari, Pantelleria, and Palagruža. Researchers have stressed the fact that these early activities have no clear links to the islands' subsequent settlement, with up to seven millennia separating the two phases in the case of Melos (Broodbank

2000, 110). Nonetheless, it is highly likely that resources other than minerals were sought and exchanged, but their perishable nature has not allowed their survival in the archaeological record. Even if permanent structures have not been found, shelter and food would have been necessary to the people involved in the extraction of obsidian. Consequently, quite a few more islands may have been visited without this activity leaving any traces.

Another form of visitation is for burial or ritual. On the island of Vulcano, prehistoric burials were excavated and dated to the first half of the 2nd millennium cal BC (Bernabò Brea 1957). As a result of this high concentration of burials, the island has been nicknamed *l'isola funebre* (i.e. funerary island) (Giustolisi 1995, 10). In classical sources, the island is referred to as Hiera, the sacred one, and as the entrance to the underworld (ibid.). Unlike the other Aeolian Islands, to which it belongs, Vulcano was not permanently settled in prehistory. As a burial ground, the island would have been visited by surrounding islanders, and acquired prominence without ever being settled. Visitation should therefore not be seen exclusively as an exploratory activity leading to settlement, as it may have been an established practice in its own right.

Settlement. Settlement, particularly if permanent, becomes archaeologically more visible or recognisable in several islands during the Neolithic, through the large numbers of village remains or cemeteries. In the Aegean islands, Neolithic villages are found at several locations, including Saliagos (Paros), Grotta (Naxos), Ftelia (Mykonos), Strofilas (Andros), Kephala (Keos), Knossos (Crete). In the central Mediterranean, classic examples include Castellaro Vecchio, the Lipari Acropolis, Contrada Diana (Lipari), Rinicedda (Salina), and Prato Don Michele (Tremiti). Most display a selection of the classic settlement indicators listed by Vigne (1989), Cherry (1990), and Vigne and Desse-Berset (1995), such as extensive ceramic and lithic surface scatters, post holes, hut floors and hearths, walls, burials, fortifications, evidence for craft specialisation, and evidence for food processing. This kind of evidence is specific to the Neolithic, which explains why settlement (repeated or seasonal) in the preceding periods is harder to demonstrate owing to the lack of equivalent diagnostic elements.

Figure 2.4 is based on the analysis of the settlement data from 20 islands selected from the main database on the basis of their extensive archaeological record (see Dawson 2004-6 for details). It shows that islands colonised up to the 4th millennium cal BC generally experienced initial occupation periods that lasted longer than those colonised in the 3rd and 2nd millennia cal BC. This may be due to their being smaller or less favourable to prolonged occupation than those colonised in earlier periods, when, as we have seen, larger islands (which could sustain larger populations) were mostly colonised.

Establishment. Establishment can be inferred through an increase in activity intensity, which should be reflected in archaeological remains (e.g. material wealth or evidence for good health as suggested by Peltenburg *et al.* 2001b). A long-term record of change is thus usually necessary if establishment is to be distinguished from pioneering, i.e. the initial phases of colonisation. Peltenburg *et al.* (2001b, 84) have pointed out that, unless tighter chronological control is available, it is preferable to 'refer to trends of island adaptation, greater elaboration and diversification'. A criterion they explore, which is useful when investigating establishment, is the development of an island 'way of life', or the elaboration of insular cultural traits distinguishable from mainland ones, implemented as a way of overcoming specific problems. It is worth noting that divergence from long-established cultural traditions can result from both contact and isolation. In the case of Malta, for example, the development of distinctive

megalithic temples (c. 4000-2500 BC) has been interpreted as the result of internal social tensions or as a response to interaction with Sicily (e.g. Bonanno 1990; Dixon 1998; Robb 2001; Stoddart 1999a, 1999b). The temple culture came to an end after being established for a considerable time, indicating that certain practices are not sustainable in the long run. Knapp (1989, 200) warns that 'factors that promoted constant growth may have generated a trajectory towards disintegration'.

Conclusions: *settling* the Neolithic question

This study of colonisation started off by focusing on the pan-Mediterranean scale, carrying on the task of modelling island colonisation where Cherry left it in the early 1990s. Cherry argued that 'it is more profitable to get on with the job of trying to make sense of what we know now' (1990, 203); but exciting new finds (particularly from the Aegean and Cyprus) are influencing greatly our understanding of colonisation. As the temporal gap between early visits to the islands and their settlement is reduced, a fundamental question to be addressed in the future will be the coexistence and interaction between two very different ways of lives: a seafaring lifestyle and a land-based lifestyle (Ammerman *et al.* 2006, 2007; Broodbank 2006; Robb 2008). In the meantime, the available data can be analysed systematically in order to bring to light both similarities and differences in the cultural trajectories of different island groups. In some cases, these can be explained through their geographic characteristics, but in others the link is less straightforward. Overall, the examples in this paper suggest that, while it has limited explanatory or predictive power in the Mediterranean, island biogeography is still a useful exploratory tool for identifying basic variations in colonisation trends. The analysis of all the available colonisation data shows that the Neolithic is the key period for the colonisation (intended as permanent *settlement*, in this case) of the islands in the Mediterranean, and that distance was an obvious concern to Neolithic settlers.

Variability in archaeological remains can be taken to represent distinct phases leading to permanent settlement (when substantiated by a long-term record), but also to embody different activities or types of island colonisation. These different types of colonisation require attention, particularly in terms of the conditions that may have stimulated their development. Visitation and settlement, for example, are not necessarily tied exclusively to specific periods. Although, as already mentioned, permanent settlement is largely a Neolithic feature, some islands continued to be visited in the Neolithic and Bronze Age without ever being settled; and there is growing evidence for forms of early settlement (albeit very different from Neolithic settlement) emerging, particularly in the eastern Mediterranean. These activities can therefore take place in different periods, but with different outcomes and for different reasons. This seems supported by the variability in the rates of islands colonised in the Early, Middle, and Late Neolithic eastern and western Mediterranean, but also by the differences noted between different island groups within them.

Colonisation studies have been conducted at two levels, which are on parallel but separate tracks: while biogeographical models have tended to be too removed from actual reality, individual island histories have privileged the detail at the expense of the wider picture. Comparing the colonisation of the islands at different times, places the Neolithic firmly in first place, but there remains a need to conduct island studies at several connected levels and, as much as possible, to bring real people into the archaeological spotlight.

Acknowledgements

I am very grateful to Cyprian Broodbank and Ruth Whitehouse, who supervised the doctoral research on which this paper is based. Albert Ammerman offered stimulating insights into colonisation and biogeography, and we had stimulating discussions during the excavations at Nissi Beach and Aspros (Cyprus) in 2008. Last but not least, many thanks to Nellie Phoca-Cosmetatou for inviting me to contribute to this volume. Needless to say, any mistakes or omissions are my own doing.

References

AMMERMAN, A.J. and CAVALLI SFORZA, L.L. 1973: A population model for the diffusion of early farming in Europe. In Renfrew, C. (ed.), *The explanation of culture change* (London), 345-358.

AMMERMAN, A.J. and CAVALLI SFORZA, L.L. 1979: The wave of advance model for the spread of agriculture in Europe. In Renfrew, C. and Cooke, K.L. (eds.), *Transformations: Mathematical Approaches to Culture Change* (London), 275-294.

AMMERMAN, A.J. and NOLLER J. 2005: New light on Aetokremnos. *World Archaeology* 37 (4), 533-543.

AMMERMAN, A. J., FLOURENTZOS, P., McCARTNEY, C., NOLLER, J. and SORABJI, D., 2006: Two new early sites on Cyprus. *Report of the Department of Antiquities, Cyprus*, 1-22.

AMMERMAN, A. J., FLOURENTZOS, P., GABRIELLI, R., McCARTNEY, C., NOLLER, J., PELOSO, D. and SORABJI, D., 2007: More on the new early sites on Cyprus. *Report of the Department of Antiquities, Cyprus*, 1-26.

ANDERSON, A., 2003: Entering unchartered waters: models of initial colonization in Polynesia. In Rockman, M. and Steele, J. (eds.), *Colonization of unfamiliar landscapes: the archaeology of adaptation* (London), 169-189.

ANTHONY, D. 1997: Prehistoric migration as Social Process. In Chapman, J. and Hamerow, H. (eds.), *Migrations and invasions in archaeological explanation* (Oxford, BAR International Series 664), 21-32.

BALASKAS, S. 2009: Oikismos 14.000 eton sti Lemno. *Eleutherotipia* newspaper (25 June 2009; archived: http://www.enet.gr/?i=news.el.article&id=57303, accessed 25-01-10)

BASS, B. 1998: Early Neolithic offshore accounts: remote islands, maritime exploitations, and the trans-Adriatic cultural network. *Journal of Mediterranean Archaeology* 11, 165-190.

BERNABÒ BREA, L. 1957: *Sicily before the Greeks* (London).

BERNABÒ BREA, L. and CAVALIER, M. 1980: *Meligunìs Lipára IV. L'Acropoli di Lipari nella Preistoria* (Palermo).

BONANNO, A. 1990: *Gozo, the roots of an island* (Valletta).

BROODBANK, C. 1999: Colonization and configuration in the insular Neolithic of the Aegean. In Halstead, P. (ed.), *Neolithic society in Greece* (Sheffield, Sheffield Studies in Aegean Archaeology 2), 15-41.

BROODBANK, C. 2000: *An island archaeology of the early Cyclades* (Cambridge).

BROODBANK, C. 2006: The origins and early development of Mediterranean maritime activity. *Journal of Mediterranean Archaeology* 19 (2), 199-230.

CASTAGNINO BERLINGHIERI, E.F. 2002: *The Aeolian islands: crossroads of Mediterranean routes. A survey on their maritime archaeology and topography from the prehistoric to the Roman Periods* (Oxford, BAR International Series 1181).

CHAPMAN, J.C. and MÜLLER, J. 1990: Early farmers in the Mediterranean Basin: the Dalmatian evidence. *Antiquity* 64, 127-134.

CHERRY, J.F. 1981: Pattern and process in the earliest colonization of the Mediterranean islands. *Proceedings of the Prehistoric Society* 47, 41-68.

CHERRY, J.F. 1990: The first colonization of the Mediterranean islands: a review of recent research. *Journal of Mediterranean Archaeology* 3 (2), 145-221.

CHERRY, J.F. 1997: Review of Patton, M. 1996. Islands in time. London, Praeger. *Journal of Anthropological Research* 53 (4), 501-503.

CHERRY, J.F. 2004: Mediterranean island prehistory: what's different and what's new? In Fitzpatrick, S.C. (ed.), *Voyages of Discovery: The Archaeology of Islands* (Westport), 233-250.

DAVIS, J.L., TZONOU-HERBST, I. and WOLPERT, A.D. 2001: Addendum: 1992-1999. In Cullen, T. (ed.), *Aegean Prehistory: a review* (Boston, American Journal of Archaeology Supplement 1), 77-94.

DAWSON, H.S. 2005: *Island colonisation and abandonment in Mediterranean prehistory* (Unpublished PhD thesis, UCL).

DAWSON, H.S. 2004-6: Understanding colonisation: adaptation strategies in the central Mediterranean islands. *Accordia Research Papers* 10, 35-60.

DAWSON, H.S. 2008: Unravelling "mystery" and process from the prehistoric colonisation and abandonment of the Mediterranean islands. In Conolly, J and Campbell, M. (eds.), *Comparative island archaeologies: proceedings of the International Conference, University of Auckland, New Zealand 8th-11th December 2004* (Oxford, BAR International Series 1829), 105-133.

DIXON, C.A. 1998: The end of Malta's Temple-building Culture. *Journal of Prehistoric Religion* 11-12, 37-93.

EVANS, J.D. 1977: Island archaeology in the Mediterranean: problems and opportunities. *World Archaeology* 9, 12-26.

FIEDEL, S.J. and ANTHONY, D.W. 2003: Deerslayers, pathfinders, and icemen: origins of the European Neolithic as seen from the frontier. In M. Rockman, M. and Steele, J. (eds.), *Colonization of unfamiliar landscapes: the archaeology of adaptation* (London), 144-168.

FUMO, P. 1980: *La preistoria delle Isole Tremiti. Il Neolitico* (Campobasso).

GAFFNEY, V., KIRIGIN, B., PETRIĆ, M., and VUJNOVIĆ, N. 1997: *The Adriatic Islands Project: contact, commerce and colonialism 6000BC-AD 600. Volume 1: the archaeological heritage of Hvar, Croatia* (Oxford, BAR International Series 660).

GIUSTOLISI, V. 1995: *Vulcano: introduzione alla storia e all'archeologia dell'Antica Hiera* (Palermo).

GOSDEN, C 1993: *Social Being and Time* (Oxford).

GRAVES, M.W. and ADDISON, D.J. 1995: The Polynesian settlement of the Hawaiian Archipelago: integrating models and methods in archaeological interpretation. *World Archaeology* 26, 380-399.

GUILAINE, J., BRIOIS, F., COULAROU, J. and CARRÈRE, I. 1995: L'établissement néolithique de Shillourokambos (Parekklisha, Chypre). Premiers résultats. *Report of the Department of Antiquities, Cyprus 1995* (Nicosia), 11-36.

GUILAINE, J., BRIOIS, F., COULAROU, J. VIGNE, J.-D. and CARRÈRE, I. 1996: Shillourokambos et les débuts du Néolithique à Chypre. *Espacio, Tiempo y Forma,* sér. 1, *Prehistoria y Arqueologia* 9, 159-171.

GUERRERO, V.M. 2001: The Balearic islands: prehistoric colonization of the furthest Mediterranean islands from the mainland. *Journal of Mediterranean Archaeology* 14 (2), 136-158.

HELD, S.O. 1989: Colonization cycles on Cyprus 1: the biogeographic and palaeontological foundations of Early Prehistoric Settlement. *Report of the Department of Antiquities, Cyprus* (Nicosia), 7-28.

KAISER, T. and FORENBAHER, S. 1999: Adriatic sailors and stone knappers: Palagruža in the 3rd millennium BC. *Antiquity* 73, 313-324.

KNAPP, A.B. 1989: Paradise gained and paradise lost: intensification, specialization, complexity, collapse. *Asian Perspectives* 28, 179-214.

KOPAKA, K. and MATZANAS, C. 2009: Palaeolithic industries from the island of Gavdos, near neighbour to Crete in Greece. *Antiquity* 83 (321) (Project Gallery, archived: http://www.antiquity.ac.uk/projgall/kopaka321, accessed 24-01-10).

LULL, V., MICÓ, R., RIHUETE, C., and RISCH, R. 2002: Social and ideological changes in the Balearic islands during Later Prehistory. In Waldren, W.H. and Ensenyat, J.A. (eds.), *World islands in prehistory: international insular investigations. V Deia International Conference of Prehistory* (Oxford, BAR International Series 1095), 117-126.

MACARTHUR, R.H. and WILSON, E.O. 1967: *The theory of island biogeography* (Princeton).

MIRACLE, P. 1997: Early Holocene foragers in the karst of northern Istria. *Poročilo o raziskovanju paleolitika, neolitika in eneolitika v Sloveniji* 24, 43-62.

MORTENSEN, P. 2008: Lower to Middle Palaeolithic artefacts from Loutró on the south coast of Crete. *Antiquity* 82 (317) (Project Gallery, archived: http://antiquity.ac.uk/projgall/mortensen/index.html, accessed 24-01-10).

MOSCATI, S. 1968: *The world of the Phoenicians* (London).

MOSCATI, S. 1988: *The Phoenicians. catalogue of the exhibition held at the Palazzo Grassi in Venice in 1988* (Milan).

OSBORNE, R. 1997: Early Greek colonization? The nature of Greek settlement in the West. In Fisher, N. and van Wees, H. (eds.), *Archaic Greece: new approaches and new evidence* (London).

PATTON, M. 1996: *Islands in time: island sociogeography and Mediterranean prehistory* (London).

PELTENBURG, E. 2003: *The colonisation and settlement of Cyprus: investigations at Kissonerga-Mylouthkia, 1976-1996* (Sävedalen).

PELTENBURG, E., COLLEDGE, S., CROFT, P., JACKSON, A., McCARTNEY, C., and MURRAY, M.A., 2000: Agro-pastoralist colonization of Cyprus in the 10th millennium BP: initial assessments. *Antiquity* 74, 844-853.

PELTENBURG, E., COLLEDGE, S., CROFT, P., JACKSON, A., McCARTNEY, C., and MURRAY, M.A., 2001a: Neolithic dispersals from the Levantine Corridor: a Mediterranean perspective. *Levant* 33, 35-64.

PELTENBURG, E., CROFT, P., JACKSON, A., McCARTNEY, C., and MURRAY, M.A., 2001b: Well-established colonists: Mylouthkia 1 and the Cypro-Pre-Pottery Neolithic B. In Swiny, S. (ed.), *The earliest prehistory of Cyprus: from colonization to exploitation* (Boston), 61-93.

RAMIS, D. and ALCOVER, J.A. 2001: Revisiting the earliest human presence in Mallorca, Western Mediterranean. *Proceedings of the Prehistoric Society* 67, 261-269.

RAMIS, D., ALCOVER, A.A., COLL, J., and TRIAS, M. 2002: The chronology of the first settlement of the Balearic islands. *Journal of Mediterranean Archaeology* 15 (1), 3-24.

ROBB, J. 2001: Island identities: ritual, travel and the creation of difference in Neolithic Malta. *European Journal of Archaeology* 4 (2), 175-201.

ROBB, J. 2008: *The early Mediterranean village: agency, material culture, and social change in Neolithic Italy* (Cambridge).

SIMMONS, A.H., 1999: *Faunal extinction in an island society: pigmy hippopotamus Hunters of Cyprus* (New York).

STODDART, S. 1999a: Contrasting political strategies in the islands of the southern central Mediterranean. *Accordia Research Papers* 7, 59-73.

STODDART, S. 1999b: Long-term cultural dynamics of an island community: Malta 5500BC-2000AD. In Tykot, R.H., Morter, J. and Robb, J.E. (eds.), *Social dynamics of the prehistoric central Mediterranean* (London, Accordia Specialist Studies on the Mediterranean 3), 137-148.

STRASSER, T.F., RUNNELS, C., WEGMANN, K., PANAGOPOULOU, E., McCOY, F., DIGREGORIO, C., KARKANAS, P. and THOMPSON, N. 2010: Dating Palaeolithic sites in southwestern Crete, Greece. *Journal of Quaternary Science* 26 (5), 553-560.

VAN ANDEL, T.H. and RUNNELS, C.N. 1995: The earliest farmers in Europe. *Antiquity* 69, 481-500.

VIGNE, J.-D. 1989: Le peuplement paléolithique des îles: le débat s'ouvre en Sardaigne. *Les nouvelles de l'archéologie* 35, 39-42.

VIGNE, J.-D. 1998: Contribution des peuplements de vertébrés insulaires à la connaissance de la navigation préhistorique en Méditerranée. In *Pour qui la Méditerranée au 21ème siècle? Navigation, échanges et environnement en Méditerranée. Actes du Colloque Scientifique, Montepellier France 11-12 Avril 1996* (Montpellier), 65-76.

VIGNE, J.-D. and DESSE-BERSET, N. 1995: The exploitation of animal resources in the Mediterranean islands during the Pre-Neolithic: the example of Corsica. In Fischer, A. (ed.), *Man and sea in the Mesolithic* (Oxford), 309-318.

WHITTAKER, C.R. 1974: The Western Phoenicians: colonization and assimilation. *Proceedings of the Cambridge Philological Society* 200, 58-79.

ZILHÃO, J. 2000: From the Mesolithic to the Neolithic in the Iberian Peninsula. In Douglas, T. (ed.), *Europe's first farmers* (Cambridge), 144-182.

Re-writing the colonisation of Cyprus: tales of hippo hunters and cow herders

Alan Simmons

Introduction

People visit and colonise islands for a variety of reasons. Much of the archaeological litera-ture dealing with this issue is based, to one extent or another, on concepts of island biogeog-raphy. This has been eloquently expressed by MacArthur and Wilson (1967), and adapted for general archaeological purposes by Keegan and Diamond (1987). Much of this literature addresses an island's size and its distance from the mainland in terms of ease of colonisation. Many feel that islands' isolation make them ideal 'laboratories' for 'pure study'. Rainbird (1999, 231) has criticised these approaches, emphasising that views of islands as 'places where the strange and the exotic' occur are inappropriate and that archaeologists need to look at alternative explanatory scenarios. Such perspectives, certainly as reflected in many of the contributions in this volume, provide a broader interpretative palette. The Mediterranean islands are one area where a huge and varied literature exists on colonisation, and in this paper, I examine recent evidence that has rewritten the early prehistory of Cyprus and the eastern Mediterranean.

Cyprus is the third largest island in the Mediterranean after Sardinia and Sicily, and yet, until recently, our understanding of both its initial and permanent occupations was limited. The traditional paradigm was that permanent colonisation was a late development by mainlan-ders who imported a complete Neolithic package but left few material linkages, resulting in a somewhat idiosyncratic and isolated island adaptation. Many scholars, at least implicitly, believed that the Cypriot Neolithic was little more than a footnote within the broader Neolithic world. We now know that this is a flawed perspective.

Recent studies on the Neolithic of the islands are presently at the forefront of early Holocene research in the Mediterranean. This includes not only those close to the Greek and Anatolian mainlands, such as in the Aegean, where two-thirds of the islands have Neolithic settlements (Broodbank 1999, 19), but also the more remote islands such as Cyprus (e.g. Broodbank 1999, 2000; Cherry 1990; Davis *et al*. 2001, 77-78; Guilaine and LeBrun 2003; Mavridis 2003; Peltenburg and Wasse 2004; Steel 2004; Swiny 2001). In particular, the past two decades have seen the entire prehistory of the Mediterranean revised by recent discoveries made in Cyprus (Simmons 2008). These include documenting a pre-Neolithic occupation (the Akrotiri Phase) as well as earlier aspects of the aceramic Neolithic (primarily the Cypro-Pre-Pottery Neolithic B, or Cypro-PPNB). This paper summarises some of the Cypriot develop-ments that have so radically challenged concepts of human interactions in the eastern Mediterranean. Specifically, I address four consistent themes found throughout this volume: the interconnectedness of Cyprus with the mainland, the initial permanent occupation of Cyprus, the nature and character of this occupation, and why colonise Cyprus in the first place. Figure 3.1 shows the location of some of the sites mentioned in the text.

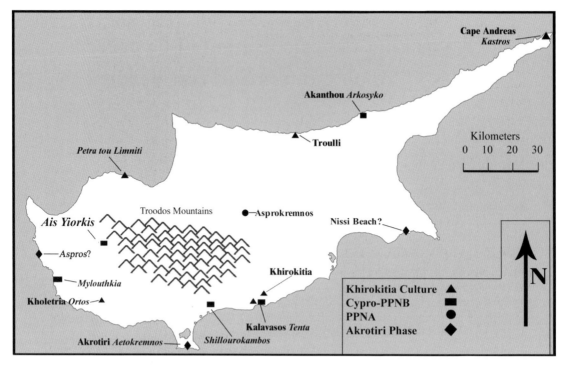

Figure 3.1: Map of some of the sites mentioned in the text (modified from Simmons 2007, fig. 9.1)

Interconnections with the mainland: fact or fiction, isolation or interaction?

Traditional views of the Cypriot Neolithic did not allow for much in the way of relationships with the mainland. Certainly by the aceramic Khirokitia Culture (KC), which for years was believed to be the earliest occupation of the island, commencing around 7000 cal BC (cf. LeBrun *et al.* 1987), there is a sense of isolation with few parallels to contemporary mainland developments, as reflected by the PPNB there. From the new evidence summarised below, however, it is now clear that during the Cypro-PPNB, there were direct and likely frequent contacts with the mainland. These were initially necessary for provisioning the island's first true colonists, but likely continued for social and possibly ritual reasons as well. That they lessened during the KC implies that an island identity focusing on cultural conservatism had been forged by that time. This is reflected by nondescript chipped stone artefacts, circular (similar to the PPNA) rather than rectangular (common in the PPNB) structures, and limited evidence of the elaborate ritual activity seen on the mainland.

 In this context, while the transmission of the Neolithic from the Near East to Europe often is thought to have been overland through Anatolia (cf. Özdoğan 1993; van Andel and Runnels 1995), long-distance colonisation and exploratory forays by various marine routes also have been suggested (e.g. Broodbank 2000; Broodbank and Strasser 1991; Cherry 1981, 1990; Davis 1992; Patton 1996, 35-62; Perlès 2001, 52-63). Early marine travel likely involved stops on islands, perhaps using them both as stepping-stones or resting points to their ultimate destinations and for exploring new territories. The new investigations on Cyprus fuel arguments surrounding how and why the Neolithic spread. These studies have implications for a network of alternate routes from

Table 3.1: Chronology for the Cypriot Neolithic (from Simmons 2007, 234).
Calibrated and uncalibrated equivalents are rounded and approximate.

Period	Conventional (Uncalibrated) BP	Calibrated BP
Akrotiri Phase	?10,800-10,200	?12,000-11,500
PPNA	10,200-9500?	11,500-10,500?
Early Cypro-PPNB	?9500-9100	?10,500-10,200
Middle Cypro-PPNB	9100-8500	10,100-9500
Late Cypro-PPNB	8500-8000	9500-9000
Khirokitia Culture	8000-6500	9000/8500-7800/7500
gap?		
Sotira Culture	6100-5000	7000/6500-5900/5700

the Near East, suggesting that early and frequent interactions between Cyprus and the mainland were more of a 'two-way street' than previously believed. It is conceivable that Cyprus served as a staging ground for exploration further west, such as the Aegean islands or even the Greek mainland, although extremely early Neolithic manifestations in those regions remain elusive (Hansen 1992; Runnels 1995, 2001). Clearly, this new research requires a dramatic re-interpretation of the diffusion and migration of Neolithic peoples and ideas from the Near Eastern and Anatolian mainlands to a wider circum-Mediterranean region (cf. Peltenburg *et al.* 2001a). There is no longer reason to believe in one vast Neolithic colonisation attempt, and the concept of multiple 'pioneer colonisers' (Perlès 2001, 62) is gaining momentum. Given these developments, Broodbank's (2000, 41) statements that '...Mediterranean islands are potential stepping-stones from everywhere to everywhere else...' and that Cyprus is '...unusual in its [geographic] isolation...' makes the finds from Cyprus all the more exciting since they represent some of the earliest evidence for continuous seafaring episodes.

What does the Cypriot Neolithic tell us of the island's role within the wider Neolithic world? By the KC and the later Pottery Neolithic, mainland contacts may have been minimised, but such linkages were maintained during the Cypro-PPNB. Cyprus clearly was a Neolithic 'colony' far earlier and longer than initially believed. This points to the island's role within a wider PPNB interaction sphere (cf. Bar-Yosef 2001). Many researchers now acknowledge multiple core-centres for the agricultural transition that include areas outside of the Levantine Corridor (Nesbitt 2002; Wilcox 2002). The Cypriot subsistence economy was distinct from that of the mainland, and it seems quite likely that there were multiple maritime journeys to Cyprus from several mainland areas over a relatively long period that resulted in the establishment of a permanent Neolithic presence on the island.

There is no doubt that the Cypriot Neolithic contributes to a better understanding of Neolithic developments from a broad perspective, adding new data to the increasingly elaborate east to west trajectory of Neolithic colonisation of the Mediterranean islands. Recent studies establish the complexity of human and environmental interactions within the sensitive biogeographic constraints imposed by islands. More and more, this research is focusing on cultural processes by which unfamiliar landscapes were colonised by both hunters and gatherers (Kelly 2003) and agriculturalists (cf. Rockman and Steele 2003). Let us turn to some of this new Cypriot evidence.

The initial settlement of Cyprus

Introduction

What this new research has demonstrated is that there were two early moments in the initial occupation of Cyprus. Prior to these studies, conventional wisdom was that the island was occupied and permanently colonised rather late in the Neolithic sequence during the KC. We now know, however, that there were at least two earlier human experiences with Cyprus. The first was pre-Neolithic, while the second is an earlier Aceramic Neolithic occupation. Both presently are only represented by a few sites, but it is useful to compare these two 'snapshots' of the island's first encounters with humans. As will be argued shortly, it may well be that in fact these two episodes were not so separate and that a perceived hiatus is likely an artefact of archaeological research rather than a reflection of cultural reality.

Episode 1: initial occupation

Akrotiri-*Aetokremnos*, or 'Vulture Cliff', is a small collapsed rockshelter located on the south coast of Cyprus. It was this small, seemingly unimpressive site that initially challenged existing conventional wisdom on the first occupation of the island (Simmons 1999). For many years there have been claims for early (that is, pre-Neolithic) human occupation of many of the Mediterranean islands. Cherry (1990), however, has eloquently and convincingly demonstrated that there are few, if any, robust arguments for people being on most of the Mediterranean islands during the Late Pleistocene or Early Holocene. This was particularly true for isolated oceanic islands such as Cyprus. Despite a few unsubstantiated claims for pre-Neolithic occupation on the island (summarised in Simmons 1999, 21-25), there was no compelling evidence for humans earlier than the KC.

Aetokremnos, however, demolished this view, being securely dated to over 10,000 cal BC. This indicates some of the earliest open seafaring in the Mediterranean, perhaps facilitated by lower sea levels at this time (Simmons 1999, 11-12). Not only is *Aetokremnos* the oldest site on the island, but, more controversially, it is associated with a huge assemblage of the extinct endemic Pleistocene Cypriot pygmy hippopotamus (*Phanourios minutus*). Several other Mediterranean islands contain dwarfed fauna (e.g. Sondaar 1986), although their chronology is unclear, but only at *Aetokremnos* is there evidence for a human connection. During much of the later Pleistocene, palaeoenvironmental data suggest that generally favourable environmental conditions persisted in much of the Near East. While such data are limited for the Mediterranean islands, it is likely that warmer and moister climates, compared to today's, characterised islands such as Crete and Cyprus, and that these would have been ideal environments for these unique island-adapted fauna (e.g. Rackham and Moody 1996, 38-39). However, towards the end of the Pleistocene adverse climatic effects brought on by the Younger Dryas resulted in environmental stress (Bar-Mathews *et al*. 1997, 165-166, 1999, 166; Bar-Yosef 1998, 159-161; Severinghaus and Brook 1999). Under these conditions, these animals could have been on the verge of extinction.

We believe that *Aetokremnos* demonstrates that humans were instrumental in finalising the demise of these unique animals. The role of humans in Pleistocene extinctions on a global basis is a controversial one (e.g. Martin and Klein 1984), and this certainly is true in the Mediterranean as well (e.g. Mavridis 2003). Given the controversy associated with humans

and Pleistocene extinctions, understandably not all agreed with our conclusions (e.g. Ammerman and Noller 2005; Bunimovitz and Barkai 1996; Binford 2000). While the present paper is not directly concerned with this debate, one point of concern to some was Olsen's (1999) failure to find cut marks, which she interpreted as indicating that the hippos were naturally, not culturally, deposited. We published her conclusions in the final volume, with abundant commentary, addressing why the absence of cut marks was not critical (Simmons 1999, 230-237, footnotes 4-15). Likewise, Ammerman and Noller (2005) are concerned about the geomorphology and radiocarbon determinations on hippo bones vs. other materials at the site, and it is clear to us that they have seriously misread both the detailed chronology (Wigand and Simmons 1999) and geomorphology (Mandel 1999) chapters in the volume (Simmons and Mandel 2007).

We stand by our conclusions, based on substantial and varied datasets that include artefacts, geomorphology, over 30 radiocarbon determinations, and taphonomy. Briefly, we argue that the presence of over 500 pygmy hippos, their contemporaneity with cultural materials, selective burning, the presence of hippo remains with artefacts, and the site's stratigraphic integrity, all support the association of humans with these animals (e.g. Reese 1996; Simmons 1996, 1999, 2001, 2004).

What is missing, of course, are additional sites dating to the Akrotiri Phase. Although there are over 30 palaeontological sites in Cyprus, none has a demonstrated association with cultural materials. Two sites might hint to such a situation. They are Xylophagou-*Spilia tis Englezous*, located on the southern coast, and Akanthou-*Mikhail*, a collapsed rockshelter, located not far from the Aceramic Neolithic site of Akanthou-*Arkosyko* near the northern coast, but the evidence is less than compelling (Simmons 1999, 24-25). To date, *Aetokremnos* is the sole example of the Akrotiri Phase that is well-dated. Recent investigations, however, suggest contemporary, or at least pre-Neolithic, sites, but remain unverified (e.g. Ammerman *et al.* 2007), and until intact cultural materials associated with a solid radiocarbon chronology can be demonstrated, such claims must be viewed with caution. It seems likely, however, that with additional systematic work, contemporary sites will, in fact, be documented.

Before leaving *Aetokremnos*, we may summarise the site's significance by making four points. First, *Aetokremnos* firmly establishes a human occupation of Cyprus in the 11th millennium BC, making it one of the earliest occupied Mediterranean islands. Second, the date of the site has ramifications for how islands are colonised, or at least visited. While those responsible for *Aetokremnos* were not sedentary Neolithic people, they clearly had the technology and ability to make a relatively substantial sea voyage. Third, it is one of the very few sites anywhere dating to the Pleistocene/ Holocene boundary that shows a relationship between extinct megafauna and humans. Certainly we know that humans have rapidly induced extinctions on islands. This is documented in later prehistory in the Mediterranean (e.g. Blondel and Vigne 1993; Burleigh and Clutton-Brock 1980; Waldren 1994 [although see Ayuso (2001) and Ramis and Alcover (2001) who question the human role in Balearic island extinctions]) and elsewhere (Anderson 1991), and especially well documented historically, particularly in the Pacific (e.g. Steadman 1995). What *Aetokremnos* does is project this back twelve thousand years and thus it causes us to re-visit the controversial role of humans in Late Pleistocene extinction episodes. Finally, and perhaps most significantly, *Aetokremnos* has challenged research paradigms that exist on many of the Mediterranean islands on the nature of archaeological data. For many years, scholars believed that the islands were too impoverished in both faunal and floral resources to have supported hunter-gatherer populations.

Coupled with this has been the unspoken belief that archaeology must equal substantial architecture. New studies on Cyprus and elsewhere are showing this to be an incorrect assumption.

Episode 2: permanent occupation?

What is important to realise about *Aetokremnos* is that, based on current evidence, it is unlikely that it represents the permanent occupation of Cyprus. It is here that Cherry's (1981, 1990) 'visitation' vs. 'colonisation' models are relevant. *Aetokremnos* supports a 'two-stage' migration/ colonisation model (cf. Fiedel and Anthony 2003, 153; Peltenburg *et al.* 2000), representing the first stage in which 'explorers' or 'scouts' assessed the suitability of colonising unfamiliar landscapes (cf. Rockman and Steele 2003). The second stage in such a model is effective colonisation and settlement by a wider range of people (Fiedel and Anthony 2003, 153). Those responsible for *Aetokremnos* arrived on an unoccupied island, found residual herds of an unique fauna, hunted them into extinction, and then left. Or, did they? Even if they did leave, it is likely that they did not forget Cyprus. It is here where exciting new research has added to the complexity of the Cypriot Neolithic. It is upon this that I would now like to focus.

Aetokremnos presented a chronological dilemma since it was some 3000 years earlier than the KC. Thus there existed a sort of 'no-man's land' between the Akrotiri Phase and the traditionally defined KC. This gap, however, is now greatly diminished, or even eradicated, with both the documentation of the Cypro-PPNB (see below) and two very recently identified PPNA sites, that of Ayia Varvara *Asprokremnos* in the interior (Manning *et al.* 2010; McCartney *et al.* 2008) and Tihonas *Klimonas*, a coastal entity (Department of Antiquities of Cyprus, 2011). What we do know for sure, however, is that the 3000 year gap is an illusion.

Thus, the perception that the Cypriot Neolithic was a relatively late phenomenon is quickly fading with the documentation of earlier Neolithic entities on the island. We now know that at least part of the chronological gap between the Akrotiri Phase and the Neolithic has been filled with what Peltenburg and his colleagues have termed the 'Cypro-PPNB' (Peltenburg 2003a, 2003b; Peltenbrug *et al.* 2000, 2001a, 2001b). This hints at permanent occupation by groups using complex economic strategies across a wide array of local landscapes. In particular, some Cypro-PPNB sites contain amongst the earliest domesticates known in the Near East. Furthermore, unlike the KC, Cypro-PPNB peoples appear to be using upland localities as well as the coastal settings preferred during the KC.

These dramatic new discoveries must be evaluated not only in a Cypriot context, but also from a broader perspective that assesses interactions between the island and the mainland (Simmons 2007, 229-263). Apparently Cyprus' isolation was an illusion and did not block considerable continental interactions. This new research repudiates earlier prejudices, demonstrating that the Neolithic on Cyprus was more sophisticated and of a longer duration than previously believed. The Cypro-PPNB exhibits similarities to mainland PPNB groups and is at least 1000 years older than the KC. Likewise, the recently documented PPNA sites also show mainland similarities. The relationship of both the PPNA and the Cypro-PPNB to the earlier Akrotiri Phase is still unclear, although the time separating them has been considerably shortened. These new studies have resulted in a substantially revised early chronology for the island (Table 2.1).

The Cypro-PPNB is presently a work in progress. It thus far consists of at least four newly investigated sites and an early component of Kalavasos-*Tenta,* a KC site (Todd 2001). Of

these, Parekklisha-*Shillourokambos* (Guilaine 2003; Guilaine and Briois 2001; Guilaine *et al.* 2000, 2001; Vigne *et al.* 2000, 2003) and Kissonerga-*Mylouthkia* (Peltenburg 2003a) are so far the best documented. Kritou Marottou-*Ais Yiorkis* is another Cypro-PPNB site, unusual in that it is an upland site (Simmons 1998a, 1998b, 2003a, 2005, 2007, 241-243; Simmons and O'Horo 2003). Finally, Akanthou-*Arkosyko* is yet another Cypro-PPNB locality, and while little has yet been published, radiocarbon determinations confirm its placement (Şevketoğlu 2000, 75-79, 2002, 2008).

A few other sites also may date to the Cypro-PPNB. These are Ayia Varvara-*Asprokremnos* (but now documented as PPNA), Politico-*Kelaïdhoni* and Agrokipia-*Palaeokamina*, all in the central portion of the island. These have not yet been excavated, but analysis of surface chipped stone suggests the same kind of technological shift as seen from the Cypro-PPNB to the KC (McCartney 2001, 432, 2004, 2005; McCartney and Gratuze 2003, 19). It seems likely that additional systematic survey will record more early sites.

The nature and character of the Cypro-PPNB

Since documenting *Aetokremnos*, we now know that at least Cyprus was first visited by non-agriculturalists, followed by more permanent settlement during the early Neolithic. This makes Cyprus the earliest island in the Mediterranean to be colonised. Since documenting the Cypro-PPNB, current investigations are grappling with the complex issue of permanency and colonisation (cf. Broodbank 2000; Cherry 1990). By the KC, Cyprus was fully colonised and was represented by a complex, elaborate culture, albeit one with few mainland parallels. It was during the Cypro-PPNB and perhaps the PPNA, however, that we have the opportunity to model the processes by which this complexity emerged. Thus this period may represent an excellent case study for discussing the initial colonisation of Cyprus, before later elaborations and the development of a more insular character.

We have known for quite some time that there was some variation of site types during the Cypriot Neolithic. These tended to be dichotomised into two principal types: large 'core' villages, such as Khirokitia and *Tenta*, and smaller peripheral villages or hamlets. New research, however, indicates that this dichotomy is too simple with investigations at sites that are not typical villages, such as *Shillourokambos*, *Mylouthkia*, *Ais Yiorkis*, and *Ortos* (the latter a large KC site with limited evidence for architecture [Simmons 1994]) (Simmons 2003b). In particular, Cypro-PPNB sites vary considerably: no two are alike, though admittedly, only five sites are thus far well-documented. None of these contains 'traditional' architecture.

Mylouthkia's most impressive feature is a series of deep wells containing a variety of intriguing materials. These include animal and botanical remains, chipped and ground stone, and human remains. Of particular interest are the botanical remains, which include domesti-cated einkorn, emmer, hulled barley and wild or domesticated lentil, other large seeded legumes, fig, pistachio, and linseed/flax. These are similar to what is found in later contexts, and indicate that the KC agricultural tradition was in place by the Cypro-PPNB. It also is notable that these remains represent some of the earliest domesticates not only in Cyprus but in the Near East. Although only limited architecture was recovered, its excavators feel that it must have been a village rather than an isolated set of wells (Peltenburg 2003a and individual contributors therein).

Shillourokambos also has wells, in addition to a series of bedrock features representing likely structural foundations, postholes, and possible animal pens. There also are multiple human

burials, including an apparent cat burial (Guilaine 2003; Vigne *et al.* 2004). Very significant are the faunal data from *Shillourokambos*, since small numbers of *Bos* are present (Vigne 2011; Vigne *et al.* 2003, 249). This is important because prior to this discovery cattle had not been documented in Cyprus predating the Bronze Age (Croft 1991, 63; Knapp *et al.* 1994, 418).

Ais Yiorkis was initially felt to represent an ephemeral upland site (most Cypriot Neolithic sites are near the coast) emphasising deer hunting. Ongoing excavations, however, have revealed a more complex scenario, including at least three circular/oval stone 'rotundas' (Figure 3.2) unlike anything documented in the Cypriot Neolithic. In addition, other features suggest more permanent architecture. *Ais Yiorkis* is important economically, since it contains well-preserved domesticated barley and emmer, and, significantly, small amounts of cattle (Simmons 2007, 241-243, 2009b).

The Cypro-PPNB occupation at *Tenta* also is represented by bedrock features (postholes and pits), suggesting a lack of solid standing architecture, a situation that parallels both *Mylouthkia* and *Shillourokambos* (Todd 2001, 2003). Peltenburg (2003b, 86), however, believes there is more substantial architectural development consisting of what he (2004, 78-79) refers to as the Circular Radial Building, common on the mainland during the PPNA. *Tenta*'s Cypro-PPNB placement is further supported by chipped stone similarities identified by McCartney (2001).

Finally, Akanthou contains outdoor plastered surface with incorporated pits and intriguing sub-rectangular architecture, a rarity in the Cypriot Neolithic, where most architectural features are round. The site also contains large amounts of imported Anatolian obsidian, mostly in the form of bladelets, and cattle remains (Frame 2002), although we must await more published reports to fully assess their context.

Figure 3.2: Circular structure or 'rotunda' at Ais Yiorkis (author's photo)

Based on these new data, what can we say of the nature of the Cypro-PPNB, before the formation of the KC and its relatively standardised patterns? Although baseline data are still being established, what we do know indicates that the sites were relatively small, and that the economy was mixed, consisting of both animal husbandry and farming, as well as fishing in some cases (Peltenburg 2003b). It is unclear how important farming was, although domestic cereals are present. Given the variety of both wild (i.e. deer) and domestic animals, one might tentatively argue that animal husbandry was more significant. What clearly stands out is that no one Cypro-PPNB site is similar to one another in terms of architecture and configuration. *Shillourokambos* appears to have been a small village with relatively ephemeral architecture, and *Mylouthkia* also may have functioned as a village although supporting data are sparse. Early *Tenta* has some features similar to *Shillourokambos*, but we do not know its extent. *Ais Yiorkis* may also be a sedentary settlement, given the presence of unique architectural features that indicate some degree of permanence. Both farming and animal husbandry occurred at the site. Finally, Akanthou seems to represent a small settlement too, with sub-rectangular architecture that does not fit into the Cyprus scheme at all.

Of particular significance are the economic implications of the Cypro-PPNB, and the new investigations have posed more questions than they answer. From a pan-Near Eastern perspective, Cyprus greatly complicates the matter by having both domesticated plants and animals during the Cypro-PPNB at a time when evidence of morphological domestication on the mainland is limited. It is unlikely that independent domestication occurred in Cyprus, since relevant species are not endemic to the island. The only exception to this is the wild progenitor of domestic barley (Peltenburg *et al.* 2001b, 71). It is clear that principal economic animals were under enough human control to be transported across the sea to Cyprus during the 9th millennium BC (Vigne 2001, 57).

Certainly the *Bos* from *Ais Yiorkis* and *Shillourokambos* are amongst the earliest evidence of domesticated, or 'predomesticated', cattle in the Near East. Mainland data point to Halula in the Middle Euphrates, which is roughly contemporary, or perhaps slightly later, than the Cypriot sites, as having morphologically domesticated cattle. Additionally, domestic status is suggested at nearby early PPNB Dja'de (c. 8300-8800 cal BC) (Helmer *et al.* 2005), somewhat earlier than the Cypriot evidence. Vigne (2001, 57; Vigne *et al.* 2005) feels that contemporary researchers must re-evaluate the criteria for determining 'domestication,' giving more importance to non-morphological criteria. Vigne *et al.* (2003, 250-251) have suggested that the term 'predomestic' is ambiguous and should be abandoned, with the understanding that these animals were anthropologically domesticated even if morphological changes had not yet occurred.

Even on the island itself, the economic picture is far from clear. One emerging aspect of the increasingly diverse Cypriot Neolithic economy that is especially compelling relates to early herding (cf. Vigne 2001, Vigne *et al.* 1999). The relationship between pastoralists and farmers is an issue that has rarely been addressed for Neolithic Cyprus, with few exceptions (e.g. Marks 1999). Studies such as Atherden's (2000) in Crete, looking at human impacts in both lowland and upland grazing areas are badly needed in Cyprus. In general, for the Mediterranean region, two contrasting models are often presented. The first proposes long-distance transhumance divorced from farming villages, while the second envisions mixed farming and herding systems where herders kept animals close to villages (summarised by Chang 1994, 353-354).

Where the Cypro-PPNB sites fit into this scenario remains to be demonstrated, and the presence of cattle, with very different herding requirements than caprines or pigs, has

confused the matter. Thus far, cattle have only been found at Cypro-PPNB sites, which are not traditional large villages. The absence of cattle during the KC, when larger settlements were well-established, could indicate that they were not compatible with villages, where forage could have been quickly depleted. During the Cypro-PPNB, the presence of cattle at *Ais Yiorkis* suggests that the livestock may have been moved between summer and winter ranges, thus supporting the first model of transhumance. This would indicate an economic dichotomy selecting against keeping cattle in large villages and hinting at different types of land use strategies in which herds were rotated to upland pastures. On the other hand, cattle also are present at the lowland sites of Akanthou and *Shillourokambos*. Until we have more robust data, we simply cannot fully evaluate these explanatory scenarios.

Perhaps the questions to ask are why have cattle not been previously recovered from Neolithic Cyprus and, now that they have been, why did they not persist? Was this due to economic or ritual reasons, or could it simply be a research bias that has focused on excavating large coastal villages? After all, cattle were common in mainland faunal Neolithic assemblages. They also occur during the Neolithic on other Mediterranean islands such as Ftelia on Mykonos (Phoca-Cosmetatou 2008), Knossos on Crete (Evans 1964, 1968, 1971; Isaakidou 2006; Jarman 1996), Son Matge in the Balearics (Waldren 1982 [although see Ramis *et al.* (2002) who question the antiquity of humans in the Balearics]), or Terrina IV on Corsica (Camps 1981), albeit in Middle or Late Neolithic contexts, and thus are more recent than the Cypriot materials. It seems that once established on these islands, cattle remained significant. In Cyprus, however, current data indicate an early withdrawal or die-off of cattle during the late Aceramic Neolithic, a proposition favoured by the investigators of *Shillourokambos* (Vigne 2001, 57). The timing and reasons for this apparent disappearance are not clear: what mechanisms attributed to this apparent abandonment of cattle keeping until the beginning of the Bronze Age? Davis (2003, 263) suggests that their absence could have been due to the appearance of a type of bovine disease or, that by the KC, people may simply have tired of maintaining such large animals.

Was there, however, perhaps some ritual reasons for their appearance, and subsequent disappearance? After all, we know that during the Neolithic on the Anatolian and Levantine mainlands, cattle figured prominently in ritual behaviour (e.g. see Cauvin 2000). Was there a similar reverence for these animals in Cyprus, or were they imported for purely economic reasons? The low numbers of cattle could be nothing more than a factor of their large size: one cow will provide more meat and secondary products such as milk (even though the 'secondary products revolution' is a later phenomenon), and thus feed more people than will several sheep. Issues relating to the relationship of cattle to other domesticates in terms of feeding and forage requirements, for example, may also be relevant here and help explain why cattle apparently did not thrive on Cyprus after the Cypro-PPNB (for example, see earlier discussion on transhumance and mixed farming/herding strategies). Or, people simply perhaps failed or chose not to maintain cattle because they already had a successful dual economy based on agro-pastoralism and deer-hunting by the KC (Rainbird 1999, 228).

Even though a functional economic interpretation is reasonable, we should consider the possible symbolic significance of cattle. Perhaps the earliest colonisers of Cyprus were attempting to retreat from the type of formalised life that was becoming standardised on the mainland. This could well have included the avoidance of certain religious activities. In this sense, Ronen (1995, 1999) may have been correct in positing that Cypriot Neolithic people were akin to a conservative religious sect, or, at least, people who chose not to participate in

a conventional Neolithic lifestyle, preferring, instead, to colonise a new geographic area where they could maintain their traditional lifestyles and ultimately establish their own unique identities. However, they may not have wished to entirely sever their mainland identities. Cattle could have been one ritual element, which also had economic benefits, that were imported to ensure symbolic ties with the homeland. After all, Cauvin (2000) has argued that cattle, or at least 'the bull,' were a major factor in the very birth of the Neolithic, although not all agree with his conclusion (e.g. Hodder 2001; Rollefson 2001). In any case, however, it appears that a unique island identity was established by the KC, and thus there may have been no need to retain cows as a material symbol of a ritual world. Such scenarios, of course, are speculative, and we need to continually remind ourselves that these early societies likely did not separate the sacred from the profane to the degree that many modern societies do. At this point, the role of cattle simply cannot be adequately evaluated in Cyprus (Simmons 2009b).

Cyprus gradually dropped out of the Near Eastern and Anatolian interaction spheres during the KC. It appears that while transmarine connections were still maintained, they lessened, with people now using only a few exotics. Peltenburg (2003b, 103) believes that the islanders preferred to emphasise their own material culture as an expression of their uniquely developing Cypriot identity. Why did this happen, and why did Cyprus, from essentially the KC onward, develop its unique, insular trajectory? Such issues represent fruitful avenues for future research.

A final point to consider here is ecological. Ecological degradation, which figured prominently on the mainland during the Neolithic (e.g. Köhler-Rollefson 1988; Köhler-Rollefson and Rollefson 1990; Rollefson 1997; Simmons *et al.* 1988), does not appear to have been as significant on Cyprus. Perhaps herds were properly managed to avoid the type of overgrazing so common in much of the Near East. Additionally, population levels may have been low enough during the Cypro-PPNB to minimise impacts. But even if the Cypro-PPNB occupation of the island was relatively limited, why is there so little evidence for accelerated impacts during the subsequent KC, when larger sites are documented? With the exception of Khirokitia and Kalavasos-*Tenta*, however, most KC sites are relatively small, and thus population growth on Cyprus still may have been sufficiently low to avoid the ecological havoc witnessed on the mainland. Davis (2003, 262-263) notes that while pollen analysis from Khirokitia does not support local degradation, a decline in pigs and fallow deer hints at this, and he suggests that detrimental impacts may have been only on a local scale, perhaps affecting a radius of no more than c. 25 km from the site. Overall, though, there is little support for massive human impacts during the Neolithic.

If the extinction scenario posed for the Akrotiri Phase is correct, certainly the earliest occupants of Cyprus had a more dramatic ecological impact, helping to drive the endemic fauna to extinction. As populations grew in post-Neolithic times, the consequences of agriculture and animal husbandry also took their toll. By practicing diverse economic strategies based on a balance between farming, herding, and wild resources, however, Neolithic peoples may have been offered a respite from the ecological deterioration seen in both earlier and later periods (Simmons 2009a).

Why colonise Cyprus?

In light of the previous discussion, two critical questions need to be posed. The first is 'why was Cyprus colonised in the first place?' and the second is 'who were these colonists?' The

question of why Cyprus was colonised may never be fully resolved, but it has not stopped archaeologists from speculating. I (Simmons 1999, 319-323) proposed that those responsible for *Aetokremnos* may well have been either late Natufian or early PPNA people who were 'traditionalists' not wishing to participate in the 'Neolithic Revolution'. Likewise, Ronen (1995), in the provocative articles noted earlier, refers to the early Neolithic colonists of Cyprus as 'Asprots', comparing them to modern and conservative North American Hutterites. In other words, he views Cypriot Neolithic peoples essentially as a 'closed society', and certainly there are parallels amongst, for example, prison populations or religious sects, as noted by Rainbird (1999, 230). Ronen was referring specifically to the KC, since the Cypro-PPNB was not well-documented at the time of his writing. As such, he supports his argument to some extent by noting the absence of cattle during the Neolithic, which, of course, we now know is not true. Despite this, and realising that Ronen is perhaps stretching ethnographic analogy, he presents some provocative ideas, and essentially argues that the early colonists were disgruntled mainlanders who chose not to participate in many aspects of the Neolithic revolution.

Of course, islands can be colonised simply due to human curiosity. After all, Cyprus is visible from some mainland vantage points. Certainly there also are pragmatic reasons why the island was colonised, as outlined by Davis (2003), who looks at the zooarchaeological record from the mainland and Cyprus. He notes that the data suggest a shift in balance between humans and animals in southern Levant over a period of several thousand years. This includes changes in the spectrum of species hunted, and increased pressures on wildlife around the Neolithic, attributed to a rise in human populations. This could partially explain why people had to seek new territory and began colonising Cyprus. Marine transgression resulting in long-term loss of subsistence resources and ecological stress for Neolithic coastal populations may have contributed to this as well, with one option being for local migration to Cyprus. Thus, Davis (2003, 258) suggests that people '...came to Cyprus for the same reason that they began husbanding animals – they were looking to increase their food supply.'

Peltenburg (2003b, 97) provides an alternate scenario. He observes that while there may have been 'rare and valuable' resources on Cyprus (such as fruits, cf. Wilcox 2003, 237), this likely was not enough incentive to cause colonisation. He notes that Early Holocene sea levels in the eastern Mediterranean were generally lower than today's, resulting in reduced distances between the mainland and Cyprus, and perhaps even the creation of 'stepping-stone islets'. This may have facilitated visits to Cyprus during the Akrotiri Phase. During the Neolithic, however, sea levels gradually rose, diminishing the littoral. Peltenburg (2003b, 97) proposes that such sites ultimately were abandoned, and coastal Neolithic groups, who subsisted on mixed farming, fishing, herding, and hunting economies, were now forced to move due to impoverishment of subsistence resources and ecologic stress. Inland movement would have been difficult, due to the relatively high populations already inhabiting these zones. Therefore, the alternate decision of colonising Cyprus, already known from visits to the island during the Akrotiri Phase, may have been attractive (see also Galili *et al.* 2004).

There are many models to explain the colonisation of Cyprus and other Mediterranean islands. For Cyprus, Peltenburg has proposed a very thoughtful model, which likely will be modified as new data become available. His model is one of initial exploration, as represented by *Aetokremnos*, followed by an extended period of, first, colonisation by agro-pastoralists (early Cypro-PPNB) and then by consolidation and continual mainland contact (middle Cypro-PPNB). During the late Cypro-PPNB expansion, there may have been less external

contact and the unique island character of Cyprus was being forged. This was followed by a fluorescence period as reflected by the idiosyncratic KC (Peltenburg 2003b, 99). In this model, Peltenburg does not consider the role of the subsequent Pottery Neolithic, a complex phase that may be more related to the Chalcolithic and discussion of this is beyond the present paper's scope.

Where did these people come from? Given that there were virtually no endemic species on the island, the Neolithic colonisers of Cyprus must have arrived, likely in successive waves, with veritable Noah's arks containing subsistence items that they enjoyed on the mainland. Thus, their seafaring abilities and craft must have been considerable. This scenario, of course, assumes that there had been some degree of contact with the island's earliest visitors during the Akrotiri Phase. While speculative, 'communal knowledge' may have played a role in their understanding that the lack of resources on the island required the importation of virtually all their economic needs.

Peltenburg (2003b, 93-99; 2004) considers three general scenarios for the origins of Cyprus' first colonisers. These include: 1. native 'islanders' (essentially the future generations of those responsible for *Aetokremnos*, which assumes that there was, in fact, continuous [i.e. PPNA] occupation of the island – see earlier discussion), 2. a combination of islanders and newcomers, and 3. 'farmer/colonists'. After careful consideration, he prefers the mainland 'farmer/colonist' migration model since '[T]he multiple, close parallels in subsistence, technology, settlement organisation, ideological indicators, and participation in the PPNB interaction sphere are best interpreted as evidence for the presence of mainland farmers who emigrated to the island' (Peltenburg 2003b, 96). This clearly is a complex issue, and it is likely that additional research may change these conclusions, but Peltenburg provides a cogent argument. Their specific points of origins are open to debate, and beyond the present discussion. At this stage, although general mainland parallels can be documented in the Cypro-PPNB, regionally-specific data are simply not yet convincing. Suffice it to say that it is likely that colonisation occurred over multiple visits, and that these may have been made by people from several Levantine and/or Anatolian localities.

Conclusions

What are the implications of this new research? First, we now know that Cyprus was occupied before the Neolithic, as demonstrated by the likely short-lived Akrotiri Phase. Second, Neolithic people arrived on the island much earlier than suspected, thereby shortening the chronological gap between the Neolithic and the Akrotiri Phase. In fact, with the documentation of the PPNA, there may not have been a gap. Third, this research is unfolding a story of an economically complex Neolithic adaptation. We have learned that not all early settlements were restricted to the coastal areas of Cyprus, nor were they all villages. More importantly, this economic strategy involved some of the earliest domesticates known in the Near East. Fourth, despite land-altering activities associated with the Neolithic on the mainland, there is little indication that Cypriot Aceramic Neolithic peoples had substantial ecological impacts.

The Neolithic in the Near East clearly was a tumultuous time. Dramatic economic and social changes were occurring that included continual and systematic contact with Cyprus, and perhaps other islands. The Cypriot Neolithic is far more complex than any of us originally thought, and clearly was not a watered-down version of the mainland. All of this new research, which must be evaluated within a broader, circum-Mediterranean perspective assessing the

transmission of a 'Neolithic Package' from the mainland, adds to the increasingly elaborate trajectory of the Neolithic world. This makes it a very exciting time to be doing Neolithic research, both on the mainland and in Cyprus.

References

AMMERMAN, A. and NOLLER, J. 2005: New light on Aetokremnos. *World Archaeology* 37, 533-543.

AMMERMAN, A., FLOURENTZOS, P., GABRIELLI, P., McCARTNEY, C., NOLLER, J., PELOSO, D. and SORABJI, D. 2007: More on the new early sites on Cyprus. *Report of the Department of Antiquities, Cyprus 2007* (Nicosia), 1-26.

ANDERSON, A. 1991: *Prodigious birds: moas and moa hunting in prehistoric New Zealand* (Cambridge).

ATHERDEN, M. 2000: Human impact on the vegetation of southern Greece and problems of palynological interpretation: a case study from Crete. In Halstead, P. and Frederick, C. (eds.), *Landscape and land use in postglacial Greece* (Sheffield, Sheffield Studies in Aegean Archaeology 3), 62-78.

AYUSO, V. 2001: The Balearic Islands: prehistoric colonisation of the furthest Mediterranean islands from the mainland. *Journal of Mediterranean Archaeology* 14, 136-158.

BAR-MATHEWS, M., AYALON, A. and KAUFMAN, A. 1997: Late Quaternary palaeoclimate in the eastern Mediterranean region from stable isotope analysis of speleothems at Soreq cave, Israel. *Quaternary Research* 47, 155-168.

BAR-MATHEWS, M., AYALON, A., KAUFMAN, A. and WASSERBURG, G. 1999: The eastern Mediterranean palaeoclimate as a reflection of regional events: Soreq cave, Israel. *Earth and Planetary Science Letters* 166, 85-95.

BAR-YOSEF, O. 1998: The Natufian culture in the Levant, threshold to the origins of agriculture. *Evolutionary Anthropology* 6, 159-177.

BAR-YOSEF, O. 2001: The world around Cyprus: from Epi-Palaeolithic foragers to the collapse of the PPNB civilization. In Swiny, S. (ed.), *The earliest prehistory of Cyprus: from colonisation to exploitation* (Boston), 129-164.

BINFORD, L. 2000: Review of faunal extinctions in an island society: pygmy hippopotamus hunters of the Akrotiri peninsula, Cyprus by A. Simmons. *American Antiquity* 65, 771.

BLONDEL, J. and J. VIGNE 1993: Space, time and man as determinants of diversity of birds and mammals in the Mediterranean region. In Ricklefs, R. and Schluter, D. (eds.), *Species diversity in ecological communities* (Chicago), 135-146.

BROODBANK, C. 1999: Colonisation and configuration in the insular Neolithic of the Aegean. In Halstead, P. (ed.), *Neolithic society in Greece* (Sheffield, Sheffield Studies in Aegean Archaeology 2), 15-41.

BROODBANK, C. 2000: *An island archaeology of the early Cyclades* (Cambridge).

BROODBANK, C. and STRASSER, T. 1991: Migrant farmers and the Neolithic colonisation of Crete. *Antiquity* 65, 233-245.

BUNIMOVITZ, S. and BARKAI, R. 1996: Ancient bones and modern myths: ninth millennium BC hippopotamus hunters at Akrotiri Aetokremnos, Cyprus? *Journal of Mediterranean Archaeology* 9, 85-96.

BURLEIGH, R. and CLUTTON-BROCK, J. 1980: The survival of Myotragus balearicus

(Bate, 1909) into the Neolithic on Mallorca. *Journal of Archaeological Science* 7, 385-388.

CAMPS, G. 1981: Terrina IV (Aléria, Haute Corse). Campagne de fouille de 1981. *Travaux du Laboratoire d'Anthropologie, de Préhistoire et d' Ethnologie de la Méditerranée Occidentale Aix-en-Provence 1981*, 1-8.

CAUVIN, J. 2000: *The birth of the gods and the origins of agriculture* (Cambridge).

CHANG, C. 1994: Sheep for the ancestors: ethnoarchaeology and the study of ancient pastoralism. In Kardulias, P. (ed.), *Beyond the site: regional studies in the Aegean area* (Lanham), 353-371.

CHERRY, J. 1981: Pattern and process in the earliest colonisation of the Mediterranean islands. *Proceedings of the Prehistoric Society* 47, 41-68.

CHERRY, J. 1990: The first colonisation of the Mediterranean islands: a review of recent research. *Journal of Mediterranean Archaeology* 3, 145-221.

CROFT, P. 1991: Man and beast in Chalcolithic Cyprus. *Bulletin of the American Schools of Oriental Research* 282/283, 63-79.

DAVIS, J. 1992: Review of Aegean prehistory 1: the islands of the Aegean. *American Journal of Archaeology*. 96, 699-756.

DAVIS, J., TZONOU-HERBST, I. and WOLPERT, A. 2001: Addendum. In Cullen, T. (ed.), *Aegean Prehistory: a review* (Boston, American Journal of Archaeology Supplement 1), 77-94.

DAVIS, S. 2003: The zooarchaeology of Khirokitia (Neolithic Cyprus), including a view from the mainland. In Guilaine, J. and LeBrun, A. (eds.), *Le Néolithique de Chypre* (Athens, Bulletin de Correspondance Hellénique Supplément 43), 253-268.

Department of Antiquities, Cyprus 2011: Completion of the French mission excavation at the site of "Klimonas" at Ayios Tychonas. Press release, June 2, 2011. Department of Antiquities, Press and Information Office. Nicosia, Cyprus.

EVANS, J. 1964: Excavations on the Neolithic settlement at Knossos, 1957-60. Part 1. *Annual of the British School of Archaeology at Athens* 59, 132-240.

EVANS, J. 1968: Knossos Neolithic. Part 2: summary and conclusions. *Annual of the British School of Archaeology at Athens* 63, 267-276.

EVANS, J. 1971: Neolithic Knossos: the growth of a settlement. *Proceedings of the Prehistoric Society* 37, 95-117.

FIEDEL, S. and ANTHONY, D. 2003: Deerslayers, pathfinders, and icemen: origins of the European Neolithic as seen from the frontier. In Rockman, M. and Steele, J. (eds.), *Colonization of unfamiliar landscapes: the archaeology of adaptation* (London), 144-168.

FRAME, S. 2002: Island Neolithics: animal exploitation in the Aceramic Neolithic of Cyprus. In Waldren, W. and Ensenyat, J. (eds.), *World islands in prehistory: international insular investigations. V Deia International Conference of Prehistory* (Oxford, BAR International Series 1095), 233-238.

GALILI, E., GOPHER, A., ROSEN, B. and HORWITZ, L. 2004: The emergence of the Mediterranean fishing village in the Levant and the anomaly of Neolithic Cyprus. In Peltenburg, E. and Wasse, A. (eds.), *Neolithic revolution: new perspectives on Southwest Asia in light of recent discoveries on Cyprus* (Oxford, Levant Supplementary Series 1), 91-101.

GUILAINE, J. 2003: Parekklisha-Shillourokambos: périodisation et aménagements domestiques. In Guilaine, J. and LeBrun, A. (eds.), *Le Néolithique de Chypre* (Athens, Bulletin de Correspondance Hellénique Supplément 43), 4-14.

GUILAINE, J. and BRIOIS, F. 2001: Parekklisha Shillourokambos: an early Neolithic site in Cyprus. In Swiny, S. (ed.), *The earliest prehistory of Cyprus: from colonisation to exploitation* (Boston), 37-53.

GUILAINE, J. and LEBRUN, A. (eds.) 2003: *Le Néolithique de Chypre* (Athens, Bulletin de Correspondance Hellénique Supplément 43).

GUILAINE, J., BRIOIS, F., VIGNE, J.-D. and CARRÈRE, I. 2000: Découverte d'un Néolithique Précéramique Ancien Chypriote (fin 9e, début 8e millénaires cal. BC), apparenté au PPNB Ancien/Moyen du Levant Nord. *Earth and Planetary Sciences* 330, 75-82.

GUILAINE, J., BRIOIS, F. and VIGNE, J.-D. (eds.) 2011: *Shillourokambos: un établissement Néolithique Pre-Céramique à Chypre. Les Fouilles du Secteur 1* (Athens).

HANSEN, J. 1992: Franchthi cave and the beginnings of agriculture in Greece and the Aegean. In Anderson, P. (ed.), *Préhistoire d'agriculture: nouvelles approches expérimentales et ethnographiques* (Paris, Monographies du CRA 6), 231-247.

HELMER, D., GOURICHON, L., MONCHOT, H., PETERS, J. and SAÑA SEGUI, M. 2005: Identifying early domestic cattle from Pre-Pottery Neolithic sites on the Middle Euphrates using sexual dimorphism. In Vigne, J.-D., Peters, J. and Helmer, D. (eds.), *First steps of animal domestication* (Oxford), 86-95.

HODDER, I. 2001: Symbolism and the origins of agriculture in the Near East. *Cambridge Archaeological Journal* 11, 107-112.

ISAAKIDOU, V. 2006: Ploughing with cows: Knossos and the secondary products revolution. In Serjeantson, D. and Field, D. (eds.), *Animals in the Neolithic of Britain and Europe* (Oxford), 95-112.

JARMAN, M. 1996: Human influence in the development of the Cretan mammalian fauna. In Reese, D. (ed.), *Pleistocene and Holocene fauna of Crete and its first settlers* (Madison, Monographs in World Archaeology, No. 28), 211-229.

KEEGAN, W. and DIAMOND, J. 1987: Colonisation of islands by humans: a biogeographical perspective. In Schiffer, M. (ed.), *Advances in archaeological method and theory, vol. 10* (New York), 49-92.

KELLY, R. 2003: Colonisation of new land by hunter-gatherers: expectations and implications based on ethnographic data. In Rockman, M. and Steele, J. (eds.), *Colonization of unfamiliar landscapes: the archaeology of adaptation* (London), 44-58.

KNAPP, A., HELD, S. and MANNING, S. 1994: The prehistory of Cyprus: problems and prospects. *Journal of World Prehistory* 8, 377-453.

KÖHLER-ROLLEFSON, I. 1988: The aftermath of the Levantine Neolithic revolution in light of ecologic and ethnographic evidence. *Paléorient* 14, 87-93.

KÖHLER-ROLLEFSON, I. and ROLLEFSON, G. 1990: The impact of Neolithic subsistence strategies on the environment: the case of 'Ain Ghazal, Jordan. In Bottema, S., Entjes-Nieborg, G. and van Zeist, W. (eds.), *Man's role in the shaping of the Eastern Mediterranean landscape* (Rotterdam), 3-14.

LEBRUN, A., CLUZAN, S., DAVIS, S., HANSEN, J. and RENAULT-MISKOVSKY, J. 1987: Le Néolithique Précéramique de Chypre. *L'Anthropologie* 91, 283-316.

MACARTHUR, R. and WILSON, E. 1967: *The theory of island biogeography* (Princeton).

MANDEL, R. 1999: Stratigraphy and sedimentology. In Simmons, A. (ed.), *Faunal extinction in an island society: pygmy hippopotamus hunters of Cyprus* (New York), 49-69.

MANNING, S., McCARTNEY, C., KROMER, B. and STEWART, S. 2010: The earlier
 Neolithic in Cyprus: recognition and dating of a Pre-Pottery Neolithic A occupation.
 Antiquity 84: 693-706.
MARKS, S. 1999: *Rethinking the Aceramic Neolithic: insights from an ethnoarchaeological
 study on Cyprus* (Unpublished MA thesis, University of Nevada).
MARTIN, P. and KLEIN, R. (eds.) 1984: *Quaternary extinctions: A prehistoric revolution*
 (Tucson).
MAVRIDIS, F. 2003: Early island archaeology and the extinction of endemic fauna in the
 eastern Mediterranean: problems of interpretation and methodology. In Kotjabopoulou,
 E., Hamilakis, Y., Halstead, P., Gamble, C. and Elefanti, P. (eds.), *Zooarchaeology in
 Greece: recent advances* (London, British School at Athens Studies 9), 65-74.
McCARTNEY, C. 2001: Chipped stone assemblage from Tenta (Cyprus), cultural and
 chronological implications. In Caneva, I., Lemorini, C., Zampetti, D. and Biagi, P. (eds.),
 Beyond tools: redefining the PPN lithic assemblages of the Levant (Berlin: Studies in
 Early Near Eastern Production, Subsistence, and Environment 9), 427-436.
McCARTNEY, C. 2004: Cypriot Neolithic chipped stone industries and the progress of
 regionalization. In Peltenburg, E. and Wasse, A. (eds.), *Neolithic revolution: new
 perspectives on Southwest Asia in light of recent discoveries on Cyprus* (Oxford: Levant
 Supplementary Series 1), 103-122.
McCARTNEY, C. 2005: Preliminary report on the re-survey of three Early Neolithic sites in
 Cyprus. *Report of the Department of Antiquities, Cyprus 2005* (Nicosia), 1-21.
McCARTNEY, C. and GRATUZE, B. 2003: The Chipped Stone. In Peltenburg, E. (ed.), *The
 colonisation and settlement of Cyprus. Investigations at Kissonerga-Mylouthkia, 1976-
 1996* (Sävedalen, Studies in Mediterranean Archaeology vol. 70: 4), 11-34.
McCARTNEY, C., MANNING, S., ROSENDAHL, S. and STEWART, S. 2008: Elaborating
 Early Neolithic Cyprus (EENC): preliminary report on the 2007 field season: excavations
 and regional field survey at Agia Varvara-*Asprokremnos*. *Report of the Department of
 Antiquities, Cyprus 2008* (Nicosia), 67-86.
NESBITT, M. 2002: When and where did domesticated cereals first occur in Southwest Asia?
 In Cappers, R. and Bottema, S. (eds.), *The dawn of farming in the Near East* (Berlin,
 Studies in Early Near Eastern Production, Subsistence, and Environment 6), 113-132.
OLSEN, S. 1999: Investigation of the Phanourios bones for evidence of cultural modifica-
 tion. In Simmons, A. (ed.), *Faunal extinction in an island society: pygmy hippopotamus
 hunters of Cyprus* (New York), 230-237.
ÖZDOĞAN, M. 1993: Vinca and Anatolia: a new look at a very old problem (or redefining
 Vinca Culture from the perspective of Near Eastern tradition). *Anatolica* 19 (Roodenberg,
 J. (ed.), *Anatolia and the Balkans*), 173-193.
PATTON, M. 1996: *Islands in time: island sociogeography and Mediterranean prehistory*
 (London and New York).
PELTENBURG, E. (ed.) 2003a: *The colonisation and settlement of Cyprus. Investigations
 at Kissonerga-Mylouthkia, 1976-1996* (Sävedalen, Studies in Mediterranean Archaeology
 vol. 70: 4).
PELTENBURG, E. 2003b: Conclusions: Mylouthkia I and the early colonists of Cyprus.
 In Peltenburg, E. (ed.), *The colonisation and settlement of Cyprus. Investigations at
 Kissonerga-Mylouthkia, 1976-1996* (Sävedalen, Studies in Mediterranean Archaeology
 vol. 70: 4), 83-103.

PELTENBURG, E. 2004: Social space in early sedentary communities of Southwest Asia and Cyprus. In Peltenburg, E. and Wasse, A. (eds.), *Neolithic revolution: new perspectives on Southwest Asia in light of recent discoveries on Cyprus* (Oxford: Levant Supplementary Series 1), 71-89.

PELTENBURG, E. and WASSE, A. (eds.) 2004: *Neolithic revolution: new perspectives on Southwest Asia in light of recent discoveries on Cyprus* (Oxford, Levant Supplementary Series 1).

PELTENBURG, E., COLLEDGE, S., CROFT, P., JACKSON, A., McCARTNEY, C. and MURRAY, M. 2000: Agro-pastoralist colonisation of Cyprus in the 10th millennium BP: initial assessments. *Antiquity* 74, 844-853.

PELTENBURG, E., COLLEDGE, S., CROFT, P., JACKSON, A., McCARTNEY, C. and MURRAY, M. 2001a: Neolithic dispersals from the Levantine corridor: a Mediterranean perspective. *Levant* 33, 35-64.

PELTENBURG, E., CROFT, P., JACKSON, A., McCARTNEY, C. and MURRAY, M. 2001b: Well-established colonists: Mylouthkia 1 and the Cypro-Pre-Pottery Neolithic B. In Swiny, S. (ed.), *The earliest prehistory of Cyprus: from colonisation to exploitation* (Boston), 61-93.

PERLÈS, C. 2001: *The Early Neolithic in Greece* (Cambridge).

PHOCA-COSMETATOU, N. 2008: Economy and occupation in the Cyclades during the Late Neolithic: the example of Ftelia, Mykonos. In Brodie, N., Doole, J., Gavalas, G. and Renfrew, C. (eds.), *Horizon: a colloquium on the prehistory of the Cyclades* (Cambridge), 37-41.

RACKHAM, O. and MOODY, J. 1996: *The making of the Cretan landscape* (Manchester).

RAMIS, D. and ALCOVER, J. 2001: Revisiting the earliest human presence in Mallorca, Western Mediterranean. *Proceedings of the Prehistoric Society* 67, 261-269.

RAMIS, D., ALCOVER, J., COLL, J. and TRIAS, M. 2002: The chronology of the first settlement of the Balearic Islands. *Journal of Mediterranean Archaeology* 15, 3-24.

RAINBIRD, P. 1999: Islands out of time: towards a critique of island archaeology. *Journal of Mediterranean Archaeology* 12, 216-234.

REESE, D. 1996: Cypriot hippo hunters no myth. *Journal of Mediterranean Archaeology* 9, 107-112.

ROCKMAN, M. and STEELE, J. (eds.) 2003: *Colonization of unfamiliar landscapes: the archaeology of adaptation* (London).

ROLLEFSON, G. 1997: The Neolithic devolution: ecological impact and cultural compensation at 'Ain Ghazal, Jordan. In Seger, J. (ed.), *Retrieving the past* (Mississippi), 219-229.

ROLLEFSON, G. 2001: An archaeological odyssey. *Cambridge Archaeological Journal* 11, 112-114.

RONEN, A. 1995: Core, periphery, and ideology in Aceramic Cyprus. *Quartär* 45/46, 177-206.

RONEN, A. 1999: Ideology-dependent subsistence in the Aceramic of Cyprus. In Ullrich, H. (ed.), *Hominid evolution: lifestyles and survival strategies* (Gelsenkirchen-Schwelm), 505-516.

RUNNELS, C. 1995: Review of Aegean prehistory IV: the stone age of Greece from the Palaeolithic to the advent of the Neolithic. *American Journal of Archaeology* 99, 699-728.

RUNNELS, C. 2001: Addendum: 1995-1999. In Cullen, T. (ed.), *Aegean Prehistory: a review* (Boston, American Journal of Archaeology Supplement 1), 255-258.

SEVERINGHAUS, J. and BROOK, E. 1999: Abrupt climate change at the end of the Last Glacial period inferred from trapped air in polar ice. *Science* 286, 930-934.

ŞEVKETOĞLU, M. 2000: *Archaeological field survey of the Neolithic and Chalcolithic settlement sites in Kyrenia District, North Cyprus* (Oxford, BAR International Series 834).

ŞEVKETOĞLU, M. 2002: Akanthou-Arkosyko (Tatlisu-Çiftlikdüzü): the Anatolian connections in the 9th millennium BC. In Waldren, W. and Ensenyat, J. (eds.), *World islands in prehistory: international insular investigations. V Deia International Conference of Prehistory* (Oxford, BAR International Series 1095), 98-106.

ŞEVKETOĞLU, M. 2008: Early settlements and procurement of raw materials: new evidence based on research at Akanthou-*Arkosykos* (Tatlisu-Çiftlikdüzü), Northern Cyprus. *Turkish Academy of Sciences Journal of Archaeology* 11, 63-72.

SIMMONS, A. 1994: Early Neolithic settlement in western Cyprus: preliminary report on the 1992-1993 test excavations at Kholetria Ortos. *Bulletin of the American Schools of Oriental Research* 295, 1-14.

SIMMONS, A. 1996: Whose myth? Archaeological data, interpretations, and implications for the human association with extinct Pleistocene fauna at Akrotiri Aetokremnos. *Journal of Mediterranean Archaeology* 9, 97-105.

SIMMONS, A. 1998a: Test excavations at two Aceramic Neolithic sites in the uplands of western Cyprus. *Report of the Department of Antiquities, Cyprus 1998* (Nicosia), 1-17.

SIMMONS, A. 1998b: Of tiny hippos, large cows, and early colonists in Cyprus. *Journal of Mediterranean Archaeology* 11, 232-241.

SIMMONS, A. 1999: *Faunal extinction in an island society: pygmy hippopotamus hunters of Cyprus* (New York).

SIMMONS, A. 2001: The first humans and last pygmy hippopotami of Cyprus. In Swiny, S. (ed.), *The earliest prehistory of Cyprus: from colonisation to exploitation* (Boston), 1-18.

SIMMONS, A. 2003a: Excavations at Kritou Marottou Ais Yiorkis, an early Neolithic site in western Cyprus: preliminary report. *Neolithics* 2, 8-12.

SIMMONS, A. 2003b: Villages without walls, cows without corrals. In Guilaine, J. and LeBrun, A. (eds.), *Le Néolithique de Chypre* (Athens, Bulletin de Correspondance Hellénique Supplément 43), 61-70.

SIMMONS, A. 2004: Bitter hippos of Cyprus: the island's first occupants and last endemic animals-setting the stage for colonisation. In Peltenburg, E. and Wasse, A. (eds.), *Neolithic revolution: new perspectives on Southwest Asia in light of recent discoveries on Cyprus* (Oxford: Levant Supplementary Series 1), 1-14.

SIMMONS, A. 2005: *Ais Yiorkis*, an upland Aceramic Neolithic site in western Cyprus: progress report of the 2003 excavations. *Report of the Department of Antiquities of Cyprus, 2005* (Nicosia), 23-30.

SIMMONS, A. 2007: *The Neolithic Revolution in the Near East: transforming the human landscape* (Tucson).

SIMMONS, A. 2008: American researchers and the earliest Cypriots. *Near Eastern Archaeology* 71, 21-29.

SIMMONS, A. 2009a: The earliest residents of Cyprus: ecological pariahs or harmonious settlers? In Fisher, C., Hill, B. and Feinman, G. (eds.), *The socio-natural connection: integrating archaeology and environmental studies* (Tucson), 177-191.

SIMMONS, A. 2009b: Until the cows come home: cattle and Early Neolithic Cyprus. *Before Farming* (on-line version) 2009/1, article 5.

SIMMONS, A. and MANDEL, R. 2007: Not such a new light: a Response to Ammerman and Noller. *World Archaeology* 39, 475-482.

SIMMONS, A. and O'HORO, K. 2003: A preliminary note on the chipped stone assemblage from Kritou Marottou Ais Yiorkis, an Aceramic Neolithic site in western Cyprus. *Neolithics* 1/03, 21-24.

SIMMONS, A., ROLLEFSON, G., KÖHLER-ROLLEFSON, I., MANDEL, R. and KAFAFI, Z. 1988: 'Ain Ghazal: a major Neolithic settlement in central Jordan. *Science* 240, 35-39.

SONDAAR, P. 1986: The island sweepstakes. *Natural History*: 95, 50-57.

STEADMAN, D. 1995: Prehistoric extinctions of Pacific island birds: biodiversity meets zooarchaeology. *Science*, 267, 1123-1131.

STEEL, L. 2004: *Cyprus before history* (London).

SWINY, S. (ed.) 2001: *The earliest prehistory of Cyprus: from colonisation to exploitation* (Boston).

TODD, I. 2001: Kalavasos Tenta revisited. In Swiny, S. (ed.), *The earliest prehistory of Cyprus: from colonisation to exploitation* (Boston), 95-107.

TODD, I. 2003: Kalavasos-Tenta: a reappraisal. In Guilaine, J. and LeBrun, A. (eds.), *Le Néolithique de Chypre* (Athens, Bulletin de Correspondance Hellénique Supplément 43), 35-44.

VAN ANDEL, T. and RUNNELS, C. 1995: The earliest farmers in Europe. *Antiquity* 69, 481-500.

VIGNE, J.-D. 2001: Large mammals of early Aceramic Neolithic Cyprus: preliminary results from Parekklisha Shillourokambos. In Swiny, S. (ed.), *The earliest prehistory of Cyprus: from colonisation to exploitation* (Boston), 55-60.

VIGNE, J.-D. 2011: Les bovins *(Bos taurus)*. In Guilaine, J., Briois, F. and Vigne, J.-D. (eds.) 2011: *Shillourokambos: un établissement Néolithique Pre-Céramique à Chypre. Les Fouilles du Secteur 1* (Athens), 1075-1091.

VIGNE, J.-D., DOLLFUS, G. and PETERS, J. 1999: The beginning of herding in the Near East: new data and new ideas. *Paléorient* 25, 9-10.

VIGNE, J.-D., CARRÈRE, I., SALIÈGE, J.-F., PERSON, A., BOCHERENS, H., GUILAINE, J., and BRIOIS, J.-F. 2000: Predomestic cattle, sheep, goat and pig during the late 9th and the 8th millennium cal. BC on Cyprus: preliminary results of Shillourokambos (Parekklisha, Limassol). In Mashkour, M., Choyke, A., Buitenhuis, H. and Poplin, F. (eds.), *Archaeozoology of the Near East IV vol. A* (Groningen, ARC Publication 32), 83-106.

VIGNE, J.-D., CARRÈRE, I. and GUILAINE, J. 2003: Unstable status of early domestic ungulates in the Near East: the example of Shillourokambos (Cyprus, IX-VIIIth millennia cal. B.C.) In Guilaine, J. and LeBrun, A. (eds.), *Le Néolithique de Chypre* (Athens, Bulletin de Correspondance Hellénique Supplément 43), 239-251.

VIGNE, J.-D., GUILAINE, J., DEBUE, K., HAYE, L. and GÉRARD, P. 2004: Early taming of the cat in Cyprus. *Science* 304, 259.

VIGNE, J.-D., HELMER, D. and PETERS, J. 2005: New archaeological approaches to trace the first steps of animal domestication: general presentation, reflections and proposals. In Vigne, J.-D., Peters, J. and Helmer, D. (eds.), *First steps of animal domestication* (Oxford), 1-16.

WALDREN, W. 1982: *Balearic prehistoric ecology and culture* (Oxford, BAR International Series 149).

WALDREN, W. 1994: *Survival and extinction: Myotragus Balearicus, an endemic Pleistocene antelope from the island of Mallorca* (Deia, DAMARC 27).

WIGAND, P. and SIMMONS, A. 1999: The dating of Akrotiri Aetokremnos. In Simmons, A. (ed.), *Faunal extinction in an island society: pygmy hippopotamus hunters of Cyprus* (New York), 193-215.

WILCOX, G. 2002: Geographical variation in major cereal components and evidence for independent domestication events in Western Asia. In Cappers, R. and Bottema, S. (eds.), *The dawn of farming in the Near East* (Berlin: Studies in Early Near Eastern Production, Subsistence, and Environment 6), 133-140.

WILCOX, G. 2003: The origins of Cypriot farming. In Guilaine, J. and LeBrun, A. (eds.), *Le Néolithique de Chypre* (Athens, Bulletin de Correspondance Hellénique Supplément 43), 231-238.

Initial occupation of the Cycladic islands in the Neolithic: strategies for survival

Nellie Phoca-Cosmetatou

Introduction

The Cycladic islands, visited since the late Upper Palaeolithic and centrally located along the Aegean aquatic routes, did not witness a permanent human occupation until the Late Neolithic at around 5000 BC. This paper will discuss the evidence for this early occupation of the islands, with a special emphasis on the timing and character of the first settlement, so as to explore the strategies, economic or social, that enabled its consolidation.

The two main themes to be discussed are:

1. The timing of the occupation. A brief chronological overview of the evidence from people's initial visits during the end of the Upper Palaeolithic till the first settlements in the Late Neolithic will be presented, to be followed by an examination of the factors that might have been involved in the date the occupation took place.
2. The nature of the occupation. The main focus will be on the type of economy practiced that allowed the consolidation of settlement. Changing uses and perceptions of the islands will further be explored. The site of Ftelia, Mykonos, and the information presented on its animal economy, will furnish relevant information as to the strategies adopted by the island inhabitants in overcoming the demands of the marginal environment they occupied.

It will be argued that despite an extensive social world with long-distance contacts and trading networks, as suggested by pottery styles and luxury items, the economic and subsistence variables seem to point to a much more insular existence. It will further be argued that by transporting their domestic animals and crops, people transformed the islands into mainland-style landscapes. Adjustments to the economy demonstrate the new inhabitants' knowledge of their new landscapes, probably accumulated over the many millennia of the prior utilisation of and visits to the Cycladic islands.

Colonisation, occupation and landscape learning in marginal environments

Island colonisation can be a long and multi-faceted process. Colonisation can be broadly defined as the setting up of human presence and activities at a previously unoccupied territory, or one newly occupied by a different human group (Dawson 2008). Subsequent use can take many guises: from the initial discovery of an island; to its visitation, exploration and utilisation, all of which involve short-term and sporadic visits to the islands with knowledge of its resources; to occupation and establishment, in the sense of a more permanent settlement, at least one which forms the centre of occupation of a given group; and also to abandonment and recolonisation (Broodbank 2000, 107-110; Cherry 1981, 1990; Dawson 2008; Graves and

Addison 1995). The presence or absence, the combination, order, length and character of each of the above stages differs for any given island, as do people's motivations, obstacles encountered, and outcomes produced (Dawson 2008).

This paper will focus on the first village settlements on the Cyclades. Their archaeological remains indicate an occupation of a sedentary nature and architectural features suggest an investment of time and effort put into their construction. It is acknowledged that the identification of the early settlements can be biased by archaeological visibility, as they may not have survived, be represented today by surface scatters, or not have been discovered or excavated yet; moreover, short-lived first settlements might look archaeologically like short-term visits, and thus not identified as such.

In the context of long-term inhabitation, I wish to explore the possible strategies people adopted in making their occupation relatively long-lived and stable. The Cyclades are small and arid islands, they were devoid of indigenous fauna during the Neolithic, and thus not particularly welcoming environments for agriculture and domestication. Consequently, people were faced with a narrower range of available economic and survival options on these islands, though the location of the early settlements suggests targeting of more favourable niches (Broodbank 2000, 147). Adaptations to new, unfamiliar and marginal environments is a much discussed topic within Archaeology more generally (e.g. Halstead 2008; Mills and Coles 1998; Mondini *et al.* 2004; Rockman and Steele 2003).

Cherry (1981) proposed four strategies that could have been adopted in establishing settlement on island environments. His model shares common elements with others (see discussion in the introduction to the volume) and focuses on archaeologically visible features. The strategies are: an increase in resource diversification, both of domesticated and wild resources; an increase in storage; an increase in exchange, trading and, thus, of alliance networks; and increased mobility and changes in settlement and group sizes. In assessing them as they appertained to the Neolithic of the Cyclades, Broodbank (2000, 81-91) concluded that there was no clear evidence for either storage or resource diversification and that the key factors were exchange and mobility.

The concept of 'landscape learning' (Rockman 2003) is pertinent. It refers to the knowledge people have to amass and process so as to learn, adapt and survive in a new landscape. This learning is both environmental and social, learning about ecological constraints and possibilities, and also imparting cultural meaning to and appropriating the new surroundings. This learning does not take place in a void though. People bring with them pre-existing knowledge of the place they come from with expectations about how things work. This knowledge in turn affects their flexibility and adaptability in their new situation. This balance of pre-existing knowledge and new learning is particularly relevant to the Cyclades. Though applicable on many levels and for various resources (see Broodbank and Kiriatzi 2007), the focus of the present analysis is primarily on subsistence and the economy. Firstly, as will be discussed below, the islands were visited and utilised for millennia preceding their occupation. Once occupied, pre-existing knowledge operated on two levels: knowledge of their lifestyles on the mainland, or point of origin; and knowledge of the islands themselves, albeit from short-term visits. Secondly, people brought with them their domestic plants and animals. Not only did they transport this pre-existing knowledge and lifestyle with them, they also transformed the islands into mainland-type landscapes, what has been termed 'transported landscapes' (Gosden and Head 1994; Kirch 1982; Phoca-Cosmetatou 2008). Meltzer (2003) has suggested that in cases of transported landscapes, landscape learning need no longer be important. Is this the case in

the Cyclades? This question will be approached on two levels by examining firstly the extent to which the subsistence economy, overall, indicates adjustments to the particular island environments, and secondly the extent to which adjustments can be identified over the duration of a settlement's existence, using the site of Ftelia, Mykonos, as a case study.

History of the colonisation of the Cyclades

The Cycladic islands form a relatively well defined group of around 30 islands located in the southern Aegean sea (Figure 4.1), notwithstanding islets and rocks. Comprised mainly of small islands, only eight are larger than 100 sq km (three of which are over 200 sq km) and another six are over 50 sq km (Broodbank 2000, fig. 14). They are located in close proximity to each other, with distances of less than 30 km and more frequently closer to 10 km. During periods of lowered sea levels in the Pleistocene the islands formed a single island (Cycladia). From the onset of the Holocene (9500 BC), although sea levels were c. 50 m lower, Cycladia had basically broken up and the configuration of the islands became similar to that of the

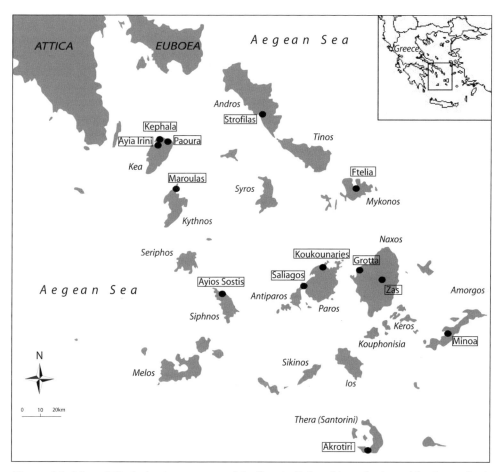

Figure 4.1: Map of Cyclades (map prepared by Yannis Galanakis and adapted by the author)

present day. By 7500 BC most islands had reached, more or less, their present day size (Lambeck 1996). Recent research over the last 30 years or so has substantially augmented our knowledge of early human presence on the islands, and many of the oldest known sites are from recent discoveries (Broodbank 2000, 2006; Cherry 1981, 1990).

The Palaeolithic and Mesolithic periods

The pre-Neolithic evidence for human presence on the Cycladic islands, and even in the Aegean more generally, is limited (Broodbank 2006). This could be due to archaeological visibility as during the Palaeolithic sea levels were lower and areas of land have subsequently been inundated. More importantly, most of the islands are too small to have sustained hunter-gatherer groups over extended periods of time, especially after the break up of Cycladia, given also that the endemic fauna seems to have become extinct before the end of the Pleistocene (Marra 2005; Reese 1996).

Direct evidence of human presence in the Aegean islands during the Upper Palaeolithic or even earlier, though amassing from recent fieldwork projects especially in and around Crete (Kopaka and Matzanas 2009; Mortensen 2008; Strasser *et al.* 2010) is scant and not well documented yet. The earliest and most secure evidence for people's presence on the Cycladic islands and for developed seafaring techniques comes from the mainland site of Franchthi. Since the end of the Upper Palaeolithic, from c. 11,000 BC, obsidian from the island of Melos appears among the raw materials represented in the lithic assemblage (Perlès 1999, 2003).

Recent research has started to document human presence in Mesolithic times (Broodbank 2006; Galanidou and Perlès 2003). In the Cyclades excavations at Maroulas, Kythnos, have demonstrated the Mesolithic date of the site and cemetery (8263-7668 BC; Sampson 2008a). Human presence has further been documented on Cyclops Cave, Yioura, in the northern Aegean, a cave site dated to the Mesolithic period (8200 BC) that has yielded numerous fish remains and fishing hooks (Mylona 2003a; Trantalidou 2008), though the obsidian tools may be intrusions from the Neolithic levels above (compare Sampson *et al.* 2003 to Kaczanowska and Kozlowski 2008).

The Early and Middle Neolithic periods

It is during the Holocene, and especially from the start of the Neolithic, that maritime activity becomes more widespread, possibly linked to the aquatic routes over which the Neolithic economy spread (Broodbank 2006). Five islands in the Aegean are colonised during the earlier part of the Neolithic (c. 7000-5200 BC; Crete, Alonissos, Kyra Panagia, Skyros and Thassos; Dawson 2008). Crete, the largest Aegean island, was occupied soon after 7000 BC (Isaakidou and Tomkins 2008), as indicated by the Aceramic level (X) at Knossos (Tomkins 2008); it has been suggested that this occupation was a result of purposeful colonisation (Broodbank and Strasser 1991).

The Cycladic islands were visited during this period as attested by the presence of Melian obsidian on mainland sites (Perlès 2001). A number of systematic surveys on various islands (e.g. Melos, Naxos, Kea, Amorgos) have recently been yielding surface finds from this period. But despite such intensive fieldwork, few sites have yielded any substantial or architectural remains (Broodbank 2000, 2006). Thus, firm proof for a more permanent occupation of the Cycladic islands during the earlier part of the Neolithic is presently lacking.

The Late and Final Neolithic periods

It is only in the later part of the Neolithic period (Late and Final Neolithic, 5200-3200 BC) that considerable evidence exists for human colonisation and occupation of the Cycladic islands, with human presence discovered in at least two thirds of the islands surveyed (Broodbank 2000). In a recent review of the evidence, Dawson (2008) calculated that 23 Aegean islands were colonised during the 5th millennium, with a further 10 during the 4th. In the Cyclades, the largest and best known settlements sites are the Late Neolithic sites of Saliagos (Evans and Renfrew 1968) and Koukounaries (Katsarou and Schilardi 2004) on Paros/Antiparos, Ftelia on Mykonos (Sampson 2002a, 2006, 2008b), Zas cave (Zachos 1999) and Grotta (Hadjianastasiou 1988) on Naxos; and the Final Neolithic settlements at Kephala (Coleman 1977) on Kea and Strofilas (Televantou 2008) on Andros (Figure 4.1). Other sites include Minoa (Marangou 2002) on Amorgos, Akrotiri (Sotirakopoulou 2008) on Santorini, Paoura and Ayia Irini on Kea (Whitelaw 1991), and further later Neolithic finds have been attested on Siphnos (Ayios Sostis), Andros (Vriokastro, Mikroyaki) and Mykonos (Mavrispilia) (Broodbank 2000; Kouka 2008). The latter consist of surface finds or limited excavations; it is expected that future fieldwork will yield a greater number of settlements.

The Late Neolithic sites are characterised by light-on-dark pottery and have been grouped into the Saliagos culture; the later Kephala culture, with pattern-burnished pottery, dates from the Final Neolithic. During the later Neolithic, each island occupied seems to have had one large settlement, a pattern contrary to that of the Bronze Age when sites decreased in size, increased in number and became more scattered (Broodbank 2000). The Neolithic settlements lasted for about 200-400 years each and were subsequently abandoned, suggesting a possible discontinuity in occupation with the subsequent Bronze Age (Broodbank 2000; Dawson 2008).

Timing: why the delay in occupation?

Based on this overview, the following observations are important in trying to understand the timing and character of the first settlement of the Cycladic islands during the later Neolithic:

1. The Neolithic period in mainland Greece dates from c. 7000-6500 BC. It is very well documented since its early phase, with more than 120 sites from Thessaly alone (Perlès 2001).
2. The Neolithic economy seems to have been introduced from the east, from Anatolia, probably reaching Greece across the islands (e.g. Broodbank 1999, 2006; Davis 2001).
3. The islands were well known and navigation skills were quite developed since at least the early Holocene. Melian obsidian has been widely recovered on mainland sites. A few sites have yielded evidence for human presence on the Cycladic, and more generally the Aegean, islands since the Mesolithic (e.g. Kythnos, Yioura). This could be due to the small size of the islands, poor in animal resources, not suitable for sustaining hunter-gatherer groups and also to the loss of the islands' landmass because of rising sea-levels.
4. Despite all the above, given our present state of knowledge, there does not seem to have been any occupation of the Cycladic islands during the early part of the Neolithic. The most

concrete evidence we have dates from the later Neolithic, which is almost 2000 years after the introduction of the Neolithic in Greece.

The question that is thus raised is why there is this delay of 2000 years in human occupation of the islands. For even if the islands were not suitable for hunter-gatherers, they clearly were for agriculturalists, as the latter occupied them in the Late Neolithic. If so, why were they not occupied since the Early Neolithic? Before discussing various factors, economic and social, that have been proposed to explain their colonisation and occupation, an assessment of the environmental constraints of the Cycladic islands will be presented.

Environmental constraints

The Cycladic islands today are quite barren and arid, with limited tree cover and water sources. The climate is dry with very small quantity of rainfall. The islands are at the limit of sustainable arable agriculture. Terraces are extensively used to enable cultivation of crops. Reconstructing the past environment is problematic as direct data in the form of lake pollen cores from the islands are lacking. Proxy lake data come from the colder and more humid climates of mainland northern Greece and from Crete (e.g. Atherden *et al.* 1993; Bottema 1994; Bottema and Sarpaki 2003; Lawson *et al.* 2004; Moody *et al.* 1996; Rackham 2008; Tzedakis 1994; Willis 1994).

The Mediterranean climate, of hot summers and cool winters, had been established in the Holocene. The main vegetation types were already present, including forests, maquis and savannah. However, human impact on the environment, in the form of deforestation, cultivation, grazing by domestic animals, and introduction of new plants and weeds, has been quite substantive since. Pollen cores in Crete have demonstrated that tree cover fluctuated during the Holocene and was not necessarily more extensive than at present (Rackham 2008). Increased precipitation and spread of deciduous oak woodland has been identified around 6400 BC (7500 BP), followed by increasing aridisation and reduction in forest cover from 4500 BC onwards (Bottema and Sarpaki 2003; Rackham 2008). The Cycladic islands would have always been more predisposed to arid and open, maquis style, vegetation, as moisture is the determinant factor for vegetation cover. Low lying islands, with elevations lower than 600 m, tend to be drier as they do not retain clouds and seldom have rivers flowing year-round (Rackham 2008).

The endemic fauna on the islands had gone extinct before the end of the Pleistocene; in Crete the last positive evidence for their presence is 21,000 BP (Marra 2005; Rackham 2008; Reese 1996). The absence of fauna on the Cycladic islands meant that people had to bring all their livestock to the islands from the mainland, including cattle.

This environmental marginality, of small, dry and deserted islands, has been considered an explanation for the late date of occupation of the Cyclades: e.g. 'environmental factors such as size, geomorphology, limited cultivable land and water sources did not encourage early settlement of the Cyclades on a permanent basis' (Kouka 2008, 271; see also Perlès 2001, 119-120). There are two reasons, though, why this is not a satisfactory explanation. First, it raises the question not so much of why was the occupation so late, as if it was meant to happen when the conditions were right, but rather of why should it occur at all. Second, it fails to explain the timing and the characteristics of the occupation once it eventually happened. It is to these concerns that we will turn next.

Enabling factors

The following section will consider some factors that could be relevant in accounting for the reasons for and the timing of the colonisation of the Cyclades. These include environmental, technological, economic and social ones. However, a number of critical considerations need to be kept in mind. The first involves separating the inevitability from the fortuitousness of such an occupation. The former implies that people were waiting for the right conditions to enable their occupation of the islands, whereas the latter implies that new needs arose that led to their occupation. The second consideration focuses on the geographical location of any changes: did these occur on the mainland, thus making people go to the islands, or did they occur on the islands, thus enabling a move there. Both considerations can be understood in terms of 'push' and 'pull' factors (Anthony 1990): the former tend to include changes on the mainland that pushed people onto the islands, whereas the latter include features of the islands that pulled people to them. A third consideration concerns our critical use of archaeological hindsight and assumptions. We need to be clear whether the factors we examine were of importance prior to the onset of occupation or whether they gained in prominence at a later date and thus might not have been as significant at the earlier date.

Past visits and utilisation of the islands, for fishing, seasonal pasture and resource acquisition, have been considered explanations for their eventual occupation. Broodbank (2000, 126-129) assessed these scenaria and argued against them. He concluded that neither fishing nor pasture were strong enough stimuli for island settlement. Not only is the evidence for them not very strong in the earlier Neolithic of Greece, but mainly the processes and settlement patterns involved are separate to establishing a permanent occupation.

A scenario of resource acquisition acknowledges that, though the Cyclades might be environmentally marginal for farming, they are the source of valuable lithic and metal raw materials. Such resources include obsidian on Melos, marble on Naxos and Paros, copper on Kythnos and Seriphos, and silver on Siphnos (Broodbank 2000; Gale and Stos-Gale 2008; Kouka 2008). Obsidian had been exploited since the end of the Upper Palaeolithic. Marble and metals begin to be exploited primarily from the 4th millennium onwards (Broodbank 2000; Kouka 2008). However, the widespread use of metals post-dates the first settlements on the Cyclades by almost 1000 years. Thus explaining their occupation due to the importance copper and metal technology would accrue later, is using archaeological hindsight rather than focusing on the economic and social features of the Neolithic world during the Middle and early Late Neolithic. Moreover, the islands that were initially settled are not those rich in metal sources (Broodbank 2000, 127).

Increased seafaring skills have also been proposed as an explanation for the timing of the Cyclades during the Late Neolithic. For example, Strasser (2003) has emphasised the innovation of polished stone axes used as woodworking tools that enabled the construction of boats large enough to transport the required domesticates for a successful occupation on the islands. Although possibly accounting for the timing of the occupation, this explanation assumes that the occupation was waiting to happen when the right technology became available, and does not account either for the reasons for or the characteristics of the occupation.

A focus on the pre-existing economic and social conditions during the Middle and early Late Neolithic can help towards answering these latter concerns. Through an examination of which islands were initially occupied and the maritime routes involved, Broodbank (2000) argued that we should not necessarily view the occupation of the Cyclades as a

purposeful colonisation, as was the case for Crete (Broodbank and Strasser 1991), but rather as a slow and gradual spill over of people from the mainland. In this context, the occupation of the islands can be connected to the changes in settlement and subsistence practices during the Middle and Late Neolithic on the mainland. These changes involved settlement expansion, a move of people to more marginal and upland areas, an increase in pastoralism, and thus an increased emphasis on domestic animals (Broodbank 2000; Halstead 2008; Johnson 1996).

The first island settlements during the Late Neolithic Saliagos culture were quite large villages, even possibly upwards of 100 people. On present evidence, each island occupied had one residential base, though many locations might have been exploited and visited, as suggested by surface finds (Broodbank 2000). As such population sizes are not self-sufficient, exchange and social networks must have been important in maintaining them, especially in the marginal environments of the Cyclades. Despite the presence of a separate style of Cycladic pottery, there is rich archaeological evidence supporting far-flung connections, including mainland type pottery in the Cyclades and light-on-dark pottery further afield; obsidian from Giali at Saliagos; copper and gold at Zas and Ftelia suggesting links with Attica and the Balkans respectively; similarities in figurine styles, pottery shapes and motifs; marble vessels suggest interaction across the Aegean sea both with mainland Greece and Turkey (Broodbank 2000; Sampson 2006; Takaoğlu 2006; Tomkins 2009; see also Quinn *et al.* 2010 for long-distance ceramic provenance in the Middle Neolithic). The wider Aegean formed part of a single interaction sphere and trade played an important role in the spread of ideas and artefacts. Papageorgiou (2008a, 2008b) has further argued that the early settlements are located on strategic locations along the wider network of sea routes across the Aegean. It is thus not fortuitous that the enduring settlement of the Cyclades has been widely attributed to the increase in trade and seafaring skills that would have, in turn, enabled increased contact between the islanders, which further implies greater reliance and interdependence (Broodbank 2000; Davis 2001; Halstead 2008; Perlès 2001).

Summing up, the first scenaria on continued use of the islands for fishing, pasture and resources, and on increased seafaring skills share an underlying assumption that island occupation was inevitable and finally took place once the right circumstances arose. An examination of changes in mobility and economy on the mainland suggested reasons for which the occupation of the islands happened when it did, and provided some pointers as to the key features of settlement patterns. The final consideration on social alliances and trade emphasised the role of 'social storage' (Halstead and O'Shea 1989) in buffering against any difficulties faced. As mentioned above, however, the question need not necessarily be 'why the delay' in occupation, but 'why at all', especially given the long history of the islands' exploitation and the environmental constraints posed (see also Broodbank 2000, 126). Precisely because of these latter two characteristics, the options available and the decisions people made in establishing residence on the islands were different to those they faced on the mainland. Thus, an exploration of the characteristics and features of people's livelihoods on the islands can lead to a better understanding of the nature of occupation. The following section will focus on the characteristics of the subsistence economy of the island settlements, examining whether it differed from mainland practices, in an attempt to assess the features of people's adaptation that might have enabled the consolidation of early occupation and their survival on these small and marginal islands.

Economic strategies for survival

Transported economies and transformed landscapes

An important feature to consider in exploring the nature of the initial occupation of the Cycladic islands during the Late and Final Neolithic is the ways in which people transformed the island environments, and thus transformed the way these environments were utilised and perceived. One such transformation is the islands' more permanent occupation itself, although not necessarily a long-lived one. These settlements do not represent a continuous flourishing of occupation throughout the Late and Final Neolithic (5500-3200 BC) (Broodbank 2000) and their abandonment has even been considered a strategy people adopted (Dawson 2008).

Another transformation involved bringing domestic animals and cultivated plants from the mainland, what has been termed 'transported landscapes' (Gosden and Head 1994; Kirch 1982). This human intervention would have transformed both the islands themselves, the fauna and flora present, and also the way in which people used them. The islands were, thus, transformed into mainland-type landscapes (Phoca-Cosmetatou 2008).

Can we, though, identify any particular features of the economies to suggest that people adjusted to the particular island environments they faced? Halstead (in Zachos 1999, 158; see also Halstead 2008) has stated that 'qualitatively, animal exploitation at [the islands] differed surprisingly little from that at the mainland open settlements – and that any breakthrough facilitating marginal colonization should be sought elsewhere'.

In a previous paper (Phoca-Cosmetatou 2008) I attempted to identify distinctive features of island economies to explore whether these might have played a role in enabling a successful settlement. A comparison of the frequency of various animal species in Late/Final Neolithic mainland (19) and island (4) sites in Greece indicated that the reliance on domesticates was very similar in both cases (90 per cent and almost 100 per cent respectively; Figure 4.2). The lower frequency on mainland sites is to be expected given the wider range of animal resources available, including wild ones. Fishing, although present at both mainland and island sites, in general was not a specialised or important activity: fish remains can be few, though exceptions

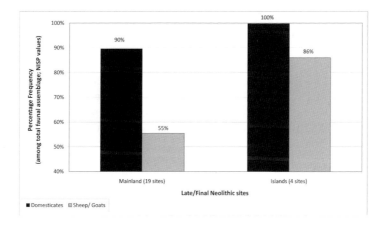

Figure 4.2: Late/Final Neolithic sites in mainland and island Greece: comparison of reliance on domestic animals and sheep/goats (based on figs. 5.3 and 5.4 in Phoca-Cosmetatou 2008)

exist and recovery techniques might be the cause, and isotope studies suggest a terrestrial diet for Neolithic populations (Mylona 2003b; Papathanassiou 2001; Powell 1996; Theodoropoulou 2007).

A notable difference between mainland and island sites was the reliance on sheep and goats: these animals constituted only 55 per cent of domesticates among Late/Final Neolithic mainland sites (down from 64 per cent in the Early Neolithic), in contrast to 86 per cent among island sites. I argued that this difference could be attributed to the environmental conditions on the islands, which lacked large pastures or forest cover suitable for cattle and pig; it is a feature that has been argued for marginal environments more generally (Halstead 1996). All the same, this was people's conscious adjustment of their mainland economy to the particular environmental conditions prevailing on the islands, rather than importing their domestic package intact and unchanged, which would not have been sustainable on the islands.

I would thus conclude that, although the differences are slight and the sample of faunal assemblages from islands is small, the differences in the ratio of the various domesticates, although most probably a direct response to the particular environmental conditions of each site, suggest that people adapted to those conditions, in the sense that some extent of landscape learning took place and they fine-tuned their transported economies to fit with their new settings and the narrower range of options available.

Landscape learning through time? The example of Ftelia, Mykonos

The settlement of Ftelia, Mykonos, is one of the earliest on the Cyclades. It is located on a sandstone hill in the innermost part of the north-facing Gulf of Panormos (Figure 4.3).

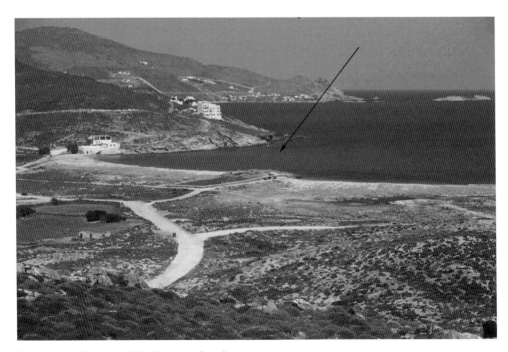

Figure 4.3: The site of Ftelia in its local setting

Currently bordering the sea, with sea levels lower by at least 6 metres at c. 5000 BC, the site would have then been located more centrally on the coastal plain (Desruelles *et al.* 2009; Lambeck and Purcell 2005).

Excavations under the direction of Prof. Adamantios Sampson (University of the Aegean, 1995-2003) uncovered a village settlement with an estimated population of 100-150 people over an area of 6500 sq m (Sampson 2002a, 2006, 2008b). Archaeological deposits were up to 2.50 m deep. Substantive walls were uncovered, often 0.8 m thick and 1 m deep, representing four architectural phases (Sampson 2008b). The material culture is attributed to the Saliagos phase of the Late Neolithic, based on its light-on-dark pottery (Sampson 2002a) and the lithic industry (Galanidou 2002). Radiocarbon dating supports this attribution and places the occupation of the site during the period 5000-4500 BC.

The study of the faunal assemblage has focused on two areas of the settlement, an internal and an external one (trenches B4 and A6 respectively; Figure 4.4). They have yielded 45,000 bone fragments, over 9,000 of which are identifiable. Focusing on a sample of 3740 NISP (number of identified specimens) from both areas, an overview of the site's economy has already been presented (Phoca-Cosmetatou 2002, 2008). Sheep and goats made up 85 per cent of the macrofaunal remains (Figure 4.5), thus suggesting an economy specialised in the herding of sheep and goats with an emphasis on the former: of the bones identified to either of the two species, sheep were twice as frequent as goats (608 NISP of 980 NISP). Pigs made up 12 per cent of the assemblage and cattle 3 per cent. Dog bones were very infrequent (0.1 per cent) but frequencies of gnawed bones reached 10.5 per cent primarily in the open area of the settlement. No deer, either red or fallow, were identified despite careful examination of the remains, in an attempt to clarify past claims for their presence on the Cycladic islands during the Neolithic (for discussion see Phoca-Cosmetatou 2008). An examination of the frequency of burning (33 per cent, 30 per cent and 34 per cent for sheep/goats, pig and cattle respectively) and the number and types of cut marks (8 per cent, 10 per cent and 4 per cent) suggested that similar butchery practices were followed for all four domestic species (Table

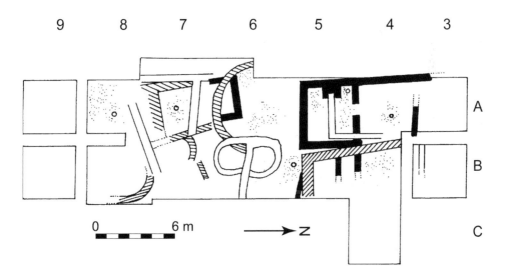

Figure 4.4: Excavation plan of Ftelia (modified from Sampson 2008b)

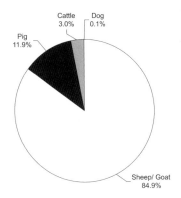

Figure 4.5: Frequency of domestic animals from Ftelia (3740 NISP; trenches A6 and B4) (based on fig. 5.2 in Phoca-Cosmetatou 2008)

**Table 4.1: Human modifications (tool marks and burning)
on the faunal assemblage from Ftelia (based on table 5.3 in Phoca-Cosmetatou 2008)**

Species	Tool Marks (cut marks and impact fractures)	Tool Marks %	Burning	Burning %	Total NISP (excl. teeth/ horns)
Sheep/ Goat	170	7.6%	737	33.1%	2225
Pig	33	10.2%	95	29.5%	322
Cattle	4	4.5%	30	33.7%	89

**Table 4.2: Modifications on bones (human and animal)
on the faunal assemblage from Ftelia, area A6: comparison of levels 8 and 3**

Level 8 (area A6)			Level 3 (area A6)		
Tool Marks[1]	Total		Tool Marks[1]	Total	
Sheep/ Goat	36	88%	Sheep/ Goat	55	85%
Pig	3	7%	Pig	10	15%
Cattle	2	5%	Cattle	0	0%
Total	41	7%[2]	Total	65	9%[2]
Burning	Total		Burning	Total	
Sheep/ Goat	94	90%	Sheep/ Goat	85	94%
Pig	9	9%	Pig	4	4%
Cattle	1	1%	Cattle	1	1%
Total	104	18%[2]	Total	90	12%[2]
Gnawing[3]	Total		Gnawing[3]	Total	
Sheep/Goat	48	87%	Sheep/Goat	76	77%
Pig	7	13%	Pig	21	21%
Cattle	0	0%	Cattle	1	1%
Total	55	10%[2]	Total	99	13%[2]

Notes:
1. Tool marks include cut marks and impact fractures
2. Percentage of total bones with modification based on total faunal assemblage; species percentages based on the total sample of modified bones in each category
3. Gnawing includes carnivore and rodent gnawing

4.1). Given the above, and the presence of cattle in all levels of the site's stratigraphy coupled with an even anatomical representation, there was not sufficient evidence to argue for a non-economic use of cattle, such as ritual feasting. A preliminary assessment of age profiles indicated that different herding strategies were followed for sheep and goats, with the former culled predominately at a juvenile age whereas the latter we kept sometimes until adulthood (Phoca-Cosmetatou 2002). This pattern has been identified in other Neolithic sites and is considered indicative of milking goats (Greenfield 2010).

As proposed above, the high frequencies of sheep and goats at Ftelia, and on the Late/Final Neolithic Cycladic sites more generally, can be attributed to people's fine tuning of their domestic economies to fit with the island's ecological settings. Marine resources were also exploited at Ftelia, as suggested by the remains of large coastal fish (*Epinephelus* and *Dentex* genera) and molluscs from a wide range of habitats, such as deep waters, rocky shores of shallow water, and sandy shores. The paucity of their remains and the absence of small fish bones is probably due to the lack of systematic wet sieving, thus rendering difficult an assessment of the importance of exploitation of aquatic resources (Mylona pers. comm.).

The question to answer next is whether an adjustment of the economy to the specific environment of Ftelia, in other words the process of landscape learning (see Rockman 2003), can be identified. Can we identify changes in herding practices across the duration of the settlement? In examining this question, I chose to concentrate on the open area (trench A6): it has the site's most complete stratigraphic sequence; it was an open area for most of the site's occupation, thus providing consistency in activity areas (Sampson 2002b); and finally it yielded a rich faunal assemblage. Although the indoor area (trench B4) corresponds to the early phases of the settlement, the size of the faunal assemblage is too small, especially so at the lowest part (levels 8-9; 22 NISP), to allow for a comparative analysis. Levels 8 and 3 of trench A6 were chosen; each level is c. 20 cm thick, dug on a horizontal plane. Level 8 represents the earlier use of the area as an open space, above the apsidal building discovered at its base (Sampson 2008b); level 3 is the first level that spans the whole trench as, due to the slope of the mound, the levels above included surface material.

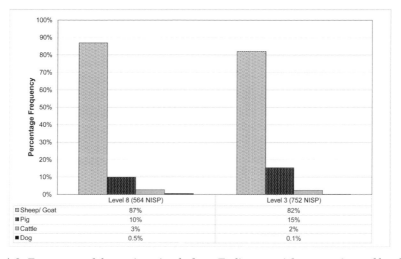

Figure 4.6: Frequency of domestic animals from Ftelia, area A6: comparison of levels 8 and 3

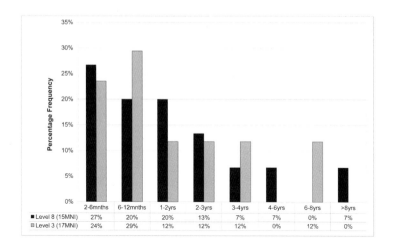

Figure 4.7: Age profiles for Sheep/ Goats combined from Ftelia, area A6: comparison of levels 8 and 3 (MNI: Minimum Number of Individuals)

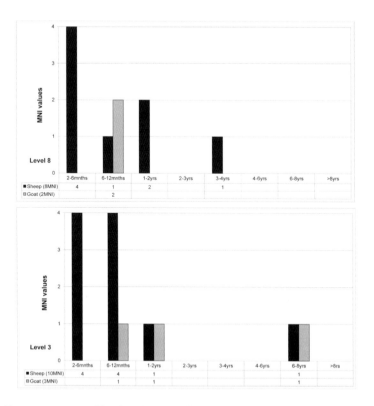

Figure 4.8: Separate age profiles for Sheep and Goats from Ftelia, area A6: comparison of levels 8 and 3

The comparison of the two phases focused on those attributes of the economy discussed in the general overview above, primarily the frequency of the various domesticates and the herding practices of sheep and goats. The frequency of species is almost identical in both levels: sheep and goats are heavily dominant (87 and 82 per cent in the earlier and later phases respectively), with pigs much less frequent (10 and 15 per cent) and cattle (3 and 2 per cent) simply present (Figure 4.6). The ratio of sheep to goats is also consistent in both phases: sheep constituted 68 and 65 per cent of the bones identified to either species in levels 8 (171 NISP) and 3 (168 NISP) respectively. Moreover, the frequency of tool marks and burning was almost identical in both levels (Table 4.2). The frequency of animal gnawing, mainly by dogs, is also similar in both assemblages considered, thus further supporting the conclusion that they both come from an area of the site used as an open space, especially in comparison with the low frequency of gnawing in the internal area (Phoca-Cosmetatou 2008).

The herding strategies adopted for sheep and goats did not witness any major changes either, as indicated by the examination of age profiles (Figure 4.7). The majority of animals were killed as juveniles, less than two years old, with the remaining animals in general not older than four years, with only a few exceptions. The similarity in the profiles could be due to the domesticate context of both assemblages, where animals were culled at a young age, and to not particularly large sample sizes. With smaller samples sizes when considering only those animals identified to either sheep or goat, observations are more tentative (Figure 4.8): goats are less numerous than sheep; the general trend at Ftelia that sheep were culled at a younger age than goats can still be upheld; the absence of adult goats in level 8 might, though, be a result of small sample sizes.

From the data presented we can conclude that there was consistency in the use of the space examined. Although it represents only one part of the settlement, and the comparison between different areas of the site highlighted some slight differences (Phoca-Cosmetatou 2008), the almost identical features of the two levels compared lead to the conclusion that there was no major shift in the characteristics of the faunal assemblage through time. This observation could suggest that there was not much fine-tuning of the economy and herding strategies employed over the 300 years or so of the settlement's existence.

It can thus be proposed that once people decided to settle at Ftelia they organised their economy, domestic animals and herding practices, in a way that remained stable for as long as they lived there. They brought their domesticates, thus transporting their mainland-type economy to the island, although they adjusted it to fit with the environmental requirements and narrower range of opportunities they encountered on Mykonos. Any landscape learning took place at the foundation of the settlement rather than constituting an ongoing process. This could be either due to their long familiarity with the Cyclades over the previous millennia, or to an unwillingness to change and adjust to the new conditions (for comparison see Blanton 2003). On present evidence it is difficult to assess whether such a possible unwillingness had any effect on the decline of the settlement, especially as the upper phases of the settlement have been eroded off.

Conclusions

This paper has examined the timing of the first settlement of the Cycladic islands through an examination of environmental constraints, enabling factors and economic subsistence choices that people made. Although intensive research over the last few decades has been yielding

evidence for ever older activity on the islands, the first residential bases discovered so far date from the Late Neolithic (5000-4500 BC). Though future research might conceivably push this date further back in time, the questions raised in the present paper will still remain pertinent, even if the answers given might be reassessed.

The ecological setting of the Cyclades posed major constraints on island occupation thus not making it a necessarily viable option. Islands in general can sustain lower biodiversity (Whittaker 1998) and this is especially true for the quite small, arid and barren Cycladic islands. It seems that various behavioural thresholds needed to be crossed to allow for their settlement. A long period of repeated visitation, utilisation and occupation of at least 5000 years, since the late Upper Palaeolithic, must have created knowledge, traditions and folklore regarding the Cyclades. Developed seafaring skills that allowed for multiple journeys to and from the islands, and maintenance of trade and alliance networks, were important. The presence of such networks not only worked as buffering mechanisms in times of need but also created and maintained island identities. Settlement change and a move towards more marginal areas of mainland Greece during the Middle and early Late Neolithic could well have made the move to the islands more necessary and also smoother.

What about surviving and living on these islands once settlement was established? Alliances may be key to survival, but they do not necessarily provide the food to live off. People transported their domestic animals and crops to the Cycladic islands, which were devoid of any endemic fauna. This could have resulted in the establishment of a mainland type economy on the islands. However, the distinctive features of the island economies, such as the dominance of sheep and goats, although partly determined by the islands' ecology, suggests that people were responding to the particular constraints and potential offered by their new homes. The lack of change in herding strategies across the 300 year duration of the Late Neolithic settlement at Ftelia, Mykonos, suggests that people had consolidated their learning of the Cycladic landscapes over the 5000 years of earlier visits rather than during the duration of the settlement itself.

Acknowledgments

I wish to thank Prof. Adamantios Sampson for inviting me to study the faunal assemblage from Ftelia. This study has inspired my research on the early occupation of the Cycladic islands and island archaeology. Various aspects of the present paper have been presented at a number of conferences and talks in Oxford, Cambridge, Southampton, Thessaloniki and Athens; I have benefited from all the ensuing discussions. Two referees kindly commented on earlier versions of this paper; all remaining shortcomings are my own. A number of students on the Ftelia excavation project helped me with the sorting and identification of the faunal assemblage; particular thanks are due to Ourania Sepsa and Georgia Kokka. The study was made possible through financial support from the University of the Aegean and the Wiener Laboratory at the American School of Classical Studies at Athens. The faunal assemblage from Ftelia was studied during my tenure of a Research Associateship at the Wiener Laboratory; I wish to thank Sherry Fox and all members of the Lab who helped me and inspired me in my work and made the Lab such a fantastic place to work.

References

ANTHONY, D.W. 1990: Migration in Archaeology: the baby and the bathwater. *American Anthropologist* 92 (4), 895-914.

ATHERDEN, M., HALL, J. and WRIGHT, J.C. 1993: A pollen diagram from the northeast Peloponnese, Greece: implications for vegetation history and archaeology. *The Holocene* 3 (4), 351-356.

BLANTON, D.B. 2003: The weather is fine, wish you were here, because I'm the last one alive: "learning" the environment in the English New World colonies. In Rockman, M. and Steele, J. (eds.), *Colonization of unfamiliar landscapes: the archaeology of adaptation* (London), 190-200.

BOTTEMA, S. 1994: The prehistoric environment of Greece: a review of the palynological record. In Kardulias, P.N. (ed.), *Beyond the site: regional studies in the Aegean area* (Maryland), 45-68.

BOTTEMA, S. and SARPAKI, A. 2003: Environmental change in Crete: a 9000-year record of Holocene vegetation history and the effect of the Santorini eruption. *The Holocene* 13 (5), 733-749.

BROODBANK, C. 1999: Colonization and configuration in the insular Neolithic of the Aegean. In Halstead, P. (ed.), *Neolithic society in Greece* (Sheffield, Sheffield Studies in Aegean Archaeology 2), 15-41.

BROODBANK, C. 2000: *An island archaeology of the early Cyclades* (Cambridge).

BROODBANK, C. 2006: The origins and early development of Mediterranean maritime activity. *Journal of Mediterranean Archaeology* 19 (2), 199-230.

BROODBANK, C. and KIRIATZI, E. 2007: The first "Minoans" of Kythera revisited: technology, demography and landscape in the Prepalatial Aegean. *American Journal of Archaeology* 111, 241-274.

BROODBANK, C. and STRASSER, T.F. 1991: Migrant farmers and the Neolithic colonization of Crete. *Antiquity* 65, 233-245.

CHERRY, J.F. 1981: Pattern and process in the earliest colonization of the Mediterranean islands. *Proceedings of the Prehistoric Society* 47, 41-68.

CHERRY, J.F. 1990: The first colonisation of the Mediterranean islands: a review of recent research. *Journal of Mediterranean Archaeology* 3, 145-221.

COLEMAN, J.E. 1977: *Keos I. Kephala: a late Neolithic settlement and cemetery* (Princeton).

DAVIS, J.L. 2001: Review of Aegean prehistory I: the islands of the Aegean. In Cullen, T. (ed.), *Aegean Prehistory: a review* (Boston, American Journal of Archaeology Supplement 1), 19-94.

DAWSON, H.S. 2008: Unravelling "mystery" and process from the prehistoric colonisation and abandonment of the Mediterranean islands. In Conolly, J. and Campbell, M. (eds.), *Comparative island archaeologies: proceedings of the International Conference, University of Auckland, New Zealand 8th-11th December 2004* (Oxford, BAR International Series 1829), 105-133.

DESRUELLES, S., FOUACHE, E., CINER, A., DALONGEVILLE, R., PAVLOPOULOS, K., KOSUN, E., COQUINOT, Y. and POTDEVIN, J.-L. 2009: Beachrocks and sea level changes since Middle Holocene: comparison between the insular group of Mykonos-Delos-Rhenia (Cyclades, Greece) and the southern coast of Turkey. *Global and Planetary Change* 66, 19-33.

EVANS, J.D. and RENFREW, A.C. 1968: *Excavations at Saliagos near Antiparos* (London).

GALANIDOU, N. 2002: The chipped stone industry of Ftelia: an introduction. In Sampson, A. (ed.), *The Neolithic settlement at Ftelia, Mykonos* (Rhodes), 317-332.

GALANIDOU, N. and PERLÈS, C. (eds.) 2003: *The Greek Mesolithic: problems and perspectives* (London, British School at Athens Studies 10).

GALE, N.H. and STOS-GALE, Z. 2008: Changing patterns in prehistoric Cycladic metallurgy. In Brodie, N.J., Doole, J., Gavalas, G. and Renfrew, A.C. (eds.), *Horizon: a colloquium on the prehistory of the Cyclades* (Cambridge), 387-408.

GOSDEN, C. and HEAD, L. 1994: Landscape – a usefully ambiguous concept. *Archaeology in Oceania* 29, 113-116.

GRAVES, M. and ADDISON, D. 1995: The Polynesian settlement of the Hawaiian archipelago: integrating models and methods in archaeological interpretation. *World Archaeology* 26, 380-399.

GREENFIELD, H. 2010: The Secondary Products Revolution: the past, the present and the future. *World Archaeology* 42 (1), 29-54.

HADJIANASTASIOU, O. 1988: A late Neolithic settlement at Grotta, Naxos. In French, E.B. and Wardle, K.A. (eds.), *Problems in Greek prehistory* (Bristol), 11-20.

HALSTEAD, P. 1996: Pastoralist or household herding? Problems of scale and specialization in early Greek animal husbandry. *World Archaeology* 28 (1), 20-42.

HALSTEAD, P. 2008: Between a rock and a hard place: coping with marginal colonisation in the later Neolithic and early Bronze Age of Crete and the Aegean. In Isaakidou, V. and Tomkins, P. (eds.), *Escaping the labyrinth: the Cretan Neolithic in context* (Oxford, Sheffield Studies in Aegean Archaeology 8), 229-257.

HALSTEAD, P. and O'SHEA, J. (eds.) 1989: *Bad year economics* (Cambridge).

ISAAKIDOU, V. and TOMKINS, P. (eds.) 2008: *Escaping the labyrinth: new perspectives on the Neolithic of Crete* (Oxford, Sheffield Studies in Aegean Archaeology 8).

JOHNSON, M. 1996: Water, animals and agricultural technology: a study of settlement patterns and economic change in Neolithic southern Greece. *Oxford Journal of Archaeology* 15, 267-295.

KACZANOWSKA, M. and KOZLOWSKI, J.K. 2008: Chipped stone artefacts. In Sampson, A. (ed.), *The cave of the Cyclops: Mesolithic and Neolithic networks in the Northern Aegean, Greece: 1. Intra-site analysis, local industries, and regional site distribution* (Philadelphia), 169-178.

KATSAROU, S. and SCHILARDI, D.U. 2004: Emerging Neolithic and early Cycladic settlements in Paros: Koukounaries and Sklavouna. *The Annual of the British School at Athens* 99, 23-48.

KIRCH, P.V. 1982: Transported landscapes. *Natural History* 91 (12), 32-35.

KOPAKA, K. and MATZANAS, C. 2009: Palaeolithic industries from the island of Gavdos, near neighbour to Crete in Greece. *Antiquity* 83 (321) (Project Gallery: http://www.antiquity.ac.uk/projgall/kopaka321).

KOUKA, O. 2008: Diaspora, presence or interaction? The Cyclades and the Greek mainland from the Final Neolithic to the Early Bronze Age II. In Brodie, N.J., Doole, J., Gavalas, G. and Renfrew, A.C. (eds.), *Horizon: a colloquium on the prehistory of the Cyclades* (Cambridge), 271-279.

LAMBECK, K. 1996: Sea-level change and shore-line evolution in Aegean Greece since Upper Palaeolithic time. *Antiquity* 70, 588-611.

LAMBECK, K. and PURCELL, A. 2005: Sea-level change in the Mediterranean Sea since the LGM: model predictions for tectonically stable areas. *Quaternary Science Reviews* 24, 1969-1988.

LAWSON, I., FROGLEY, M., BRYANT, C., PREECE, R. and TZEDAKIS, P.C. 2004: The Late Glacial and Holocene environmental history of the Ioannina basin, north-west Greece. *Quaternary Science Reviews* 23, 1599-1625.

MARANGOU, L. 2002: *Amorgos I–Minoa: i polis, o limin kai i meizon perifereia* (Athens, Vivliothiki tis en Athinais Archaiologikis Etairias 228).

MARRA, A.C. 2005: Pleistocene mammals of Mediterranean islands. *Quaternary International* 129 (1), 5-14.

MELTZER, D.J. 2003: Lessons in landscape learning. In Rockman, M. and Steele, J. (eds.), *Colonization of unfamiliar landscapes: the archaeology of adaptation* (London), 222-241.

MILLS, C.M. and COLES, G. (eds.) 1998: *Life on the edge: human settlement and marginality* (Oxford).

MONDINI, M., MUÑOZ, S. and WICKLER, S. (eds.) 2004: *Colonisation, migration and marginal areas* (Oxford).

MOODY, J., RACKHAM, O. and RAPP, G. Jr. 1996: Environmental archaeology of prehistoric NW Crete. *Journal of Field Archaeology* 23 (3), 273-297.

MORTENSEN, P. 2008: Lower to Middle Palaeolithic artefacts from Loutró on the south coast of Crete. *Antiquity* 82 (317) (Project Gallery: http://antiquity.ac.uk/projgall/mortensen/index.html).

MYLONA, D. 2003a: The exploitation of fish resources in Mesolithic Sporades: fish remains from the cave of Cyclops, Yioura. In Galanidou, N. and Perlès, C. (eds.), *The Greek Mesolithic: problems and perspectives* (London, British School at Athens Studies 10), 181-188.

MYLONA, D. 2003b: Archaeological fish remains in Greece: general trends of the research and a gazetteer of sites. In Kotjabopoulou, E., Hamilakis, Y., Halstead, P., Gamble, C. and Elefanti, P. (eds.), *Zooarchaeology in Greece: recent advances* (London, British School at Athens Studies 9), 193-200.

PAPAGEORGIOU, D. 2008a: Sea routes in the prehistoric Cyclades. In Brodie, N.J., Doole, J., Gavalas, G. and Renfrew, A.C. (eds.), *Horizon: a colloquium on the prehistory of the Cyclades* (Cambridge), 9-11.

PAPAGEORGIOU, D. 2008b: The marine environment and its influence on seafaring and maritime routes in prehistoric Aegean. *European Journal of Archaeology* 11 (2-3), 199-222.

PAPATHANASSIOU, A. 2001: *A bioarchaeological analysis of Neolithic Alepotrypa cave, Greece* (Oxford, BAR International Series 961).

PERLÈS, C. 1999: Long-term perspectives on the occupation of the Franchthi cave: continuity and discontinuity. In Bailey, G.N., Adam, E., Panagopoulou, E., Perlès, C. and Zachos, K.L. (eds.), *The Palaeolithic archaeology of Greece and adjacent areas* (London, British School at Athens Studies 3), 311-318.

PERLÈS, C. 2001: *The early Neolithic in Greece* (Cambridge).

PERLÈS, C. 2003: The Mesolithic at Franchthi: an overview of the data and problems. In Galanidou, N. and Perlès, C. (eds.), *The Greek Mesolithic: problems and perspectives* (London, British School at Athens Studies 9), 79-89.

PHOCA-COSMETATOU, N. 2002: The faunal remains from Ftelia: a preliminary report. In Sampson, A. (ed.), *The Neolithic settlement at Ftelia, Mykonos* (Rhodes), 221-226.

PHOCA-COSMETATOU, N. 2008: Economy and occupation in the Cyclades during the Late Neolithic: the example of Ftelia, Mykonos. In Brodie, N.J., Doole, J., Gavalas, G. and Renfrew, A.C. (eds.), *Horizon: a colloquium on the prehistory of the Cyclades* (Cambridge), 37-41.

POWELL, J. 1996: *Fishing in the prehistoric Aegean* (Jonsered).

QUINN, P., DAY, P., KILIKOGLOU, V., FABER, E., KATSAROU-TZEVELEKI, S. and SAMPSON, A. 2010: Keeping an eye on your pots: the provenance of Neolithic ceramics from the Cave of the Cyclops, Youra, Greece. *Journal of Archaeological Science* 37 (5), 1042-1052.

RACKHAM, O. 2008: Holocene history of Mediterranean island landscapes. In Vogiatzakis, I.N., Pungetti, G. and Mannion, A. (eds.), *Mediterranean island landscapes: natural and cultural approaches* (Springer), 36-69.

REESE, D.S. (ed.) 1996: *Pleistocene and Holocene fauna of Crete and its first settlers* (Madison, Monographs in World Archaeology 28).

ROCKMAN, M. 2003: Knowledge and learning in the archaeology of colonization. In Rockman, M. and Steele, J. (eds.), *Colonization of unfamiliar landscapes: the archaeology of adaptation* (London), 3-24.

ROCKMAN, M. and STEELE, J. (eds.) 2003: *Colonization of unfamiliar landscapes: the archaeology of adaptation* (London).

SAMPSON, A. (ed.) 2002a: *The Neolithic settlement at Ftelia, Mykonos* (Rhodes).

SAMPSON, A. 2002b: The excavation at Ftelia. In Sampson, A. (ed.), *The Neolithic settlement at Ftelia, Mykonos* (Rhodes), 17-37.

SAMPSON, A., (with contributions by KATSAROU-TZEVELEKI, S., KOZLOWSKI, J.K., KACZANOWASKA, M. and TELEVANTOU, C.A.) 2006: *The prehistory of the Aegean basin: Palaeolithic, Mesolithic, Neolithic* (Athens).

SAMPSON, A. 2008a: The Mesolithic settlement and cemetery of Maroulas on Kythnos. In Brodie, N.J., Doole, J., Gavalas, G. and Renfrew, A.C. (eds.), *Horizon: a colloquium on the prehistory of the Cyclades* (Cambridge), 13-17.

SAMPSON, A. 2008b: The architectural phases of the Neolithic settlement of Ftelia on Mykonos. In Brodie, N.J., Doole, J., Gavalas, G. and Renfrew, A.C. (eds.), *Horizon: a colloquium on the prehistory of the Cyclades* (Cambridge), 29-35.

SAMPSON, A., KOZLOWSKI, J.K and KACZANOWSKA, M. 2003: Mesolithic chipped stone industries from the Cave of Cyclope on the island of Youra (northern Sporades). In Galanidou, N. and Perlès, C. (eds.), *The Greek Mesolithic: problems and perspectives* (London, British School at Athens Studies 9), 123-130.

SOTIRAKOPOULOU, P. 2008: Akrotiri, Thera: the Late Neolithic and Early Bronze Age phases in light of recent excavations at the site. In Brodie, N.J., Doole, J., Gavalas, G. and Renfrew, A.C. (eds.), *Horizon: a colloquium on the prehistory of the Cyclades* (Cambridge), 121-134.

STRASSER, T.F. 2003: The subtleties of the seas: thoughts on Mediterranean island biogeography. *Mediterranean Archaeology and Archaeometry* 3 (2), 5-15.

STRASSER, T.F., PANAGOPOULOU, E., RUNNELS, C.N., MURRAY, P.M., THOMPSON, N., KARKANAS, P., McCOY, F.W. and WEGMANN, K.W. 2010: Stone

Age seafaring in the Mediterranean: evidence from the Plakias region for Lower Palaeolithic and Mesolithic habitation of Crete. *Hesperia* 79 (2), 145-190.

TAKAOĞLU, T. 2006: The Late Neolithic in the eastern Aegean: excavations at Gülpinar in the Troad. *Hesperia* 75, 289-315.

TELEVANTOU, C.A. 2008: Strofilas: a Neolithic settlement on Andros. In Brodie, N.J., Doole, J., Gavalas, G. and Renfrew, A.C. (eds.), *Horizon: a colloquium on the prehistory of the Cyclades* (Cambridge), 43-53.

THEODOROPOULOU, A. 2007: *L'exploitation des ressources aquatiques en Egée septentrionale aux périodes pré- et protohistoriques* (Unpublished PhD thesis, Université Paris I).

TOMKINS, P. 2008: Time, space and the reinvention of the Cretan Neolithic. In Isaakidou, V. and Tomkins, P. (eds.), *Escaping the labyrinth: new perspectives on the Neolithic of Crete* (Oxford, Sheffield Studies in Aegean Archaeology 8), 22-51.

TOMKINS, P. 2009: Domesticity by default: ritual, ritualization and cave-use in the Neolithic Aegean. *Oxford Journal of Archaeology* 28 (2), 125-153.

TRANTALIDOU, K. 2008: Glimpses of Aegean island communities during the Mesolithic and Neolithic periods: a zooarchaeological point of view. In Brodie, N.J., Doole, J., Gavalas, G. and Renfrew, A.C. (eds.), *Horizon: a colloquium on the prehistory of the Cyclades* (Cambridge), 19-27.

TZEDAKIS, P.C. 1994: Vegetation change through glacial-interglacial cycles: a long pollen sequence perspective. *Philosophical Transactions of the Royal Society London: Biological Sciences (series B)* 345 (1314), 403-432.

WHITELAW, T.M. 1991: Investigations at the Neolithic sites of Kephala and Paoura. In Cherry, J.F., Davis, J.L. and Mantzourani, E. (eds.), *Landscape archaeology as long-term history: northern Keos in the Cycladic islands from earliest settlement to modern times* (Los Angeles, Monumenta Archaeologica 16), 199-216.

WHITTAKER, R.J. 1998: *Island biogeography: ecology, evolution and conservation* (Oxford).

WILLIS, K.J. 1994: The vegetation history of the Balkans. *Quaternary Science Reviews* 13, 769-788.

ZACHOS, K.L. 1999: Zas cave on Naxos and the role of caves in the Aegean Late Neolithic. In Halstead, P. (ed.), *Neolithic society in Greece* (Sheffield, Sheffield Studies in Aegean Archaeology 2), 153-163.

Palagruža and the spread of farming in the Adriatic

Stašo Forenbaher and Timothy Kaiser

Introduction

From mini-continents the size of Greenland to specks of rock barely breaking the ocean's surface, islands come in an almost infinite number of shapes and sizes. Their pasts are nearly as varied. An island's place in human history depends on a variety of factors, and is sometimes out of all proportion to the number of square kilometres it covers. This paper investigates the role of a tiny Adriatic islet in one of the crucial transitions of European prehistory: the spread of farming.

Palagruža is not an ordinary Adriatic island. For one thing, it is among the oldest. While virtually every other Adriatic island was formed when the Holocene marine transgression drowned what had until then been the westernmost ranges of the Dinaric Mountains, Palagruža was already an island in pre-Pleistocene times. Today, seas that are 130 m deep at their shallowest and much deeper for the most part elsewhere surround Palagruža. Thus Palagruža must have been an island even when the sea was at its lowest, c. 120 m below its current level. Only Sušac and the lonely gabbro crag of Jabuka share with Palagruža the distinction of not having been connected to the mainland during the Last Glacial Maximum (Forenbaher 2002, fig. 1; van Andel 1989, 1990). It is therefore somewhat meaningless to talk about the 'first occupation' of the Adriatic islands: since they used to be part of the mainland, presumably they were inhabited as early as the rest of southern Europe. Judging from their archaeological records (e.g. Gaffney *et al*. 1997; Stančič *et al*. 1999), most of them continued to be occupied as they gradually became detached from the mainland between c. 15,000 and 5000 BC (Forenbaher 2002, fig. 2).

Palagruža may be an old island, but human activity there is a relatively recent phenomenon. Archaeological research on the island, which has included intensive surface survey, test – and area-excavations, has yet to encounter any evidence of human presence on Palagruža during the Late Upper Pleistocene or Early Holocene. It may be, of course, that archaeological sites of those periods once existed at some lower elevation(s) of what was then a much larger island, and were drowned by rising Holocene seas. The rocks that remain above water today would have been that island's least productive and least attractive part. Be that as it may, the earliest archaeological finds recovered from Palagruža to date are Early Neolithic Impressed Ware potsherds, and they may well be evidence for the first occupation of the island.

Located virtually at the centre of the Adriatic, Palagruža is that sea's most remote island (Figure 5.1). The closest landfalls in any direction are about 45 km away: the small island of Sušac to the north-northeast, and the tiny islet of Pianosa to the south-west, while mainland Italy (Monte Gargano) lies 57 km to the south. Just 1390 m long and 270 m wide, Palagruža is a rugged place, its cliffs and slopes plunging to the waves below (Figures 5.2 and 5.3). The island is made up of bedded limestone and breccia strata that are folded, knife-like, along an

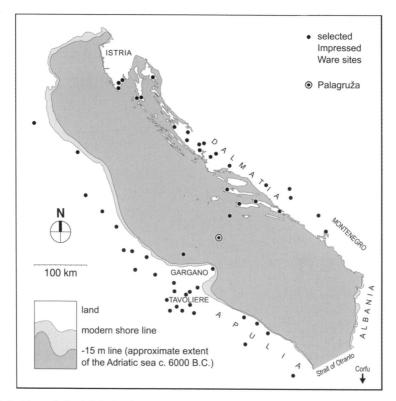

Figure 5.1: Map of the Adriatic showing Palagruža and other selected Impressed Ware sites

east-west ridge. There are two small plateaus indenting this ridge: Salamandrija in the middle and Jonkova njiva at the eastern extremity. Crowning Palagruža's highest point (103 m a.s.l.), a lighthouse anchors the island's western end. The north slope is steep, descending at 25-30° from Palagruža's spine to the water, whereas the south coast is a forbidding line of cliffs rising up to 90 m above the sea. These precipitous gradients continue underwater. The seafloor drops away from the island rapidly, leaving Palagruža surrounded by what are for the Adriatic abyssal waters, one hundred metres deep and more. Two coves with pebble beaches on the south-central and north-west coasts provide the only landing places. Across a narrow channel lies Palagruža's sister island, Mala Palagruža, surrounded by a number of rocks and reefs. Although it is only a fifth the size, Mala Palagruža's terrain is even more daunting.

Archaeologists have known about Palagruža since the late 19th century. The Italian archaeologist, Carlo de Marchesetti, and the English adventurer, Sir Richard Burton, visited the island together in 1873. They reported finding stone blades, broken pottery, and architectural fragments bearing Latin inscriptions (Burton 1879, 179; Marchesetti 1876, 287-289). This lead, however, was never really followed up by subsequent visitors (e.g. Petrić 1975), until a one-day visit in 1992 showed Marchesetti to have been entirely correct in observing that the island's past is unexpectedly rich. Since then, extensive archaeological investigation has been under way and is still in progress (Kaiser and Forenbaher 1999; Kaiser and Kirigin 1994; Kirigin and Čače 1998; Kirigin and Katunarić 2002). Fieldwork there has included a systematic surface survey of the two small islands, underwater reconnaissance to a depth of 25 m, a

number of test excavations, as well as a sub-surface survey by ground-penetrating radar and a major excavation of the island's central plateau, Salamandrija, where an area of about 150 sq m has been exposed so far. This work has brought to light prehistoric remains of the Early Neolithic, of the Late Copper Age and of the Early Bronze Age, as well as remains from the Classical Greek, Hellenistic, Early Roman, Late Roman, and Early Modern periods.

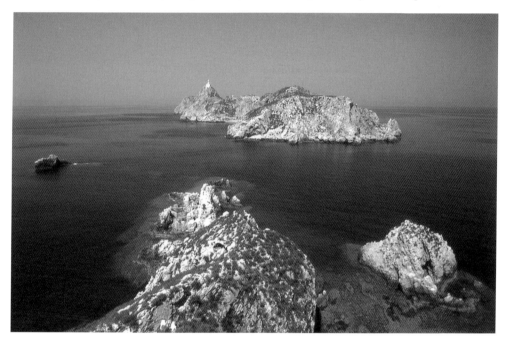

Figure 5.2: View of Palagruža from the summit of Mala Palagruža (looking towards WNW); the Early Neolithic site of Jonkova njiva is on the plateau immediately overlooking the chan-

Figure 5.3: Map of Palagruža and adjacent islets

Early Neolithic finds from Palagruža

Palagruža has so far yielded only a handful of finds that are unmistakably Early Neolithic. Four cardial impressed sherds were collected from the surface at Jonkova njiva, near the eastern end of the island (Figure 5.4, 1-3); we shall return to discuss these finds in some detail below. Another Early Neolithic sherd, decorated by impressions of a thin, flat object (perhaps the end of a broken blade), was picked up from the surface of the north-facing slope above the cove of Stara vlaka, near the opposite end of the island (Figure 5.4, 4). It is not like the other artefacts found nearby (a large, thin scatter of later prehistoric pottery and lithics), and were this sherd the only find of its kind on the island, we might have hesitated before attributing it to the Early Neolithic, but not in the light of the finds from Jonkova njiva.

Jonkova njiva ('Jonko's Field') is the second largest parcel of level terrain on the island. This 0.12 ha plateau is located at the island's eastern tip and is connected to the rest of the island by a knife-edge saddle called Tanko ('Slim'). Fifty-metre cliffs sheer away from the plateau on three sides and drop straight into the sea, barring any landing (Figure 5.5). The plateau dips slightly to the east, towards the cliffs, and is evidently in the process of being eroded away. It is partially encircled by portions of at least four low retaining walls, single and double courses of stone. Although their dates are unknown, they probably relate to the agricultural activities of the last few centuries.

After mapping, an intensive surface collection by 10 sq m was carried out in 1993, yielding a low density of Neolithic potsherds and lithics (0.1/sq m). Additional artefacts were collected from the same area during later informal visits to the site[1]. In order to determine whether there were further cultural materials or any archaeological features, six randomly placed one by one

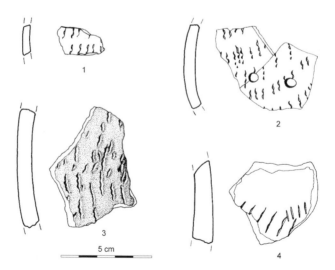

Figure 5.4: Impressed Ware potsherds from Palagruža; 1-3 Jonkova njiva, 4 north slope above Stara vlaka

[1] These may have been missed during the systematic surface collection due to the fact that it was carried out in the late spring, when relatively lush vegetation reduces ground visibility; subsequent visits took place in the late summer, when most of the vegetation is dry. Alternatively, progressive erosion may have exposed more artefacts.

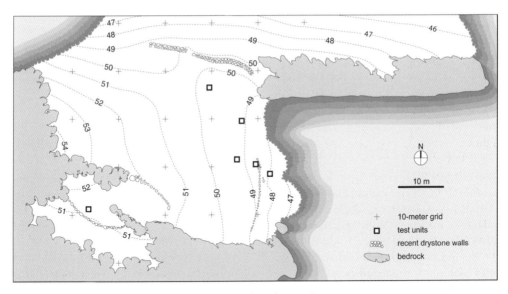

Figure 5.5: Plan of the Early Neolithic site of Jonkova njiva

metre test units were excavated (Figure 5.5). The results were disappointing. In none of the test squares did we find anything beyond a very low-density distribution of nondiagnostic pottery fragments and lithics. The excavated sediments consisted of 0.4–0.6 m of fine-grained soil lying upon bedrock. No features were encountered, except for the retaining wall abutting trench 40/41 that was already visible on the surface. Directly datable organic materials were not recovered. It is reasonable to conclude that apart from these few artefacts no other traces of the Early Neolithic use of this locality remain. Our discussion of what appears to have been the first landfall on Palagruža begins, therefore, with a handful of sherds.

The four cardial impressed sherds (two of which conjoin) represent parts of two pottery vessels. The first vessel (Figure 5.4, 1-2) was relatively fine and thin-walled, and apparently smaller compared to the second (Figure 5.4, 3), of which we have only a single sherd. Both have been decorated by multiple impressions of the edge of a *Cardium* shell that apparently extended across large areas of their surface and, in the first example, were roughly aligned in rows. Such archetypal stylistic attributes allow us to date these Impressed Ware sherds to the first half of the 6th millennium cal BC (Forenbaher 1999; Forenbaher and Miracle 2005). According to Müller (1994, 152-153), this particular kind of simple cardial decoration is entirely characteristic of an early phase of the eastern Adriatic Impressed Ware.

The chipped stone artefacts from Jonkova njiva are far less diagnostic of a particular block of time and space. Two dozen pieces altogether were recovered from uncertain contexts (surface or non-stratified sub-surface deposits), and we presume that they belong to the Early Neolithic because of the total absence of any diagnostic finds that would point to a later prehistoric occupation. A broad blade and a long blade core preparation flake (Figure 5.6), both made of chert, are of the same general appearance as other examples from Adriatic Neolithic contexts (compare with Bass 2004, fig. 4; Forenbaher 2006; Martinelli 1990). Little more can be said about their affinities, though, since post-Pleistocene lithic assemblages have received very little attention in the eastern Adriatic. These chipped stone pieces are unlikely to have been imports. Abundant sources of tabular and pebble chert exist on the neighbouring

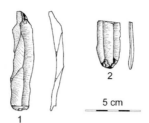

Figure 5.6: Selected lithics from Jonkova njiva

islet of Mala Palagruža. There, in many places, gaping holes mark the spots where chert was quarried. This exploitation may well have begun in the Neolithic. The two pieces from Jonkova njiva, which we take to belong to the Early Neolithic, are similar in colour and micro-texture as microcrystalline and cryptocrystalline radiolarian cherts from Mala Palagruža, and likely were quarried there (P. von Bitter, pers. comm.).

The few potsherds and lithic artefacts collected from the eroded surface of Jonkova njiva may look like evidence of only a very ephemeral occupation, especially when compared to sites with much more abundant finds on the islands that lie closest to Palagruža – Sušac (Bass 1998, 2004) and San Domino, Tremiti (Fumo 1980). It is remarkable that the main site on Palagruža, Salamandrija, at which activities were concentrated during all later periods, and which was surveyed in detail and extensively excavated (Kaiser and Forenbaher 1999; Kirigin and Katunarić 2002), has not yielded a single Early Neolithic potsherd. Appearances, however, may be deceptive. There is, for example, the likelihood that the topography of the island has changed considerably over the last 8000 years.

Salamandrija is today the largest flat area on Palagruža, centrally positioned immediately above the beach that provides the best opportunity for landing. In the past, however, the situation may have been quite different. Jonkova njiva occupies what is now only the second largest plateau, at the eastern end of the island. It is accessed with difficulty, along a narrow ridge with precipitous drops on both sides, and is completely surrounded by cliffs that plunge straight into the sea, providing no place for landing. During the Early Neolithic, however, the sea level was some 15 m lower than today (van Andel 1990), which means that the character of the shoreline (the distribution of cliffs and beaches at the sea level) may have been different. Furthermore, it is clear that the destructive force of the sea, which is extreme on this exposed island, erodes its flanks at a relatively rapid pace. We repeatedly observed small rock falls during our stay. Large blocks of limestone that recently tumbled from the cliffs litter the main south-facing beach, while during a particularly violent storm in the summer of 2004, many tons of rocks crashed into the west-facing cove of Stara vlaka, obliterating the trail that led into it. Oral tradition linked to a local place name, '*Pod Forane*' (meaning, literally, 'underneath the people from Hvar'), tells the story of a disastrous cliff collapse that, a few centuries ago, buried a number of fishermen from the island of Hvar, unfortunates who camped at the wrong end of the main beach.

It is therefore quite plausible that the plateau of Jonkova njiva was much larger during the Early Neolithic. At the time, it may have offered the largest flat area on the island, possibly close to beaches that now are drowned. That would help explain the otherwise somewhat curious absence of Early Neolithic finds at what became Palagruža's main site in later times. As the sea level rose, parts of the Jonkova njiva plateau would have been undercut by wave

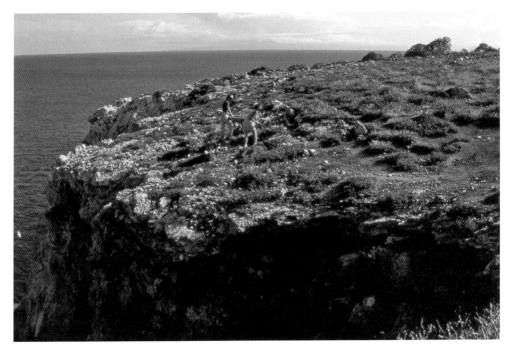

Figure 5.7: View of the Early Neolithic site of Jonkova njiva (looking from NNE); Gargano is just visible below the clouds in centre; most of the finds were recovered near the cliff edge

action and would have collapsed into the sea over the millennia. It is perhaps significant that most of the finds from Jonkova njiva were picked up from the eroded surface only a few metres away from the cliff edge of the plateau (Figure 5.7). This suggests that we may in fact be dealing with the last remains of a much more substantial Early Neolithic site.

Palagruža and the spread of farming

What brought people to Palagruža during the Early Neolithic? It would be hard to imagine that these two islets ever could have supported permanent settlers. Neither one has any source of fresh water, although modest amounts of rain at all seasons have been sufficient to support limited plant cover and a number of small animal species. Palagruža has little arable land – in the Middle Ages as much as 7 ha on the island's north slope may have been terraced for the cultivation of grain (Kovačić 1997) but still there were no permanent residents. What is more, the island is so small and craggy that even in prehistoric times it would not have provided much in the way of fuel resources. It would only have taken a few winters before those scant resources were depleted.

More likely, the Early Neolithic evidence reflects occasional visits and temporary occupations on the part of voyagers who may have been drawn by one or more of Palagruža's attributes. The island's main resource is the sea around it, which is one of the richest fisheries in the Adriatic (Županović 1993), but its systematic exploitation is a capital-intensive activity. The aquatic resources of the mid-Adriatic are normally beyond the means of a solitary fisher. Harvesting large schools of fish in the middle of the sea is an activity that requires nets, boats

and crews and is in this sense a capital-intensive endeavour. Although the details of Mediterranean shipbuilding before the 2nd millennium BC are sketchy, the carpentry skills, labour time, and raw materials necessary to fashion a moderately large watertight hull of wooden planks, eventually replete with masts and superstructures, represent a long-term investment. As such, deep-water fishing is unlikely to have been pursued in any serious fashion before hierarchically organised societies emerged in the Late Copper / Early Bronze Age – that is, before elites developed an interest in, and capacity for, the kind of capital accumulation necessary for such a venture (Gilman 1981, 7; Harding 2000, 181-185; Kaiser and Forenbaher 1999, 322). A relatively rich and accessible source of chert may have provided another incentive to visit the island. The most likely reason to visit Palagruža, however, was the island's strategic geographic position, its key location within any trans-Adriatic communications network.

Whenever possible, ancient Mediterranean sailors preferred not to stray too far from land, moving instead from headland to headland, island to island, as wind and currents permitted (Casson 1995). From this point of view, using Palagruža as a landfall made excellent navigational sense for anyone trying to cross the Adriatic (Bass 1998, 171; Kaiser and Kirigin 1994; Petrić 1975). Palagruža is the central island in a chain that spans the Adriatic. From Italy to Dalmatia, the islands of Tremiti, Pianosa, Palagruža, Sušac and Vis are stepping-stones across the sea. On a clear day you can see one island from the next; on some days even the mainland is visible. Offering anchorage, a modicum of shelter, and a place to rest, these islands have long attracted sailors and fishermen. A brief glance at a map of the Adriatic (Figure 5.1) makes the logic clear. By using the islands as stopping places, sailors could traverse the Adriatic in safe stages of a day's length or less, without losing sight of land. Palagruža is the keystone of this unique trans-Adriatic bridge. Indeed, ancient seafarers could hardly help but make Palagruža a port of call since two major currents – one easterly, the other westerly – converge on the island. Carried along by the current alone a boat would drift towards Palagruža.

This would have been of particular importance during the Early Neolithic, the period that witnessed the spread of farming in the Mediterranean. The introduction of the earliest domesticated animals and plants in the Adriatic can best be understood as a consequence of dispersal processes that ultimately involved sea-going immigrants who entered the Adriatic through the Strait of Otranto, and then moved north-west along its coasts and from island to island. Under such circumstances it is likely that navigational knowledge would have been at a premium. If the embarked pioneers of the Early Neolithic made effective use of the Adriatic's intricate sea-lanes then Palagruža would have often been a welcome sight on the horizon.

It is now beyond question that the main domesticates associated with the Early Neolithic in Mediterranean Europe (sheep, goats and wheat) were introduced into the region from western Asia (Demoule 1993; Rowley-Conwy 2003; Zohary and Hopf 1993). Since it seems unlikely that these species would have moved into the region without human involvement, we must consider at least some form of population transfer during the Mesolithic-Neolithic transition. A growing body of genetic evidence supports this assumption (Richards *et al.* 2002). The transition to farming in Europe has been explained by a wide variety of models, ranging from those that rely primarily on migrating farmers (e.g. Ammerman and Cavalli-Sforza 1984) to those that highlight the contribution of Mesolithic foragers (e.g. Tringham 2000; Zvelebil 2002). At the regional (Adriatic) level, most of the explanations that have been put forward over the last decade take into account primarily the migrating farmers, while acknowledging a greater or lesser contribution by autochthonous foragers (Bass 2004; Forenbaher 1999;

Müller 1994). One of the reasons for the explanatory emphasis on incoming agro-pastoralists is the scarcity of information about Late Mesolithic hunter-gatherers, especially in the eastern Adriatic. An exception is Budja's model that envisions an autochthonous population taking up a limited number of innovations, but rejects the possibility of any form of migration (Budja 1999). Nonetheless, today it is clear that the Mesolithic-Neolithic transition can no longer be considered in simple dichotomous terms such as acculturation vs. colonisation.

Other generalisations are more enduring. One such, at least in the eastern Adriatic, is the assumption that the earliest pottery accompanies the spread of farming. Domestic animals do indeed dominate faunal assemblages associated with Early Neolithic pottery in open-air sites. The pattern is much more variable in caves. At some caves domestic animals dominate the assemblages, while at others the appearance of pottery is associated with mixed (wild and domestic) assemblages, or assemblages dominated by wild taxa. There are always, however, at least a few remains of domestic animals that appear along with the first pottery whenever and wherever the earliest ceramics show up in the region (for a comprehensive overview of the evidence see Forenbaher and Miracle 2005 and 2006). Thus one can safely use the appearance of pottery (be it Impressed Ware, or other wares at the north-west end of the Adriatic) as a proxy for the appearance of herding, and possibly also of cereal cultivation, although direct evidence for the latter is still slim (Chapman and Müller 1990, 129-132).

The geographic distribution of Early Neolithic Impressed Ware sites (Figure 5.1) strongly suggests that sea was the main avenue by which immigrants, domesticates, and other innovations were dispersed. Furthermore, the earliest radiocarbon dates for pottery on both sides of the Adriatic grow progressively younger from south-east to north-west (Forenbaher 1999, 526-527; Skeates 2003, 169-172), suggesting that new technologies and subsistence strategies entered the region through the Strait of Otranto shortly before 6000 cal BC and reached the head of Adriatic some five hundred years later. They also suggest that this dispersal was rapid in the southern Adriatic and slower in its northern part.

Recently, Forenbaher and Miracle proposed a two-stage model of the spread of farming along the eastern Adriatic coast (Forenbaher and Miracle 2005). According to this model, the initial stage involved a very rapid dispersal, perhaps by 'leapfrog colonisation' (Zvelebil and Lillie 2000, 62), and is associated with the cave sites of southern Dalmatia. The second stage comprised a slower agro-pastoral expansion and is associated with both cave and open-air sites along the eastern Adriatic littoral. During this second stage also, in the mountainous hinterland, indigenous groups may have adopted farming via processes collectively termed 'individual frontier mobility' (Zvelebil and Lillie 2000, 62).

According to this model, pottery associated with some domestic animals, but not the complete Neolithic package, appears around 6500 cal BC among local hunter-gatherers at Sidari on the Ionian island of Corfu, just south of the Strait of Otranto (Sordinas 1969, 401, 406, note 14). Some 300 year later, a new way of making and decorating pottery known as Impressed Ware appears at Sidari, alongside other novel technologies and a full suite of domestic animals (Perlès 2001, 49-50). Impressed Ware and domestic animals spread rapidly north along the coastline of the southern Adriatic, probably through a process of directed, or intentional, colonisation. It is hypothesised that groups of food producers settled new regions after having carefully planned and organised their moves, traversing long distances rapidly with only short rest stops along the way. This is consistent with processes observed earlier in the Aegean. Thus, for example, Crete was colonised from Anatolia before the intervening islands were settled (Broodbank 1999). These seagoing pioneers, Perlès and others have

argued, were small groups of risk-taking men and women, 'who did not carry, possess or choose to retain the whole technical and cultural heritage of their original communities' (Perlès 2001, 62). In the first stage of the introduction of food production and pottery use, the initial movement of exploratory groups in the eastern Adriatic may have lasted 100 years or less. Palagruža, like the other islands of southern and central Dalmatia, is well within the ambit of these Early Neolithic maritime explorers.

Shortly thereafter, there is evidence for indigenous hunter-gatherers taking up ceramics in the hinterland of the southern Adriatic, as well as the continued movement north of Impressed Ware pottery. In this second phase of expansion people may have started making more permanent settlements, settling down and farming, bringing together all of the elements of the Neolithic package (Forenbaher and Miracle 2005). The rate of spread slowed considerably, however, and Impressed Ware only reached the southern tip of Istria by about 5750 cal BC. By the time farming appears in northern Istria and neighbouring Slovenia and the Trieste Karst, perhaps 100 years later, it is associated with Middle Neolithic (Danilo/Vlaška) pottery (Forenbaher *et al*. 2004).

How does this relate to contemporary developments on the western coast of the Adriatic? The earliest reliable dates for western Adriatic Impressed Wares fall around the year 6000 cal BC and come from open air sites in and around the Tavoliere (Skeates 2000, 163-166). The most direct route from Corfu to the Tavoliere is across the Strait of Otranto and up the Apulian coast, but the currently available radiocarbon dates do not support this hypothesis. In fact, the dates for the earliest pottery gradually become *younger* as one moves either up or down the coast away from the Tavoliere (Skeates 2003, 169-171).

This raises an interesting possibility. The Tavoliere may be considered a hinterland of Monte Gargano, which lies straight across the sea from Palagruža. Might there have been a direct connection? Impressed Ware pottery may have reached the western coast of the Adriatic via a circuitous route that led along the coasts of Albania and Montenegro, the southern Dalmatian islands, and then via Sušac and Palagruža to Gargano. The dating evidence at hand does not contradict this hypothesis, since the earliest dates for Impressed Wares in southern Dalmatia are just as early as those in the Tavoliere (Forenbaher 1999; Forenbaher and Miracle 2005). On the other hand, the dating evidence does not directly support the hypothesis either, since there are no dated Impressed Ware sites along the crucial stretch of the eastern Adriatic between northern Greece and southern Dalmatia. In other words, the currently available dates do not allow us to decide whether Impressed Ware reached Italy from Dalmatia, or vice versa.

Another possibility (which we consider less likely) is that the Adriatic Impressed Ware actually originated in the central Adriatic (the area which includes the Tavoliere and southern Dalmatia), and spread north-west and south-east along both sides of the Adriatic. In that case, the early date for Impressed Ware from Sidari would have to be rejected, as would the two-stage model of its spread from Corfu (Forenbaher and Miracle 2005). Chronometric dating of the earliest pottery in coastal Montenegro and Albania may prove crucial for testing this hypothesis. Regardless of which of these scenarios eventually prevails, one thing is already certain: in either of them, the tiny islet of Palagruža must have played a pivotal role.

The finds from Palagruža demonstrate that during the Early Neolithic (some) people had sufficient seafaring skills and technology to enable them to move goods, ideas, and other people in a rapid fashion over long stretches of open water. One can easily imagine how

important the ability subsequently became. Since everything we know about the first farmers suggests that they lived in small groups, it is likely that they would have actively sought to maintain ties with one another as a kind of social insurance policy. And since in the eastern Adriatic overland communication is very difficult, maritime links would have been a good way to preserve the connections between communities struggling to make food production a viable way of life. Thanks in part to their use of Palagruža and other similar islands, the seaborne agro-pastoralists of the Adriatic Neolithic were in the end successful.

References

AMMERMAN, A.J. and CAVALLI-SFORZA, L.L. 1984: *The Neolithic transition and the genetics of populations in Europe* (Princeton).

BASS, B. 1998: Early Neolithic offshore accounts: remote islands, maritime exploitations, and the trans-Adriatic cultural network. *Journal of Mediterranean Archaeology* 11 (2), 165-190.

BASS, B. 2004: The maritime expansion of Early Neolithic agro-pastoralism in the eastern Adriatic sea. *Atti della Società per la Preistoria e Protostoria della regione Friuli-Venezia Giulia* 14, 45-60.

BROODBANK, C. 1999: Colonization and configuration in the insular Neolithic of the Aegean. In Halstead, P. (ed.), *Neolithic society in Greece* (Sheffield, Sheffield Studies in Aegean Archaeology 2), 15-41.

BUDJA, M. 1999: The transition to farming in Mediterranean Europe – an indigenous response. *Documenta Praehistorica* 26, 119-141.

BURTON, R.F. 1879: A visit to Lissa and Pelagosa. *Journal of the Royal Geographical Society* 44, 151-190.

CASSON, L. 1995: *Ships and seamanship in the Ancient World* (Baltimore).

CHAPMAN, J.C. and MÜLLER, J. 1990: Early farmers in the Mediterranean basin: the Dalmatian evidence. *Antiquity* 64, 127-134.

DEMOULE, J.-P. 1993: Anatolie et Balkans: la logique évolutive du néolithique égéen. *Anatolica* 19 (Roodenberg, J. (ed.), *Anatolia and the Balkans*), 1-13.

FORENBAHER, S. 1999: The earliest islanders of the eastern Adriatic. *Collegium Antropologicum* 23, 521-530.

FORENBAHER, S. 2002: Prehistoric populations of the island of Hvar: an overview of archaeological evidence. *Collegium Antropologicum* 36, 361-378.

FORENBAHER, S. 2006: Flaked stone artefacts. In Miracle, P.T. and Forenbaher, S. (eds.), *Prehistoric herders in Istria (Croatia): the archaeology of Pupićina Cave, Volume 1* (Pula), 225-257.

FORENBAHER, S. and MIRACLE, P.T. 2005: The spread of farming in the eastern Adriatic. *Antiquity* 79, 514-528.

FORENBAHER, S. and MIRACLE, P.T. 2006: Pupićina Cave and the spread of farming in the eastern Adriatic. In Miracle, P.T. and Forenbaher, S. (eds.), *Prehistoric herders in Istria (Croatia): The archaeology of Pupićina Cave, Volume 1* (Pula), 483-530.

FORENBAHER, S., KAISER, T. and MIRACLE, P.T. 2004: Pupićina Cave pottery and the Neolithic sequence in northeastern Adriatic. *Atti della Società per la Preistoria e Protostoria della regione Friuli-Venezia Giulia* 14, 61-102.

FUMO, P. 1980: *La preistoria delle Isole Tremiti* (Campobasso).

GAFFNEY, V., KIRIGIN, B., PETRIĆ, M., VUJNOVIĆ, N. and ČAČE, S. 1997: *Arheološka baština otoka Hvara, Hrvatska / The Archaeological Heritage of Hvar, Croatia* (Oxford, BAR International Series 660).

GILMAN, A. 1981: The development of social stratification in Bronze Age Europe. *Current Anthropology* 22, 1-23.

HARDING, A. 2000: *European societies in the Bronze Age* (Cambridge).

KAISER, T. and FORENBAHER, S. 1999: Adriatic sailors and stone knappers: Palagruža in the 3rd millennium B.C. *Antiquity* 73, 313-324.

KAISER, T. and KIRIGIN, B. 1994: Palagruža, arheološko srce Jadrana. *Arheo* 16, 65-71.

KIRIGIN, B. and ČAČE, S. 1998: Archaeological evidence for the cult of Diomedes in the Adriatic. *Hesperìa, Studi sulla grecità di occidente* 9, 63-110.

KIRIGIN, B. and KATUNARIĆ, T. 2002: Palagruža- crkva Sv. Mihovila: izvještaj sa zaštitnih iskopavanja 1996. *Vjesnik za arheologiju i historiju dalmatinsku* 94, 297-324.

KOVAČIĆ, J. 1997: Palagruža od 12. do 20. stoljeća. *Prilozi povijesti otoka Hvara* 10, 39-47.

MARCHESETTI, C. 1876: Descrizione dell'isola di Pelagosa. *Bolletino della Società adriatica di scienze naturali (Trieste)* 3 (3), 283-306.

MARTINELLI, M.C. 1990: Industrie litiche di alcuni siti neolitici della Dalmazia e loro raffronti con contemporanee industrie dell'Italia sud-adriatica e delle Isole Eolie. *Rassegna di Archeologia (Firenze)* 9, 125-151.

MÜLLER, J. 1994: *Das Ostadriatische Frühneolithikum: Die Impresso-Kultur und die Neolithisierung des Adriaraumes* (Berlin).

PERLÈS, C. 2001: *The early Neolithic in Greece: the first farming communities in Europe* (Cambridge).

PETRIĆ, N. 1975: Palagruža (Pelagosa)- arheološki most Jadrana. *Arheološki pregled* 17, 171-173.

RICHARDS, M.R., MACAULAY, V. and BANDELT, H.-J. 2002: Analyzing genetic data in a model-based framework: inferences about European prehistory. In Bellwood, P. and Renfrew, C. (eds.), *Examining the farming/language dispersal hypothesis* (Cambridge), 459-466.

ROWLEY-CONWY, P. 2003: Early domestic animals in Europe: imported or locally domesticated? In Ammerman, A.J. and Biagi, P. (eds.), *The widening harvest* (Boston), 99-117.

SKEATES, R. 2000: The social dynamics of enclosure in the Neolithic of the Tavoliere, South-east Italy. *Journal of Mediterranean Archaeology* 13 (2), 155-188.

SKEATES, R. 2003: Radiocarbon dating and interpretations of the Mesolithic-Neolithic transition in Italy. In Ammerman, A.J. and Biagi, P. (eds.), *The widening harvest* (Boston), 157-187.

SORDINAS, A. 1969: Investigations of the prehistory of Corfu during 1964-1966. *Balkan Studies* 10, 393-424.

STANČIČ, Z., VUJNOVIĆ, N., KIRIGIN, B., ČAČE, S., PODOBNIKAR, T. and BURMAZ, J. 1999: *The archaeological heritage of the island of Brač, Croatia* (Oxford, BAR International Series 803).

TRINGHAM, R.E. 2000: Southeastern Europe in the transition to agriculture in Europe: bridge, buffer, or mosaic. In Price, T.D. (ed.), *Europe's first farmers* (Cambridge), 19-56.

VAN ANDEL, T.H. 1989: Late Quaternary sea-level changes and archaeology. *Antiquity* 63, 733-745.

VAN ANDEL, T.H. 1990: Addendum to Late Quarternary sea-level changes and archaeology. *Antiquity* 64, 51-52.

ZOHARY, D. and HOPF, M. 1993: *Domestication of plants in the Old World: the origin and spread of cultivated plants in West Asia, Europe, and the Nile Valley* (Oxford, 2nd edition).

ZVELEBIL, M. 2002: Demography and the dispersal of early farming populations at the Mesolithic-Neolithic transition: linguistic and genetic implications. In Bellwood, P. and Renfrew, C. (eds.), *Examining the farming/language dispersal hypothesis* (Cambridge), 379-394.

ZVELEBIL, M. and LILLIE, M. 2000: Transition to agriculture in eastern Europe. In Price, T. D. (ed.), *Europe's first farmers* (Cambridge), 57-92.

ŽUPANOVIĆ, Š. 1993: *Ribarstvo Dalmacije u 18. stoljeću* (Split).

Subsistence, mechanisms of interaction and human mobility in the Neolithic western Mediterranean: the nature of the occupation of Lipari (Aeolian islands, Sicily)

Elena Flavia Castagnino Berlinghieri

Introduction

This paper explores key issues relating to the great transformations which affected the cultures of the western Mediterranean area at the end of the 6th millennium BC, the appearance of the first communities, of farmers and/or seafarers, on the island of Lipari, and their involvement in contact and exchange (Castagnino Berlinghieri 1997). It was a time period that saw the first movements of people, goods and ideas (McGrail 1996), and it was marked by significant changes for societies passing from a subsistence economy based on hunting and gathering (Upper Palaeolithic – Mesolithic) to one based on herding, farming and seafaring (Neolithic).

The well-investigated Neolithic sequence on Lipari (Bernabò Brea and Cavalier 1957), coupled with the growing number of laboratory analyses, mainly from prehistoric coastal sites in north-west Sicily (Mannino and Thomas 2007) that are used as an analogy, provide the framework for understanding subsistence, mobility and settlement systems on Lipari.

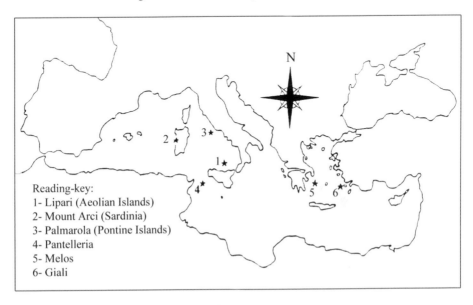

Reading-key:
1- Lipari (Aeolian Islands)
2- Mount Arci (Sardinia)
3- Palmarola (Pontine Islands)
4- Pantelleria
5- Melos
6- Giali

Figure 6.1: Sources of obsidian in the Mediterranean

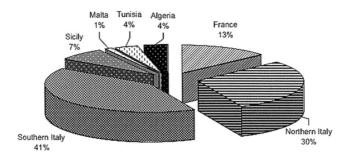

Figure 6.2: Comparison between geographical areas characterised by the occurrence of obsidian from Lipari and Mount Arci. Northern Italy includes also Dalmatia; Sicily includes the adjacent islands (Data derived from Leighton 1999; Tykot 1996)

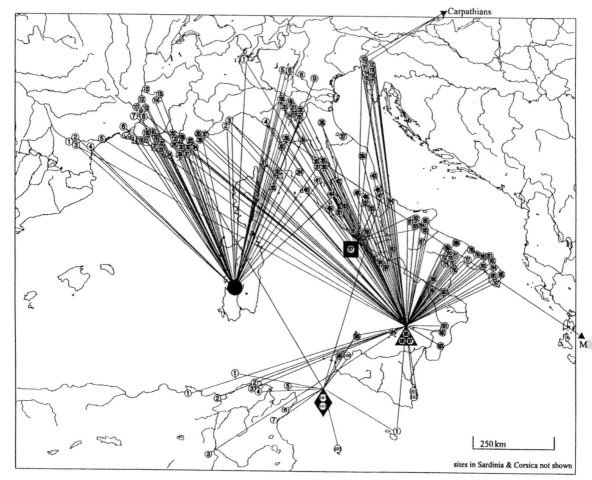

Figure 6.3: Obsidian distribution in the central and western Mediterranean: source determinations by chemical, physical or visual analysis (from Tykot 1996, fig. 10)

There is no doubt that the Aeolian islands would have figured much less in Mediterranean prehistory had it not been for the occurrence of one extraordinary circumstance: the presence of obsidian, the volcanic, black, sharp glass very much in demand before the development of metal technology. Laboratory analyses (Tykot and Ammerman 1997) show that the Lipari obsidian had a wider distribution in the Central Mediterranean than the few other sources (Figures 6.1 and 6.2), which were of poorer quality and more limited quantity (Figure 6.3). GIS models indicate that obsidian was primarily transported coastally by sea (Robb and Tykot 2002).

The fate of the Aeolian islands has been intimately connected since prehistory with the volcanic activity on the islands of Lipari and Vulcano, which has resulted in both prosperity and calamity. Geological and maritime data suggest that notable environmental transformations have deeply and repeatedly altered the land as well as the coastlines of Lipari. Apart from eruptions that occurred in geological time, which are of less significance archaeologically, the creation of obsidian flows on Lipari is connected to two main eruption events. The first, datable to between 8000-7000 BC, re-shaped part of the north-eastern area of the island and produced the obsidian flow of Lami Pomiciazzo-Gabellotto (Figure 6.4a). The later medieval eruption, between AD 650-850 produced the formation of the pumice cone of Monte Pelato and emitted the obsidian flows of Rocche Rosse and Forgia Vecchia (Figure 6.4b); it also covered part of the Gabellotto area and its Neolithic landscape.

The research strategy adopted in this paper is to combine archaeological, geological, palaeoenvironmental and ethnological data, in an attempt to evaluate the ways in which human populations responded to the geological instabilities of the landscape, both in terms of

Figure 6.4: Sketch map showing the sources of obsidian on Lipari and the area of Castellaro Vecchio Early Neolithic settlement on Quattropani. (A) flow of obsidian that occurred during the Prehistoric eruption; (B) flow of obsidian that occurred during the Medieval eruption

their subsistence base and their mechanisms of interaction. The effect of geological instabilities is particularly pertinent in the volcanically active environment of Lipari. Of relevance are also issues relating to how sailors reached the Aeolian islands and how the islands welcomed these sailors. This approach works best by examining the dynamic nature of the maritime dimension of the islands. This paper will illustrate how far removed these islands are from the concept of the island metaphor, as isolated cultures 'sheltered from some of the competitive pressure of life...at the expenses of isolating their living communities' (Evans 1973; *contra* Rainbird 1999, 2007). On the contrary, the cultural role of the known Early Neolithic sites on the islands of Lipari (Castellaro Vecchio) and Salina (Rinicedda) suggests long-term fluctuations in social relationships and external interactions. The following research questions will be addressed in this paper:

1. Can 'the role of the sea' be approached in a different way than from an insular or non-insular viewpoint?
2. Why did certain people decide to reach the shores of the Aeolian islands and then choose to settle there?
3. Were the first settlers from specialised seafaring communities or from cultures based on farming, which learnt to exploit the fertile volcanic soil together with obsidian?
4. How did the obsidian from Lipari, which was apparently managed by land-based island communities, reach far-off places?

Can 'the role of the sea' be approached in a different way than from an insular or non-insular viewpoint?

Over the last decades a plethora of archaeological and anthropological research have discussed the role of the sea in islands in prehistory, mainly questioning whether it acts as a barrier or a bridge (Baldacchino 2007). This has led to concepts such as boundary-isolation or wide-inter-

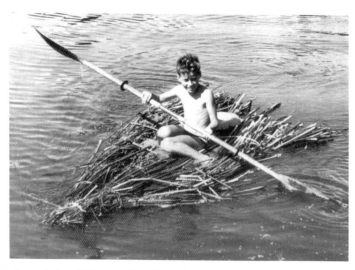

Figure 6.5: Raft made by children of bundles of sedges which was photographed by Wolfgang Rudolph in 1972

action, the sea respectively discouraging or encouraging human exchange. This debate faces two problems to be confronted simultaneously: the 'mariner's perspective' and the 'mainland viewpoint'. From a 'mariner's perspective' it is easier to appreciate the 'bridge' role of the sea, whereas a 'mainland viewpoint' (Hunter 1994) would suggest a sort of liquid barricade tricky to cross, requiring powers of navigation, perception, exploitation of marine agencies, and identification of key landmarks.

There is a lack of direct evidence for sea transport during the Neolithic in terms of wooden structures or underwater wrecked bulks. However, the study of maritime activity and exchange systems in early societies has been an essential component of theoretical models of trade, whose aim was the reconstruction of the circulation of various goods (Renfrew 1975, 1977, 1993). The use of ethnographic analogies as a means to explaining the exchange of prehistoric goods has stimulated discussions of broader social issues (Renfrew 1984) and has provided a great potential for a better evaluation of the context, meaning and circulation of goods.

This is apparent in the following brief discussion of two selected ethnographic cases of ship-like craft made out of naturally floating materials, which were potentially similar to those available on the Aeolian islands. The first ethnographic case is from Überkmünde on the Oderhaff (Figure 6.5) of a boat-like vessel in the form of a very simple raft made by children from bundles of sedges; it was photographed by Wolfgang Rudolph (1974). The second example is a form of raft called 'kadai' which is in use in the village of Buduma-Yidena in Chad (Figure 6.6). It is a solid raft made of bundles of papyrus able to carry two people together with other items (Basile and Di Natale 1994). It can take up to six tons of bulk load and is always equipped with a cooking facility (Figure 6.7). The people on board, presumably wife and husband, belong to the caste of the fishermen of *Buduma*, who are widely renowned for their excellent craftsmanship in building rafts and fishnet making, as well as for producing pottery and textile fabrics. Also of great interest is a drawing made during the 16th century by

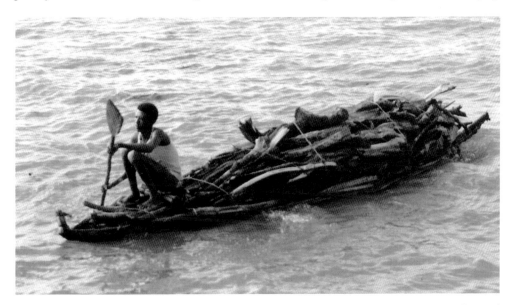

Figure 6.6: Raft made of bundles of papyrus *called a 'kadai' which is in use in the village of Buduma-Yidena on Lake Chad (from Basile and Di Natale 1994)*

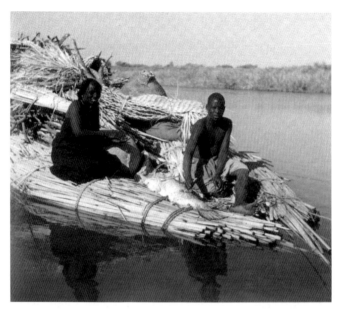

Figure 6.7: Raft made of bundles of papyrus *loaded with a cargo of wood on Lake Tana (from Basile and Di Natale 1994)*

Theodor de Bry which shows a raft (Figure 6.8) from Perù made of coupled pumpkin shells (Rudolph 1974).

These few ethnographic examples demonstrate how even very simple shapes of floating items can provide a means of water transport for people and goods. While these simple forms of watercraft offer examples of inland water transport, a similar setting with seamen travelling within sight of land suggests a simple and easy shipping system created from readily available materials. However, sea currents placed their demands on early navigation, as discussed in relation to Lipari below. Hence, the relatively late appearance of wooden boats in the Mediterranean sea-transport records (Bronze Age) was an extension of a pre-existing system of mobility across the sea (Castagnino Berlinghieri 2003a). Their existence is extremely

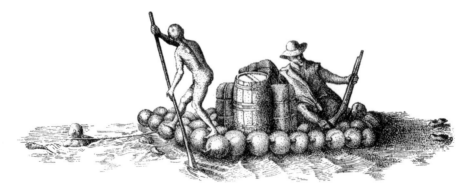

Figure 6.8: Drawing made during the 16th century by Theodor de Bry which shows a raft from Perù made of coupled pumpkin shells

important in estimating the character of maritime activity and tracing the nature of seafaring and beach-gathering cultures. In each case the types of vessels depend also on local meteorological conditions and cultural background.

In recent years, increasing attention has been paid to the role of seafaring in the creation of social alliances and identity as an essential component of relationships related to maritime activity (Broodbank 2006; Farr 2006). This type of approach had led previously to the creation of fresh concepts such as 'insular biogeography' (Evans 1973), 'maritime cultural landscape' (Parker 2001; Westerdahl 1992), or 'archaeology of maritime identity' (Boomert and Bright 2007, 18; cf. Fitzpatrick *et al.* 2007, 229); and of the original field of research of 'island archaeology'. At the same time, new studies have focused on the nature of coastal environments as characterised by significant heterogeneity and instability on a number of spatio-temporal scales (Westley and Dix 2006), and have introduced notions of sea level changes (e.g. Bailey 2004; Bailey and Whittle 2005; Flemming 1968), submerged landscapes (see recently Benjamin *et al.* 2011; Castagnino Berlinghieri *et al.* 2008) or 'transported landscapes' (Gosden and Head 1994; Phoca-Cosmetatou 2008).

All these approaches have been taken into consideration in our study of people's navigation to the Aeolian islands and of the dynamic nature of the maritime dimension of the islands, in order to gain an overall picture of people's movement across the sea. The significance of phenomena such as the spatial distribution of obsidian from Lipari cannot be grasped by linking on a map several archaeological sites across the Aeolian islands or by simply considering their material similarities, even over long distances. A study of the wider context is required. Going beyond the archaeological evidence, we need to approach simultaneously both the 'mariner's' and 'mainland' perspectives in order to understand the complex web of social relationships, and thus place the emphasis on human interactions. In this respect, Braudel's classification (1972) of the island as an 'île conservatoire' may perhaps hold true for a single island itself, far away from the mainland, but not for an archipelago as a whole such as the Aeolian islands. In fact, evidence considered here shows that the key to the Aeolians' vivid dynamism lay in the nature of the archipelago itself: spread across seven islands, blessed with the presence of natural resources in a remarkable maritime landscape, and located along a principal sailing route for people, goods and ideas.

The overriding impression (Figure 6.9) regarding the role of the first communities attested to on the Aeolian islands is one of great cultural interaction during the Early-Middle Neolithic

PERIOD	YEARS BC	RADIOCARBON DATES C14 Age BC	KEY SITES AEOLIAN ISLADS	KEY SITES SICILY
EARLY - MIDDLE NEOLITHIC	6000	none	CastellaroVecchio/Lipari Rinicedda/Salina	Stentinello Matrensa Ognina Megara Iblea
MIDDLE - LATE NEOLITHIC	5000	5200 ± 60	Serra d'Alto Lipari Acropolis	Stentinello Matrensa Ognina Megara Iblea
LATE NEOLITHIC	4000	4885 ± 55	Diana Spatarella Lipari Acropolis	Matrensa Ognina Megara Iblea

Figure 6.9: Simplified Neolithic sequence from the Aeolian islands and Sicily (data based on Bernabò Brea and Cavalier 1980; Leighton 1999; Robb 2007)

periods, and further increasing during the Late Neolithic Diana period (Figures 6.2 and 6.3). Although early long-term frequentation of Castellaro Vecchio is linked to a subsistence base bounded more with agricultural activity than with maritime involvement, the 'role of the sea' within the Neolithic economy of Lipari, along with its relationships with the central Mediterranean regions, argues for a 'bridge' function which operated on long-term patterns of social interactions and extra-insular contacts.

Why did certain people decide to reach the shores of the Aeolian Islands and then choose to settle there?

From a 'mariner's perspective' it seems reasonable to assume that the Aeolian islands were considered special not merely for the presence of obsidian but mainly for their specific insular properties and their distinctive maritime landscape in the middle of the lower part of the Tyrrhenian sea. This location was of considerable significance in the orientation of seafarers crossing the southern Tyrrhenian sea. Since mankind started crossing the sea, the Aeolian islands have represented a landmark of the greatest importance (Castagnino Berlinghieri 2003b). Early navigation was achieved only through a 'mental chart' (McGrail 1991, 97) constructed from each mariner's personal experience and knowledge inherited as part of a seafaring culture. The basic business of directing a craft from one point to another led people to find their way across the sea beyond the bounds of the established maritime environment. The Vulcano and Stromboli islands can be seen from a very long distance not only due to the high elevation of Monte Aria (500 m) on Vulcano and Pizzo Grande (924 m) on Stromboli, but also because of the volcanic activities which were, and still are, active. The identification of such key landmarks represented precious signs to every sailor. It is worth noting that in water-borne societies nowadays around the world, the use of such landmarks, even when sailing on rafts or paddle-propelled dugouts, continues to be connected with living folklore and ritual ceremonies. Although the relationships between maritime knowledge, geographical locations and literary sources are still a matter of continuing debate (de Jong 2001; Emlyn-Jones *et al.* 1992) it is interesting to note the use of landmarks as reference points for navigation in Homer's *Odyssey* (Pagliara 1995). When Circe, the powerful sorceress of mythology, was suggesting to Odysseus the two possible maritime routes following the 'island of the Sirens', she describes what has been identified (Butler 1922) to the Aeolian islands as a 'very high cliff on one side, the strong waves belong to the bluish Amphitrites, on the other side…the seas' waves together with the ill-fated violent fire, use to destroy ships and people'.[1] This brief passage could thus be regarded as a modern 'portolano', supplying meteorological and sea information and likely based on genuine mariners' accounts. The three main features of the islands, which are identifiable when approaching from a 'mariner's perspective', are highlighted: high cliffs, which constitute the nature of the coastal profile thus rendering it unfavourable for landing; waves, which are usually a strong marine condition; and volcanic eruption, a factor of destruction as well as a clear sign visible from far away. Despite all of this, the coasts of the Aeolian islands are, actually, relatively kind to mariners sailing across the South Tyrrhenian. Among the seven islands, characterised by many smaller inlets along the coast, there are a few bays and moderately safe beaches where ships could shelter in the lee of land in inclement weather; good depths of water close to land and a breeze from the shore all help to reassure, but also

[1] Odyssey, XII, 55-68

sometimes set an inescapable trap for, the sailors. Moreover the South Tyrrhenian sea is characterised by a great number of local winds, generally unpredictable in strength and duration, such as the extremely dangerous 'Scirocco di San Bartolo' blowing from the south-east.

Less than 25 km divided the southern part of Vulcano from Capo Milazzo on the north coast of Sicily. These short distances linking the Aeolian islands with the north coast of Sicily allow for navigation within visibility of land. On the other hand, more than 50 km divide Stromboli from Capo Vaticano, the nearest point off the Italian peninsula in Calabria. This is, conceivably, a considerable distance that was not readily negotiable, and certainly not without difficulty. In the Aegean archipelago, albeit a bigger one than the Aeolian but also characterised by numerous scattered islands with highlands, promontories, distinct cliffs, and flat shores, attention to the maritime topography would have allowed navigation with land constantly in sight (Agouridis 1997). In such conditions, in the Aegean as in the Aeolian archipelagos, seafaring people would had developed techniques for navigation across the sea, which would have always been adapted to the maritime topography and landmarks. It may be hypothesised (Castagnino Berlinghieri 2003b) that people, with rafts or other kinds of ship-like means of water crossing, were able to reach the coast of the Aeolian islands by crossing the sea propelled by the currents and southerly winds.

From a 'mainland perspective' it is appropriate to examine the factors that might have attracted people to the Aeolian islands. This will help establish the notion of choice of settlement in a broader context, and further highlight the environmental complexity of the islands. The Early Neolithic was a transitional phase between the hunter-gathering and agricultural way of life. In the context of this transition, the choice of settling on Castellaro Vecchio (Figure 6.10), a site located on the high plateau of Quattropani on Lipari (450 m a.s.l.), would have been dictated by practical criteria, including plant and animal habitats, raw material availability and climate (Castagnino Berlinghieri 2002a, 2002b).

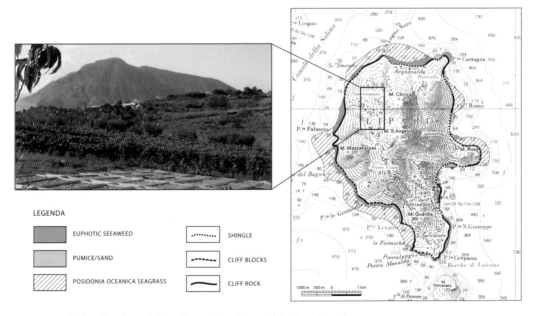

LEGENDA

▩ EUPHOTIC SEEAWEED	·········· SHINGLE
▦ PUMICE/SAND	- - - - - CLIFF BLOCKS
▨ POSIDONIA OCEANICA SEAGRASS	⌒ CLIFF ROCK

Figure 6.10: The site of Castellaro Vecchio and its local setting

Castellaro Vecchio currently constitutes the first evidence for a long-term frequentation of Lipari (Bernabò Brea and Cavalier 1960, 1968, 1980; Cavalier 1979). The site is located on the higher north-western area of the island (Figure 6.10), a position apparently deliberately chosen on top of the tableland: a plateau of about 2 sq km of land (Cavalier 1979), characterised by light soils and water supplies, was occupied by an estimated maximum population of some hundreds (Robb 2007). Indeed, Castellaro Vecchio seems to occupy a strategic position with fertile and well-watered fields with nearby obsidian sources. The quality of the Timpone Pataso region, well-endowed with floral and faunal resources, located on Quattropani, would have probably played a role in the choice of settling there. The old river basin guarantees very rich soils, while the spring offers natural water supply and good environment for plant life.

Given the absence of faunal and floral data from Neolithic levels due to the oxidation of the sediments (Villari 1997), prints of plant remains, although indirect evidence, are currently the only significant samples of palaeobotanical data recovered in archaeological levels. Prints of branches have been preserved in numerous plaster assemblages found both inside and outside the Middle Neolithic huts discovered on Lipari and Salina (Bernabò Brea and Cavalier 1995, 33; Castagnino Berlinghieri 2002b, 2003b). Prints of plant remains, such as palms, olive leaves, and small fragments of arboreal species, are documented on the old river basin of the Timpone Pataso area. Today the area constitutes one of the most fertile fields on Lipari and is prosperously planted with vineyards (Figure 6.10); the area still contains an abundance of obsidian pieces spanning from small fragments of debitage to entire artefacts such as rasping tools or blades.

Along with good quantity obsidian (Figure 6.11), a feature of Castellaro Vecchio was the presence of pits, sometimes associated with hearths, sherd scatters (Figure 6.12) and lithics (Figure 6.11), grinding stones and flag-stones (Bernabò Brea and Cavalier 1960; Cavalier 1979). Such finds suggest a long-term and intensive use of the area. The material culture found on both open-air surfaces and excavations, including a range of pottery sherds (Figure 6.12) such as Stentinello incised types and elaborately painted vessels (so-called *figulina dipinta*), is indicative of an Early Neolithic date of occupation, despite the lack of radiocarbon dating. These vessels were primarily imported or made locally using imported clay mixed with local fillers (Williams 1980; Williams and Levi 2001). Typical forms include open bowls decorated with simpler incisions with so-called cardial or rocker motifs (Castagnino Berlinghieri 2002a).

The excavations carried out in trench 'F' on Castellaro Vecchio revealed an interesting assemblage, suggestive of practices related to a special role of the site. The key evidence are pits and hearths built into the ground surface up to the *lapillo* level. The largest hearth (Cavalier 1979), which was partially lined with stones, reveals a dense accumulation of burnt ground and stones with little charcoal, along with cores and scatters of worked obsidian, pottery sherds and the remains of leftover food. This hearth also contains some flag-stones assembled with clay between them and at the base. Pits were carved into live ground, almost circular in form with diameter comprised between c. 1.25 cm and 2.40 cm. A substantially circular pit c. 2.40 cm in diameter was filled with two main groups of stones. In trench 'saggio 9' (Cavalier 1979), a reddish rectangular claybank was found, 76 cm long by 40 cm wide. Among the pits, the most remarkable one contained 26 obsidian cores along with a quantity of blades, suggesting the gathering and depositing of valuable resources for exchange, either for social or technological reasons. Archaeologically, there is little contextual evidence to deduce that Castellaro Vecchio was used as a permanent settlement since there are no features

of daily or permanent use, but the site appears to have been actively exploited for special occasions over a long period, possibly on a seasonal basis. On the other hand, given that obsidian know-how was a highly skilled business, it could be suggested that such a business would have been practiced regularly as it produced not just raw material but refined obsidian tools from specialised cores.

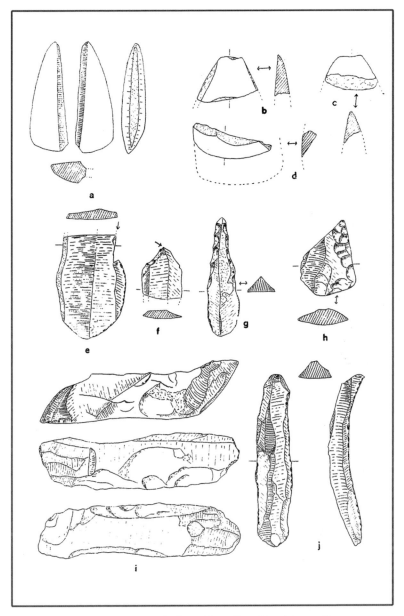

Figure 6.11: Early Neolithic lithic tools from Castellaro Vecchio: a-d) greenstone axes; e-f) flint; g-j) obsidian (adapted from Cavalier 1979, fig. 12)

a

b

c

Two sites discovered by chance during road construction provide contextual evidence for obsidian mining and on-site technical activities (Buchner 1949). Along the eastern sea-facing coast on the Canneto-Lami outcrop as well as along the Gabellotto stream bed at Canneto-Porticello-Acquacalda, evidence for quarrying and roughing out has been found across the exposed stratigraphy. Of the two mining sites found under the Medieval pumice deposit, the Canneto-Lami is the more extensively documented one (Figure 6.13): it has the most complete stratigraphic sequence and has yielded an obsidian layer along with a material culture assemblage of waste flakes, a single pottery sherd of the Diana type, as well as remains of hearths and charcoal (Buchner 1949).

Along the coastal profile between Punta Spanarello and Faro di Porticello a key role was probably played by Spiaggia della Papesca, possibly as a loading place for obsidian cores and tools ready for export. It would thus have constituted a dynamic zone of cultural interaction (Castagnino Berlinghieri 2003b). The recovery of the deposit of 26 obsidian cores and numerous ready-formed blades in the Castellaro Vecchio pit, together with the identification of the two obsidian quarries, suggest that Lipari could be viewed as a workshop centre, where cores were extracted, fashioned and subsequently cached for safekeeping or gathered for the purposes of exchange. At this location the geomorphology has been deeply modified by the violent volcanic eruption that occurred during the Medieval period. This has resulted in a considerable transformation of the landscape (Figure 6.4b), and it is possible that any Neolithic paths connecting the Castellaro Vecchio area to the coastline have been buried under this medieval obsidian flow.

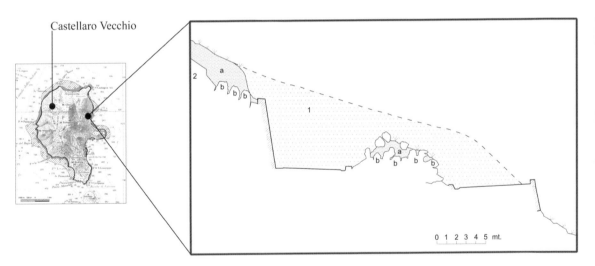

Figure 6.13: The Canneto-Lami obsidian quarry. Location and section: 1) Medieval pumice flow covering the obsidian palaeo-layer; 2) palaeo-ground layer; a) layer containing debris resulting from Medieval volcanic activities; b) obsidian (section adapted from Cavalier 1979, fig. 33)

Figure 6.12 (facing page): Samples of pottery from Castellaro Vecchio: a) finer incised Stentinello type; b) coarse impressed Stentinello type; c) painted figulina dipinta ware (adapted from Cavalier 1979, fig. 12)

The above analysis of the mutual relationship between ecosystem and people on the Lipari islands suggests that these people found a favourable landscape to establish their villages, stimulated further by the exploitation of obsidian. It is interesting to observe that, while in Lipari the first attested settlement is dated to the Early Neolithic period, neither Melos nor other Cycladic islands show evidence of settlements until the Late Neolithic (Broodbank 1999; Renfrew and Aspinall 1990). Even at Grotta dell'Uzzo or Perriere Sottano in Sicily, or at Arma di Stefano in Liguria, there is no suggestion of long-term occupation, despite these sites being linked to the earliest movement of obsidian (Malone 2003). Moreover, there is no significant indication of deep sea fishing that could be related to early off-shore seafaring either in the eastern or the western Mediterranean.

Since the remains of obsidian, hearths, flag-stones, pottery and grinding stones were often deposited in huts or at least in permanent domestic contexts in Neolithic Italy, the evidence at Castellaro Vecchio may feasibly suggest an open settlement, even though no traces of huts have been documented. Sporadic exploitation of obsidian originating from Lipari dates from the Mesolithic period (Castagnino Berlinghieri 2003b, 46), as documented at least in two sites in Sicily: Grotta dell'Uzzo in the western side (Francaviglia and Piperno 1987) and Perriere Sottano in the eastern side of the island (Aranguren and Revedin 1996). However, the site of Castellaro Vecchio constitutes the earliest evidence for long-term occupation dating to the Early Neolithic period. Either for social or ritual grounds, Castellaro Vecchio would have constituted a lasting and visible identity mark within the context of trading contacts and mobility in western Mediterranean early seafaring.

Were the first settlers from seafaring communities or from cultures based on farming which learnt to exploit the fertile volcanic soil together with obsidian?

The earliest Neolithic evidence, both in terms of obsidian exploitation and material culture (Figures 6.11 and 6.12), suggests a dense and intensive long-term frequentation of the inland Castellaro Vecchio area. If these settlers had been skilled mariners possessing nautical knowledge of weather and currents, it would be difficult to understand the reasons for settling on the highland instead of on the coast. It seems more likely that the first communities to occupy Lipari got to the island by crossing the sea from Capo Milazzo, which is the easiest and shortest way of reaching Lipari and which would not have required specialised knowledge of seafaring.

The faunal and botanical assemblages from the nearby floor deposits, together with the plaster assemblages from the Early Neolithic oval hut at Rinella on the island of Salina, suggest a specific choice in occupying a strategic position. The combination of the settlement's location and its proximity to a river basin, springs, fertile fields, plants and obsidian sources, can explain the choice of place, including the controlling, producing, knapping and, finally, exchange of obsidian. The artefact density recovered from Castellaro Vecchio is mainly related to *in situ* obsidian knapping activities and to sherds of Stentinello-impressed pottery type along with few painted sherds in low percentages (10 per cent).

In this respect, Castellaro Vecchio might be viewed as an organised open settlement specialised in obsidian knapping, which started its activity in the Early Neolithic. Similarly, the occupation of the Acropolis of Lipari, dating to the Middle Neolithic, suggests a settlement focused on control from a higher position and overlooking sea movements. This model does not imply any concern for defence. On the contrary the position of both settlements seems to

reflect a power organisation on a notable scale, related perhaps to emerging power structures and leading groups. On the other hand, Early Neolithic settlement in south-eastern Sicily (Figure 6.9), despite the presence of ditches, is generally a lowland phenomenon, likely indicative of a phase of quietness (Tusa 1985). Key sites include Stentinello, Matrensa, Megara Iblea, Ognina, Vulpiglia, which had coastal subsistence economies with a marine component. The eastern seaboard of Lipari, which has been deeply affected by geological modifications, would have been endowed with rich marine conditions for fisheries and well-suited to sea activity. The paucity of actual archaeological finds could be the result of major geological events (Castagnino Berlinghieri 2003b).

In archaeological terms, only the workshop centres identified in Canneto-Lami (Figure 6.13) and in Canneto-Acquacalda, along with the deposit of 26 obsidian cores found in the Castellaro Vecchio pit, represent significant evidence of obsidian exploitation for both gathering and export. Combining all the observations above would suggest that the newcomers were already scattered into specialised groups some of which were more linked to agricultural traditions (e.g. Castellaro Vecchio) while others to maritime involvement (e.g. Spiaggia della Papesca).

In support of the above model, the subsistence base of the first communities on the Aeolian islands will be explored in order to understand the extent of any direct interaction with the sea. The cultural material (Figures 6.11 and 6.12) and animal remains (Figure 6.14) on the first Neolithic settlements on Lipari do not indicate a culture with a prevailing maritime component. It is rather an agro-pastoral one, linked to the exploitation of the land and associated with open settlements located inland in high positions and deliberately far from the sea, such as the sites of Castellaro Vecchio, Contrada Diana and Lipari-Acropolis. Indeed, the absence of a marine component from the earlier record may also be due to the lack of sieving or, more likely, to such evidence having been lost beneath the sea, possibly in the coastal strip off the Canneto-Lami area (see Figure 6.13).

On the other hand, the subsistence base in Early Neolithic sites across the littoral Adriatic coast is very different, suggestive of fishing economies (Whittle 1996) even including whales as part of the catch. Gathering of shellfish and fishing was common in many Sicilian Neolithic coastal settlements such as Stentinello, Megara Iblea, Ognina and Vulpiglia in eastern Sicily (Guzzardi *et al.* 2003; Kapitaen 1991; Orsi 1912, 1915) and at Grotta dell'Uzzo in north-west Sicily (Borgognini and Repetto 1985; Tusa 2000). Although the analysis of faunal remains from Neolithic coastal sites on Sicily have produced slightly variant interpretations, marine resources were probably regular, even if not primary, components of human diets.

DATE	SETTLEMENTS	SHEEP/GOAT	PIG	CATTLE	LOCATION
Early Neolithic	Stentinello	225	139	170	**Sicily**
	Megara Iblea	222	146	203	
	Matrensa	195	156	375	
Middle Neolithic	Lipari-Acroplis	225	139	170	**Aeolian Islands**
	Lipari-Serra d'Alto	222	146	203	
Late Neolithic	Lipari Diana	1	//	2	

Figure 6.14: Neolithic domesticate faunal assemblages from the Aeolian islands and Sicily. Number of animal bones recovered, arranged by period (main sources Bernabò Brea and Cavalier 1980; Leighton 1999)

Radiocarbon dating (Mannino and Thomas 2007) shows that fishing and gathering of marine molluscs occurred since the earliest known occupation of north-west Sicily at sites such as Grotta dell'Addaura, Grotta Niscemi, Cala di Genovesi and Grotta Perciata.

Since the Early Mesolithic period, the economy of Grotta dell'Uzzo (Mannino *et al.* 2007) was based on shells, both terrestrial and marine, along with deer, wild pig and fox, as well as several species of bird. Through the Late Mesolithic and into the Neolithic the exploitation of a broad spectrum of sea-related resources, including aquatic birds, pond turtle, marine fish, cetaceans and molluscs, increases in both intensity and diversity (Tagliacozzo 1993). Throughout the Grotta dell'Uzzo sequence, fishing and gathering of marine molluscs, mainly from rocky shore intertidal species, constituted important multi-seasonal subsistence activities, although evidence for summer exploitation has not been attested (Mannino *et al.* 2007). However, the evidence from Grotta dell'Uzzo demonstrates the continuing importance of marine-based food resources (fish and shellfish) in the Neolithic. This conclusion is further confirmed by the presence of fishing hooks made of bone from the Early Neolithic level of Grotta dell'Uzzo (Figure 6.15). Even in the Maltese islands, the exploitation of marine resources (Trump 1966), in particular shellfish and fish, constituted an element of continuity across the entire Neolithic period, from the Ghar Dalam *facies*, to Red Sorba and Grey Skorba. This would suggest a direct and regular interaction with the sea and its resources over time.

By contrast, the subsistence on Lipari appears to have been based on farming and hunting activities and not on fishing or collecting marine resources (Figure 6.14). These activities were probably associated with a pastoral use of the neighbouring higher areas of Monte Sant'Angelo, Costa d'Agosto and Monte Chirica. Remains of sheep, goat and cattle on the Aeolian islands are not evidenced until the Middle Neolithic, while in Sicily they are already attested since the Early Neolithic (Figure 6.14) along with deer and fox. Despite the occasional presence of pig (*Sus scrofa*) there is no evidence of local domestication and the bones belonging to sheep/goats were presumably introduced already domesticated. Even in the later Neolithic the dominant subsistence at Lipari does not consist of fishing or sea resources but rather continues the earlier trend of increasing dependence on terrestrial food sources; these include several species of mammals, mainly sheep/goat along with pig.

Tools made of animal bones, mainly from sheep, have been recovered in Middle Neolithic levels (Figure 6.16). In the case of Lipari-Acropolis, among the 16 bone tools associated with Middle Neolithic trichrome pottery, some were conceived as a sort of weapon characterised by a pointed end (Castagnino Berlinghieri 2002a, fig. 5). Blades and pins were doubtless more common, mainly made using long bones of sheep, even if cattle samples are also attested.

Figure 6.15: Fishing hooks made of bone from Early Neolithic level on Grotta dell'Uzzo (from Tusa 1997, figs. II.62 and II.63)

MIDDLE NEOLITHIC		ANIMAL BONES	
Lipari-Acropolis layers	**TOTAL** 207	**BONES TOOLS** 16	- 2 pins (fishbone)
			- 1 blade (unidentified animal)
			- 3 drifts (unidentified animal)
			- 2 irregular sherds (unidentified animal)
			- 1 spatula (cattle)
			- 1 pointed long bone (cattle)
			- half pointed long bone (cattle)
			- 5 regular sherds (unidentified animal)
		Unworked bones 191	Some of them show traces of use

Figure 6.16: Animal bones both worked and unworked recovered in the Lipari-Acropolis layers, mainly associated with trichrome pottery (Middle Neolithic), classified according to common functional features (data based on Bernabò Brea and Cavalier 1980; Leighton 1999)

Pointed fish bones made into very sharp pins are also found. Those instruments, which are not very big in size, recall implements for slaughtering small animals; their presence reflects both the persistence of hunting and the practice of domestication.

Summing up, the evidence, both direct and indirect, from Castellaro Vecchio points to groups of people bound to agrarian rather than maritime economies. In contrast, the coastal strip of Spiaggia della Papesca near Canneto-Lami, where the obsidian quarries discussed above were found (Figure 6.13), points to groups benefiting from living close to the shore by exploiting marine resources and taking advantage of the opportunities for maritime activity. Here, the absence of earlier records of marine resource exploitation need not imply that these communities lacked maritime knowledge but may reflect the fact that this coastal location more likely preserves any surviving occupation beneath the sea or under the obsidian/pumice flow that occurred during Medieval times. Life on Early Neolithic Lipari was probably a collective experience balancing practical advantages, such as obsidian or fertile soil to exploit, with social relationships implying shared beliefs and symbolic meanings, probably embedded in seasonal rhythms.

How did the obsidian from Lipari, which was apparently managed by land-based island communities, reach far-off places?

Despite the absence of direct evidence for water transport related to the Mediterranean sea cultures of this age, obsidian from Lipari was widely distributed, even more so than obsidian from other sources located in the western Mediterranean, such as that of Mount Arci in Sardinia, Palmarola in the Pontine islands or Pantelleria in the Channel of Sicily (Figure 6.3). In this respect, discussion of earlier sea-crossing connections has always been concentrated on the wide ranging geographic and quantitative distribution of the obsidian from Lipari in the Levantine Mediterranean. The distribution patterns of the different sources continue to be much analysed (e.g. Cann and Renfrew 1964; Robb and Tykot 2002; Tykot 1998, 2002, 2004;

Tykot and Ammerman 1997; Williams Thorpe 1995). The utility of such distribution maps might provide the material results but not the mechanisms of interaction that produced them. There is no doubt that Lipari, together with, and even more so than, Monte Arci had a determining and privileged role in obsidian distribution (Figure 6.3). Very few researchers, though, have examined the means and mechanisms by which the obsidian from Lipari, in particular, reached shores so far from its source, except by fitting the case into rigid models or 'spots maps'.

A widely accepted theory, proposed by several scholars including Bintliff (1977) and Torrence (1986), is that early maritime activity, mainly visible through the distribution of obsidian, was connected to long-distance fishing activities of migratory fish, notably tuna, as well as birds. It would follow that we would expect to find evidence for fishing exploitation of sea resources.

On Lipari the first direct evidence for sea-resource exploitation has been recovered in a stratified context (Lipari-Acropolis) dating no earlier than the Middle Neolithic period, while the first regular frequentation of the Castellaro Vecchio area is dated to the Early Neolithic. A fishbone belonging to a species of tuna weighting a few kilos (Villari 1991) was recovered within a burial place, as part of the grave goods of the *Tomba 20* (Bernabò Brea and Cavalier 1960, 113) on Lipari-Acropolis. The burial context seems to characterise the fishbone as a prestigious and remarkable rarity: it was not merely part of the food remains left over from a ritual ceremony but an exotic item considered significant to be selected as a grave good. No large fishbones or remains of sea resources have been recorded in the Early and Middle Neolithic sites on the Aeolian islands, nor is there evidence for deep-sea fishing. The burial context, together with the scarcity of evidence attesting to such fish, at least of that size, questions the hypothesis of the migration of people following the migratory fish off-shore. Consequently, it could be suggested that such a species of fish, which requires not only a certain level of fishing equipment but also a boat capable of keeping its balance against the dynamism of the fish, had yet to be caught in the Middle Neolithic. We should also bear in mind that certain marine resources such as intertidal molluscs do not pose technological constraints since shellfish collection makes use of simple aids such as hand-held nets or other rarely preserved and perishable simple equipment.

The appraisal of ancient economy and of the exchange of prehistoric goods can benefit considerably from ethnohistorical literature and ethnographic analogies concerning the traditional life of small-scale communities. Such an approach has stimulated discussions of broader social issues (Renfrew 1984), including parallels drawn with the 'kula ring' and other 'primitive' gift exchange systems (Bradley and Edmonds 1993; Mauss 1966). This argument goes back to Malinowski's research on the 'kula ring' in the Trobriand islands (1922) and its subsequent reworkings, including Marshall Sahlins' classic 1955 paper on Easter Island; Evans' 1977 paper on the Lipari and Maltese archipelagos; Renfrew's papers (1973a, 1973b) on Malta, the Easter Island and Tonga; Bonanno's (2000) and Malone and Stoddart's (2004) works on Malta and more recently the works of Robb (2007) and Constantakopoulou (2007). It should be noted that the original anthropological interpretations, such as Malinowski's analysis of the 'kula', have been subjected to major revisions (Leach and Leach 1983); other important contributions on the Trobriand islands and neighbouring societies associated with the 'kula' were made by Firth (1957, 1983), Leach (1983), Damon (1990), Macintyre (1983) and more recently Eriksen (1993), Bloch (1994) and Ginzburg (2002). All this information can be useful in illustrating the diversity of island cultures.

This is not to say that Mediterranean Neolithic people held beliefs similar to those of Trobriand islanders about any particularly translucent material, such as the Lipari obsidian. Rather, it exemplifies that certain tools or 'gifts' can be the centre of shared cosmological beliefs and that such views are expected to involve their physical features and, possibly also, functional purposes within a long sequence of social interactions. Using ethnographic cases such as the 'kula' or the Australian Aboriginal communities with their own exchange system as an analogy, it is possible to explore how a long-distance trade structure could have expanded.

The Australian Aboriginal band communities were involved in extensive trade networks, via the Torres Strait, with mainland Papua New Guinea and the New Guinea islands. This structure of interconnections allowed different individuals to acquire useful and valuable objects whose source was far away from their own place. Among the main natural resources traded, the most appreciated were red ochre, coloured pigments, the much appreciated narcotic-drug locally named *pitcher* along with sea-shells, skins, and fibres (Gosden and Hather 1999). Among the main handcrafted goods were boomerangs, stone for axes, arrow-heads, spears of wood and reed, but also canoes and fishing nets. Their exchange was based on three mechanisms (Figure 6.17): traditional meeting places; trade routes, foot, riverine and marine; and kinsfolk and ceremonial customs.

The meetings often occurred seasonally or periodically near sources of valuable goods, attracting people from different regions. Reaching the meeting places could even take about fourteen days' travel. As noted by McCarthy (1939, 410), '...the Bunya Bunya nuts occur in a limited area of the Blackall Ranges... when the nuts were in season, natives from the Burnett, Wide Bay, Bundaderg, Mt. Perry, Bribie and Frazer islands, Gayndah, Kilroy and Brisbane, numbering between 600 and 700, turned up; tribes travelled 200 and 3000 miles to feed on

Figure 6.17: Summary scheme of Australian Aborigines mechanism of exchange (data derived from McCarthy 1939)

this fruit, which is plentiful only every three years and it was only there that the great assembly of blacks took place'. During such tribal meetings, unrelated people exchanged their typical goods with other commodities following a ritualised ceremony.

There is evidence for eight alternative routes (McCarthy 1939, 174): overland, riverine, lake, marine, and a combination of the above. Mainly overland routes are related to river-ways that allowed people to cover long distances with considerably less effort. An example of this route ran down from Cape York on the Torres Straits, covering a distance of about 1900 miles as far as the Sydney area; then the coastal rivers linked it with the communities immediately inland. It is interesting to note that no one individual or any specific tribe usually travelled the entire length of a precise route. Rather, goods were passed down-the-line mediated by social organisations that came to interact with others gradually more and more distant from the source (McCarthy 1939).

The Polynesian ethnohistorical example may suggest analogies or discrepancies to enable a better understanding of inter-island sea voyaging in the prehistory of the western Mediterranean (Bellwood 1978). Within the grouped Polynesian societies of New Zealand, Tikopia, Manihiki and Rakahanga, in the kinship structure of the Tikopia, a useful list of vessels has been classified into three main districts of Ravena, Namo and Rofea. Among

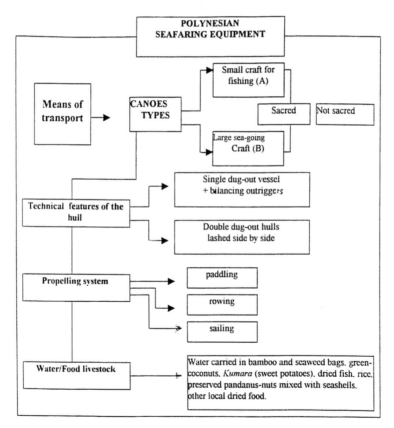

Figure 6.18: Summary scheme of Polynesian seafaring equipment and means of water transport (data derived from Mackenzie 1996)

Figure 6.19: A Polynesian paddling a dugout canoe, sail rolled up on the left side

these it is possible to distinguish two main typologies of canoe: small craft which three or four men could manage, used for short trips as well as for fishing; and larger sea-going craft for overseas voyages (Figure 6.18). Only in very special cases is a single man the owner of the canoe. More often the vessels belong to at least a dozen or more men. The canoe is the most important object of the typical equipment in Tikopia band communities (Figure 6.19). A large number of the vessels from Ravena are sacred canoes with tutelary spirits appointed to them by the clan chief or by the priest, known as *tohunga*, and are seasonally re-consecrated. These priests also used to be on board for both short- and long-distance voyages and were in practice the navigators who advised the commander how to steer the vessel by observing the weather conditions and considering the possible dangers in sight. In the rare occasions when a canoe is transferred from one kinship tribe to another this is done in a ceremonial setting (Mackenzie 1996).

The late nineteenth century romantic view shared by many scholars was that Polynesian sea-travellers were capable of voyaging to new islands right across the Pacific and of finding their way back afterwards. This view appears very unlikely, although this is what many local traditions imply. A number of scholars have been rather sceptical of this hypothesis which indeed is only sustained by the very elaborate native mythology; the latter however is also full of tusked sea-monsters or sea-lions or sea-elephants which indeed underline the native conception of the dangerousness of the sea. On the other hand, one of the most controversial works relating to this problem remarks that Polynesians might be able to reach distant islands but would never find their way back home again (Sharp 1963); this one-way voyaging hypothesis is mainly determined by the fact that those mariners had no means of measuring

the displacement caused by ocean currents. In this regard it should be pointed out that a one-way trip is not necessarily a drift-voyage and that, anyways, paddling or sailing, many times following the current, even for short distances, may be the best way to exploit sea and currents whether in Polynesia or in the Aeolian archipelago.

In reporting the Polynesian voyaging techniques on long-distance trips to unknown waters, Smith (1915, 1919) informs us that they were in the habit of setting out on voyages not in a few canoes but rather using proper fleets which they navigated in a rather special way. When they were crossing unknown waters and expected to land on some island, they used to employ a simple yet very clever strategy of exploration: the fleet spread out in a crescent form across distances of about five miles apart on each side so as to extend their view. Whichever crew saw the land first, signalled their neighbours, who passed the signal on, and so on, till the whole fleet was able to steer towards the land. It is also reported that in such a way a fleet of ten canoes could have a view of over fifty miles on their front (Smith 1915). Smith's work also contains a table displaying the itineraries undertaken by Polynesians by a celebrated *Rarotongan* seafarer named *Tangiia*. It clearly shows that by using this particular strategy of setting out on voyages in fleets, on this special ritual occasion, they were able to cover over 18,360 miles. Indeed, covering such a huge length means, rather, multiple short-distance journeys, which in any case were not too short considering that, for example, from Fiji to Easter island it is no less than 4200 miles while the next step, from Easter island to Moorea, amounts to 2400 miles. This invaluable eye-witness account reported by Smith in the late 19th century makes it clear that a fleet of canoes, forming a sort of bridge between each other and thus able to cope with long-range visibility, was key to voyaging on inter-island or even long-distance journeys in the traditional Polynesian culture.

A review of Polynesian sea-voyaging ability and customs, together with 'kula' sequence habits, also associated with data and investigations provided by direct observation accounts from 19th century sea-travellers, all give valuable insights into the world of ancient seafaring and the ways such an overall strategy can be compared to maritime activity in the Aeolian islands.

The island of Lipari may be seen as the focal point of a 'Lipari kula' version, where people from diverse areas convened during ritual visits to exchange 'gifts', along with knowledge, goods and foodstuff from their respective areas (Figure 6.20). Moreover, if the fragments of fine decorated bowls found at the site of Castellaro Vecchio along with Stentinello type vessels, were used for eating and drinking, this may suggest a certain sociality between the people who converged there. Furthermore the diffuse presence of hearth remains along with

IMPORTED		EXPORTED	
Materials	**Age**	**Materials**	**Age**
Clay	N/B	Obsidian	N/B
Flint	N/B	Alum	B/R
Ochre	N/B	Sulphur	B
Greenstone	N	Pottery	N/B
Pottery	N/B	Pumice	R

Figure 6.20: Imported and exported materials relating to the Aeolian islands (N: Neolithic; B: Bronze Age; R: Roman Age)

the reddish rectangular claybank found in trench F on Castellaro Vecchio (Cavalier 1979, fig. 3), possibly used for ritual purposes, could provide a venue for social relations, which apparently go beyond the practical needs of getting there.

Summing up, during the Neolithic, it seems possible to argue for the presence of groups which settled on different areas on the island of Lipari: on the high plateaux of Castellaro Vecchio, the land-based communities skilled enough to guarantee maintenance and transmission of obsidian knapping practices permeated by particular values and beliefs; on the northeastern coastline, communities involved with maritime activities and possibly related to marine-based economies of which any surviving evidence lies beneath the sea or buried by the pumice/obsidian flow of the Medieval period. We can conjecture that the high plateaux of Castellaro Vecchio played a vital role for both ritual and exchange purposes as a meeting place with a periodic or seasonal festival related to the availability of obsidian. In this light, Lipari could be regarded as a significant meeting place for different people specialised in diverse products that they bartered with others via long established friendly connections and, in some cases, even kinship ties.

Discussion and results

On the Aeolian islands the first considerable evidence for extra-insular contacts occurs during the Early Neolithic and indicates a highly distinctive integration of these islands within the western Mediterranean socio-economic systems. The wide diffusion of obsidian from Lipari, which interferes with the other sources (Bigazzi *et al.* 1992; Tykot *et al.* 1999), points to a dynamic exchange established on the principle of free negotiation (Castagnino Berlinghieri 2003b). This kind of exchange is still far from a competitive market and is not correlated to regular networks. Clay was imported to the Aeolian islands for local industrial production since the Early Neolithic, as demonstrated by thin section analysis (Williams 1980). Pottery production followed a similar typology to that in the western Mediterranean, both in terms of forms and decoration patterns. This does not seem to reflect a common background of the early farming cultures, as suggested by some (*contra* Leighton 1999, 65-66), but implies a preferential relationship with Sicily and southern Italy, which was stimulated by inter-island and coastal trading connections (Castagnino Berlinghieri 2002a).

Therefore, apart from the local flint from Vallata di Bagno Secco, the occurrence on the Aeolian islands of imported high-quality flint, possibly introduced from the Hyblean plateau, together with greenstone axes, probably originating in southern Italy, points to a developed system of exchange transactions mainly involving the Sicilian and southern Italian communities (Figure 6.20). Similarly, the large quantities of pigments such as ochre found in Neolithic sites on Malta, where at present no local source has been recognised, may have been imported from Lipari along with obsidian which was traded, as large cores, to Malta during the mid-late Neolithic both from Lipari and Pantelleria. By analogy with the ethnographic cases considered, it is possible to hypothesise that western Mediterranean groups were not strangers to each other but related by common affinity, even bound by ceremonial agreements. The obsidian tools found in sites in southern Italy, and as far away as the Dalmatian region or Malta, are evidence of a complex series of activities within a circuit of interaction which seems to have been inspired by a behavioural attitude of free exchange. Obsidian density in sites close to the sea or near ancient river valleys and rivers, such as the Metauro, Mesima, Savuto, Agri in relation to the isthmus of Catanzaro, or the Sele for the Metapontine area in south Italy, as well as the

Platani and the Himera meridionale river, in Sicily, suggests that these sites were exploited as effortless pathways for movements between coast and hinterland, facilitating population migrations, exchange, cultural contacts and social relationships. This involves various long-distance exchange networks as a means of expansion along a range of alternating marine and river valley routes, mediated by means of exchange between groups that came to interact with others more and more distant from the source. In this setting, the importance of Lipari as a supplier of obsidian and other natural resources, centrally located in the south Tyrrhenian sea, leads one to suggest that the site of Castellaro Vecchio acted as a meeting place.

The archaeological and ethnographical correlations examined in this paper, using the ethnographic analogy in a broad sense rather than as an explicit parallel, permit a number of assessments on the scale of social relationships and exchange systems during the Neolithic period. The Lipari farming-based settlements on Castellaro Vecchio and later on Lipari-Acropolis might be viewed as meeting places where periodical or seasonal festivals took place, possibly linked to ritual and exchange practices. The Aboriginal example reveals trading social relationships between members of different communities who were not total strangers but were related through kinship ties. Moreover, during the Early Neolithic the widespread spatial distribution of pottery in the impressed Stentinello style on Castellaro Vecchio seems to reflect cultural interactions on a large scale in the western Mediterranean and indicate that the Aeolian islands, along with ware importation, were supported by their own pottery industry (Castagnino Berlinghieri 2002a), despite an almost total absence of clay deposits on all the islands of the archipelago.

Additionally, although the archaeological evidence on Castellaro Vecchio and Lipari-Acropoli along with Spiaggia della Papesca indicate that the newcomers were associated with agricultural activity in the former two sites and with maritime activity in the latter, the role played by Lipari was clearly that of a centre operating over a *longue durée* of at least 2500 years and spanned the entire central-eastern Mediterranean. It is now even more evident that the high plateaux of Castellaro Vecchio on Lipari might be viewed as genuine meeting places where long-distance exchange of obsidian and other goods played a remarkable role in maintaining preferential ethnic or kin connections, and thus point towards the capability of western Mediterranean seafaring people in making open water crossings for both ritual and exchange purposes.

All these considerations, in light of the data from Castellaro Vecchio on the type of culture (mainly land-based), subsistence (agro-pastoral) and settlement location (on a high position overlooking the sea), suggest an interpretation rather different from the one proposed in the past. It finds in the Castellaro Vecchio area of Lipari a role which is dominant but also 'passive', at the centre of a wide circuit of cultural interaction. The identification of this role as 'passive' is in no way meant to have negative connotations, but intends rather to define a different dimension of interaction: Castellaro Vecchio does not function directly as the central motor, nor as the go-between for other maritime communities, but acts as a specialised focal point passively and indirectly, because other groups reach Lipari in order to acquire the precious resource of obsidian. Apart from the unique case of the tuna fishbone, the absence of elements closely linked to maritime activities further demonstrates that the settlers of Castellaro Vecchio did not have a constant and close relationship to the sea. This framework reinforces the impression that the absence of technological devices such as boats and deep-sea fishing related tools are not necessary a vital component in extending the range and consistency of long-distance connections across the sea.

Moreover, the selected ethnographic cases presented clearly show that exchange systems were mainly conducted by interaction between adjacent tribes, revealing the passage of several types of goods, both raw and crafted, over great distances. This can shed light upon relationships and customs that are mainly undetectable in the archaeological record but are of central concern. These ethnographic cases further suggest a linking together of short segments of routes as well as a kind of coastal trade navigation, which, at least in part, followed the well-known model of down-the-line trade at a certain distance from the source. The process of such a flexible interconnection is likely to have been a key element in the creation of preferential social exchange patterns. The importance of alliances and ceremonial behaviour cannot be underestimated. As is evident from the case of the Aboriginal Australians, a form of tribal meeting place with periodical or seasonal festivities seems to have been central to ritual and exchange practices. Indeed, since obsidian is available all year round, this model might be applied on a long-term time scale, although sometimes limited due to the occurrence of favourable local marine conditions.

By analogy it is possible to hypothesise that prehistoric Mediterranean groups would have used some selected places which were well endowed with valuable resources. Seen in this light, Lipari had high quality obsidian and other natural resources (Figure 6.20), as well as its own highly specialised obsidian knapping communities on Castellaro Vecchio. It might thus be viewed as such a meeting place for both ritual and exchange purposes.

Finally, although the prehistoric record emphasises that the Castellaro Vecchio communities were associated with agricultural rather than maritime activity, the multiple flows of obsidian, which are the most perceptible indicator of long-distance mechanisms of interaction and craft specialisation during the entire Neolithic period in the central-western Mediterranean, point to a distinctive role played by Lipari as a centre that operated over a *longue durée* of at least 2500 years. Meanwhile, the lower eastern shores of Lipari such as Spiaggia della Papesca were probably exploited by coastal communities who may have played a more significant, extensive and determinant role as groups specifically devoted to maritime activities than has been hitherto recognised, a role different to past hunter-gatherer and farmer stereotypes.

The picture thus produced is of broad-based societies, each exploiting a different ecological niche. The simultaneous exploitation of agricultural and maritime niches in the environment of Lipari increases the potential range of differences in social organisation which appears crucial in explaining the mode of subsistence and hence the entire socio-cultural profile of a society. This model, based on social organisation with specialised groups simultaneously acting on the island of Lipari and its neighbouring coastal zones, offers a new understanding of the Neolithic transition as resulting from interactions of technological innovations. It is an understanding that emphasises the environmental and technological factors that determine social organisation and culture. In considering the social value of Lipari obsidian as a prestige resource one would also reflect on its technological use for a wide range of functions which suffice to make obsidian such a prominent trade good.

Stretching this point even further, this way of approaching archaeological evidence, based upon palaeoecosystems and maritime landscapes as well as on analogies of social customs of small-scale communities, shows how the unique character of the choice of the Early Neolithic occupation of Castellaro Vecchio on Lipari and its primary subsistence economy amplify the symbolic value of the Aeolian islands and place them outside the usual exchange models for the wide diffusion of obsidian.

Acknowledgements

Financial support for early stages of writing came from the British Academy of London and the University of Bristol. I wish to thank Prof. Toby Parker (University of Bristol, UK), Profs. Italo Di Geronimo and Carmelo Monaco (Università di Catania, Italy), Prof. Luigi Bernabò Brea (former Director of the Archaeological Museum of Lipari, Italy), and Prof. Valeria Fol (Institute of Thracology 'Prof. Alexander Fol', Bulgarian Academy of Sciences) for their suggestions and constructive criticism that have greatly helped me in developing new hypotheses in my research. I am also indebted to Dr. Marcello Mannino (Max Planck Institute for Evolutionary Anthropology, Leipzig) for illuminating discussions on analyses and data on marine shells from prehistoric sites. I am also deeply grateful to an anonymous reviewer and the editor for their very helpful comments that have helped improve this paper.

References

AGOURIDIS, C. 1997: Sea routes and navigation in the third millennium Aegean. *Oxford Journal of Archaeology* 16 (1), 1-24.

ARANGUREN, B.M. and REVEDIN, A. 1996: Problemi relativi all'insorgenza del mesolitico. In Leighton, R. (ed.), *Early Societies in Sicily* (London), 31-39.

BAILEY, G. 2004: World prehistory from the margins: the role of coastlines in human evolution. *Journal of Interdisciplinary Studies in History and Archaeology* 1 (1), 39-50.

BAILEY, D.W. and WHITTLE, A. 2005: Unsettling the Neolithic: breaking down concepts, boundaries and origins. In Bailey, D.W., Whittle A. and Cummings V. (eds.), *(Un)settling the Neolithic* (Oxford), 1-10.

BALDACCHINO, G. (ed.) 2007: *A world of islands: an island studies reader* (Canada and Malta, Institute of Island Studies and Agenda Publications), 237-266.

BASILE, C. and DI NATALE, A. 1994: *Le barche di Papiro* (Siracusa, Istituto Internazionale del Papiro Monografia 1).

BELLWOOD, P. 1978: *The Polynesian prehistory of an island people* (London).

BENJAMIN, J., BONSALL, C., PICKARD, C. and FISCHER, A. (eds.) 2011: *Submerged Prehistory* (Oxford).

BERNABÒ BREA, L. and CAVALIER, M. 1957: Stazioni preistoriche delle isole Eolie. La stazione stentinelliana di Castellaro Vecchio presso Quattropani, Lipari, (I); Stazioni preistoriche di Piano Conte sull'altipiano di Lipari (II). *Bullettino di Paletnologia Italiana* 46, 97-151.

BERNABÒ BREA, L. and CAVALIER, M. 1960: *Meligunìs Lipàra 1. La stazione preistorica della contrada Diana e la necropoli protostorica di Lipari* (Palermo).

BERNABÒ BREA, L. and CAVALIER, M. 1968: *Meligunìs Lipàra 3. Stazioni preistoriche delle isole Panarea, Salina e Stromboli* (Palermo).

BERNABÒ BREA, L. and CAVALIER, M. 1980: *Meligunìs Lipàra 4. L' acropoli di Lipari nella preistoria* (Palermo).

BERNABÒ BREA, L. and CAVALIER, M. 1995: *Meligunìs Lipàra 8.1. Salina: Ricerche archeologiche (1989-1993)* (Palermo).

BIGAZZI, G., MELONI, S., ODDONE, M. and RADI, G. 1992: Nuovi dati sulla diffusione dell'ossidiana negli insediamenti preistorici italiani. In Herring, E., Whitehouse, R. and

Wilkins, J. (eds.), *Papers of the fourth conference of Italian archaeology 3. New Developments in Italian Archaeology, part 1* (London), 9-18.

BINTLIFF, J. L. 1977: *Natural environment and human settlement in Greece* (Oxford, BAR Supplementary Series 28).

BLOCH, M. 1994: Book review: Death rituals and life in the societies of the Kula Ring, edited by F.H. Damon and R. Wagner. *American Ethnologist* 21 (3), 639-640.

BONANNO, A. 2000: Early colonization of the Maltese islands: the status quaestionis. In Guerrero, V.M. and Gornés, S. (eds.), *Colonización humana en ambientes insulares: Interacción con el medio y adaptación cultural* (Palma), 323-337.

BOOMERT, A. and BRIGHT, A.J. 2007: Island archaeology: in search of a new horizon. *Island Studies Journal* 2 (1), 3-26.

BORGOGNINI TARLI, S. and REPETTO, E. 1985: Diet, dental features and oral pathology in the Mesolithic samples from Uzzo and Molara caves (Sicily). In Malone, C. and Stoddart, S. (eds.), *Papers in Italian Archaeology* 4 (Oxford, BAR International Series 244), 87-100.

BRADLEY, R. and EDMONDS, M. 1993: *Interpreting the axe trade: production and exchange in Neolithic Britain* (Cambridge).

BRAUDEL, F. 1972: *The Mediterranean and the Mediterranean world in the age of Philip II* (London).

BROODBANK, C. 1999: Colonization and configuration in the insular Neolithic of the Aegean. In Halstead, P. (ed.), *Neolithic society in Greece* (Sheffield, Sheffield Studies in Aegean Archaeology 2), 15-41.

BROODBANK, C. 2006: The origins and development of Mediterranean maritime activity. *Journal of Mediterranean Archaeology* 19 (2), 199-230.

BUCHNER, G. 1949: Ricerche sui giacimenti e sulle industrie di ossidiana in Italia. *Rivista di Scienze Preistoriche* IV, 162-186.

BUTLER, S. 1922: *The authoress of the Odyssey* (London).

CANN, J.R. and RENFREW C. 1964: The characterization of obsidian and its application to the Mediterranean region. *Proceedings of the Prehistoric Society* 30, 111-131.

CASTAGNINO BERLINGHIERI, E.F. 1997: Isole Eolie: osservazioni sui siti sommersi. Scali marittimi, approdi e antiche linee di costa tra neolitico ed età del bronzo. In Li Vigni, V. and Tusa, S. (eds.), *Atti del convegno nazionale di archeologia subacquea, 1996 Anzio, Italy,* (Bari), 153-168.

CASTAGNINO BERLINGHIERI, E.F. 2002a: New contributions to the study of the Neolithic sea/landscape and human interaction on the Aeolian Islands (Sicily, Italy). In Waldren, W.H. and Ensenyat, J.A. (eds.), *World islands in prehistory: international insular investigations. Proceedings of the 5th Deia International Conference of Prehistory* (Oxford, BAR International Series 1095), 217-232.

CASTAGNINO BERLINGHIERI, E.F. 2002b: Attività umana e assetto costiero nella protostoria eoliana: nuovi risultati di ricerca. In Li Vigni, V. and Tusa, S. (eds.), *Strumenti per la protezione del patrimonio culturale marino: aspetti archeologici. Atti del convegno* (Milano), 23-35.

CASTAGNINO BERLINGHIERI, E.F. 2003a: Il contesto archeologico sottomarino di Pignataro di Fuori: una testimonianza diretta dell'imprenditoria mercantile eoliana nell'età del bronzo antico. *Atti della XXXV Riunione Scientifica dell'Istituto Italiano di Preistoria e Protostoria*, 1043-1048.

CASTAGNINO BERLINGHIERI, E.F. 2003b: *The Aeolian Islands: crossroads of Mediterranean maritime routes. A survey on their maritime archaeology and topography from the Prehistoric to the Roman periods* (Oxford, BAR International Series 1181).

CASTAGNINO BERLINGHIERI, E.F., MONACO, C., SCICCHITANO, G. and ANTONIOLI, F. 2008: Sea level change and archaeological coastal sites: an interdisciplinary approach applied along the south-eastern coast of Sicily. In Auriemma, R. and Karinja S. (eds.), *Terre di mare. L'archeologia dei paesaggi costieri e le variazioni climatiche. Atti del Convegno Internazionale di Studi (Trieste, 8-10 novembre 2007)* (Trieste), 61-67.

CAVALIER, M. 1979: Ricerche preistoriche nell'arcipelago eoliano. *Rivista di Scienze Preistoriche* XXXIV (1-2), 45-136.

CONSTANTAKOPOULOU, C. 2007: *The dance of the islands: insularity, networks, the Athenian Empire and the Aegean world* (Oxford).

DAMON, F.H. 1990: *From Muyua to the Trobriands: transformations along the northern side of the Kula Ring* (Tucson).

DE JONG, I.J.F. 2001: *A narratological commentary on the Odyssey* (Cambridge).

EMLYN-JONES, C., HARDWICK L. and PURKIS, J. (eds.) 1992: *Homer: readings and images* (London).

ERIKSEN, T.H. 1993: In which sense do cultural islands exist? *Social Anthropology* 1, 133-147.

EVANS, J.D. 1973: Islands as laboratories for the study of cultural process. In Renfrew C. (ed.), *The explanation of culture change: models in prehistory* (London).

EVANS, J.D. 1977: Island archaeology in the Mediterranean: problems and opportunities. *World Archaeology* 9, 12–26.

FARR, H. 2006: Seafaring as social action. *Journal of Maritime Archaeology* 1, 85-99.

FIRTH, R. (ed.) 1957: *Man and culture: an evaluation of the work of Bronislaw Malinowski* (London).

FIRTH, R. 1983: Magnitudes and values in kula exchange. In Leach, E.R. and Leach, J.W. (eds.), *The Kula: new perspectives on Massim exchange* (Cambridge), 89-102.

FITZPATRICK, S.M., ERLANDSON, J.M., ANDERSON, A. and KIRCH, P.V. 2007: Straw boats and the proverbial sea: a response to "Island archaeology: In search of a new horizon". *Island Studies Journal* 2 (2), 229-238.

FLEMMING, N.C. 1968: Archaeological evidence for sea level changes in the Mediterranean. *Underwater Association Report*, 9-13.

FRANCAVIGLIA, V. and PIPERNO, M. 1987: La répartition et la provenance de l'obsidienne archéologique de la Grotta dell'Uzzo et de Monte Cofan (Sicile). *Revue Archéometrie* 11, 31-39.

GINZBURG, C. 2002: *Nessuna* isola *è un'*isola*: quattro sguardi sulla letteratura inglese* (Milano).

GOSDEN, C. and HATHER, J. 1999: The prehistory of food: appetites for change (London).

GOSDEN, C. and HEAD, L. 1994: Landscape: a usefully ambiguous concept. *Archaeology in Oceania* 29, 113-116.

GUZZARDI, L., IOVINO, M.R. and RIVOLI, A.L. 2003: L'organizzazione del villaggio Neolitico di Vulpiglia presso Pachino (Siracusa). *Atti della XXXV Riunione Scientifica dell'Istituto Italiano di Preistoria e Protostoria*, 843-847.

HUNTER, J.R. 1994: 'Maritime culture': notes from the land. *The International Journal of Nautical Archaeology* 23, 261-264.

KAPITAEN, G. 1991: Maritime aspects of early Neolithic coastal settlements in southeast Sicily. In Lazarov, M., Tatcheva, M., Angelova, C. and Georgiev, M. (eds.), *Thracia Pontica IV. Quatrième symposium international (Sozopol, 6-12 octobre 1988): les thèmes, les agglomérations côtières de la Thrace avant la colonisation grecque, les sites submergés – méthodes des recherches* (Sophia), 399-426.

LEACH, E.R. 1983: *The Kula: an alternative view*. In Leach, E.R. and Leach, J.W. (eds.), *The Kula: new perspectives on Massim exchange* (Cambridge), 529-538.

LEACH, E.R. and LEACH, J.W. (eds.) 1983: *The Kula: new perspectives on Massim exchange* (Cambridge).

LEIGHTON, R. 1999: *Sicily before history: an archaeological survey from the Palaeolithic to the Iron Age* (London).

MACINTYRE, M. 1983: Kune on Tubetube and in the Bwanabwana region of the Southern Massim. In Leach, E.R. and Leach, J.W. (eds.), *The Kula: new perspectives on Massim exchange* (Cambridge), 369-382.

MACKENZIE, D.A., 1996: *South Sea: myths and legends* (London). Originally published as: Myths and traditions of the South Sea Islands (London), 1930.

MALINOWSKI, B. 1922: *Argonauts of the western Pacific: an account of native enterprise and adventure in the archipelagos of Melanesian New Guinea* (London).

MALONE, C. 2003: The Italian Neolithic: a synthesis of research. *Journal of World Prehistory* 17 (3), 235-312.

MALONE, C. and STODDART S. 2004: Towards an island of mind? In Cherry, J., Scarre, C. and Shennan, S. (eds.), *Explaining social change: studies in honour of Colin Renfrew* (Cambridge) 93-102.

MANNINO M.A. and THOMAS, K.D. 2007: Towards establishing a chronological framework for hunter-gatherers and early farmers in Sicily: new radiocarbon dates on marine shells from prehistoric cave sites. *Accordia Research Papers* 10, 13-33.

MANNINO, M.A., THOMAS, K.D., LENG, M.J., PIPERNO, M., TUSA, S. and TAGLIA-COZZO, A. 2007: Marine resources in the Mesolithic and Neolithic at the Grotta dell'Uzzo (Sicily): evidence from isotope analyses of marine shells. *Archaeometry* 49 (1), 117-133.

MAUSS, M. 1966: *Sociologie et anthropologie* (Paris).

McCARTHY, F.D. 1939: "Trade" in Aboriginal Australia and "trade" relations with Torres Strait, New Guinea and Malaya. *Oceania* 9, 405-438.

McGRAIL, S. 1991: Early sea voyages. *The International Journal of Nautical Archaeology* 20 (2), 85-93.

McGRAIL, S. 1996: The ship: carrier of goods, people and ideas. In Rice, E.E. (ed.), *The sea and history* (Stroud), 67-96.

ORSI, P. 1912: Nuove scoperte nel territorio di Siracusa. 4. Stentinello. *Notizie Scavi,* 356-357.

ORSI, P. 1915: Stentinello (Comune di Siracusa), villaggio preistorico. *Notizie Scavi*, 209.

PAGLIARA, A. 1995: Fonti per la storia dell'arcipelago eoliano in età greca, con appendice sull'epoca romana. In Bernabò Brea, L. and Cavalier, M. (eds.), *Meligunìs Lipàra 8.1. Salina: Ricerche archeologiche (1989-1993), volume 2* (Palermo).

PARKER, A. J. 2001: Maritime landscapes. *Landscapes* 2 (1), 22-41.

PHOCA-COSMETATOU, N. 2008: Economy and occupation in the Cyclades during the Late Neolithic: the example of Ftelia, Mykonos. In Brodie, N.J., Doole, J., Gavalas, G. and Renfrew, C. (eds.), *Horizon: a colloquium on the prehistory of the Cyclades* (Cambridge), 37-41.

RAINBIRD, P. 1999: Islands out of time: towards a critique of island archaeology. *Journal of Mediterranean Archaeology* 12 (2), 216-234.

RAINBIRD, P. 2007: *The archaeology of islands* (Cambridge).

RENFREW, C. 1973a: The world's first stone temples. In Renfrew, C. (ed.), *Before civilisation: the radiocarbon revolution and Prehistoric Europe* (London).

RENFREW, C. 1973b: *The explanation of culture change* (London).

RENFREW, C. 1975: Trade as action at a distance. In Sabloff, J. and Lamberg-Karlovsky, C.C. (eds.), *Ancient civilization and trade* (Albuquerque), 3-60.

RENFREW, C. 1977: Alternative models for exchange and spatial distribution. In Earle, T.K. and Ericson, J.E. (eds.), *Exchange systems in prehistory* (New York), 71-90.

RENFREW, C. 1984: Islands out of time. In Renfrew C. (ed.), *Approaches to Social Archaeology* (Edinburgh), 200-224.

RENFREW, C. 1993: Trade beyond the material. In Scarre, C. and Healy, F. (eds.), *Trade and exchange in prehistoric Europe. Proceedings of a conference held at the University of Bristol, April 1992* (Oxford, Oxbow Monograph 33), 1-18.

RENFREW, C., and ASPINALL, A., 1990: Aegean obsidian and Franchthi cave. In Perlès, C. (ed.), *Les industries lithiques taillées de Franchthi (Argolide, Grèce). Tome II: les industries du Mésolithique et du Néolithique Initial* (Bloomington), 257-270.

ROBB, J.E. 2007: *The early Mediterranean village: agency, material culture, and social change in Neolithic Italy* (Cambridge).

ROBB, J.E. and TYKOT R. 2002: Ricostruzione di aspetti marittimi e sociali nello scambio dell'ossidiana durante il Neolitico tramite analisi GIS. *Atti della XXXV Riunione Scientifica dell'Istituto Italiano di Preistoria e Protostoria*, 1021-1025.

RUDOLPH, W. 1974: *Boats, rafts, ships* (London).

SAHLINS, M. 1955: Esoteric efflorescence in Easter Island. *American Anthropologist* 57 (5), 1045-1052.

SHARP, A. 1963: *Ancient voyagers in Polynesia* (Auckland).

SMITH, S.P. 1915: *The lore of the Whare-wananga*, chapter on Kupe (New Plymouth, Memoirs of the Polynesian Society 4), 118-133.

SMITH, S.P. 1919: History and traditions of Rarotonga. *Journal of the Polynesian Society* 28, 183-197.

TAGLIACOZZO, A. 1993: Archeozoologia della Grotta dell'Uzzo, Sicilia: da un'economia di caccia ad un'economia di pesca ed allevamento. *Bullettino di Paletnologia Italiana (Supplemento)* 84 (II), 1-278.

TORRENCE, R. 1986: *Production and exchange of stone tools; prehistoric obsidian in the Aegean* (New York).

TRUMP, D. H. 1966: *Skorba* (London).

TUSA, S. 1985: The beginning of farming communities in Italy. In Malone, C. and Stoddart, S. (eds.), *Papers in Italian Archaeology, Vol. 2* (Oxford, BAR International Series 244), 83-86.

TUSA, S. 1996: La Grotta dell'Uzzo. In Tinè, V. (ed.) *Forme e tempi della Neolitizzazione in Italia meridionale e in Sicilia* (Rossano).

TUSA, S. (ed.), 1997: *Prima Sicilia, alle origini della società siciliana* (Palermo).

TUSA, S. 2000: Ethnic dynamics during pre- and proto-history of Sicily. *Journal of Cultural Heritage* 1 (2), 17-28.

TYKOT, R.H. 1996: Obsidian procurement and distribution in the central and western Mediterranean. *Journal of Mediterranean Archaeology* 9 (1), 39-82.

TYKOT, R.H. 1998: Mediterranean islands and multiple flows: the sources and exploitation of Sardinian obsidian. In Shackley, M. (ed.), *Method and theory in archaeological obsidian studies* (New York), 67-82.

TYKOT, R.H., 2002: Geochemical analysis of obsidian and the reconstruction of trade mechanisms in the Early Neolithic of the western Mediterranean. In Jakes, K. (ed.), *Archaeological chemistry: materials, methods, and meaning* (Washington, American Chemical Society Symposium Series 831), 169-184.

TYKOT, R.H., 2004: Scientific methods and applications to archaeological provenance studies. In Martini, M., Milazzo, M. and Piacentini, M. (eds.), *Proceedings of the International School of Physics Enrico Fermi Course CLIV* (Amsterdam), 407-432.

TYKOT, R.H. and AMMERMAN, A.J. 1997: New directions in Central Mediterranean obsidian studies. *Antiquity* 71, 1000-1006.

TYKOT, R.H., MORTER, J. and ROBB, J.E. (eds.) 1999: *Social dynamics of the prehistoric Central Mediterranean* (London, Accordia Specialist Studies on the Mediterranean 3), 67-82.

VILLARI, P. 1991: The faunal remains in the Bothros of Aeolos (Lipari). *Archaeozoologia* 4 (2), 109-126.

VILLARI, P. 1997: Il ruolo della fauna nella preistoria siciliana: caccia, pesca, domesticazione, allevamento. In Tusa, S. (ed.), *Prima Sicilia, alle origini della società siciliana* (Palermo), 223-226.

WESTERDAHL, C. 1992: The maritime cultural landscape. *The International Journal of Nautical Archaeology* 21, 5-14.

WESTLEY, K. and DIX, J. 2006: Coastal environments and their role in prehistoric migrations. *Journal of Maritime Archaeology* 1 (1), 9-28.

WHITTLE, A. 1996: *Europe in the Neolithic: the creation of new worlds* (Cambridge).

WILLIAMS, J.L.L. 1980: A petrographical examination of the prehistoric pottery from the excavations in the Castello and Diana Plain of Lipari. *Meligunìs Lipàra* 4. Appendix VII (Palermo), 845-868.

WILLIAMS, J.L.L. and LEVI, S.T. 2001: Archeometria della ceramica eoliana: nuovi risultati, sintesi e prospettive. The petrographic characterisation of Neolithic pottery fabrics from the excavations in the Acropolis and Diana areas of Lipari - Capri, Serra d'Alto and Diana. In S*tudi di Preistoria e Protostoria in onore di Luigi Bernabò Brea. Quaderni del Museo Archeologico Regionale Eoliano "Luigi Bernabò Brea", Supplemento I* (Palermo), 277-304.

WILLIAMS THORPE, O. 1995: Obsidian in the Mediterranean and the Near East: a provenance success story. *Archaeometry* 37 (2), 217-224.

The lure of the islands:
Malta's first Neolithic colonisers

Anthony Bonanno

Geographical parameters

Malta's ancient history, including its prehistory, is intricately linked with that of its closest neighbour, the island of Sicily. Sicily was the land of origin of its first colonisers. Sicily was the source from which these early farmers brought the first domesticated animals and seeds to help them set up a new agricultural economy on the archipelago. From Sicily they brought the first raw materials for their lithic instruments as well as their whole cultural baggage. Throughout the Neolithic (5000-4100 BC; Table 1)[1] the inhabitants of the Maltese islands maintained a steady flow of imported hard stone from Sicily (flint) or via Sicily (Lipari and Pantelleria obsidian).

The Maltese archipelago lies about 90 km to the south of the south-eastern tip of Sicily (Figure 7.1). It consists mainly of four small islands only the two larger of which, Malta (27 km long) and Gozo (14.5 km long), between them had a sufficient surface area (just over 300 sq km) to sustain a subsistence economy based on agriculture. The predominantly limestone geology, with a very useful layer of blue clay sandwiched in-between, provided sufficient arable land and natural aquifers to support a maximum population of 10,000 heads. Colin

Table 7.1: Chronological sequence of Maltese prehistory			
PERIODS	*PHASES*	*SUGGESTED CALIBRATED RADIOCARBON DATES BC (Renfrew 1972)*	*OTHER APPROXIMATE DATES BC*
BRONZE (and IRON) AGE	Bahrija		900-700
	Borg in-Nadur		1500-700
	Tarxien Cemetry	2500-1500	
TEMPLE PERIOD	Tarxien	3300/3000-2500	
	Saflieni		3300-3000
	Ggantija	3600-3300/3000	
	Mgarr	3800-3600	
	Zebbug	4100-3800	
NEOLITHIC	Red Skorba	4400-4100	
	Grey Skorba	4500-4400	
	Ghar Dalam	5000-4500	

[1] For the purpose of this paper, the term 'Neolithic' is applied to the first of the three major divisions of Maltese prehistory, which is in turn subdivided into three phases (see Table 7.1). The second period, characterised by its megalithic temples, was previously referred to as 'Copper Age' because of its contemporaneity with that of Italy and Sicily, but is currently labeled 'Temple Period'.

Renfrew's estimate of 11,000 for the climax of the Temple Culture might be somewhat too generous (Renfrew 1973, 152-155); Brian Blouet's figure of 4000 appears much more realistic (Blouet 2004, 25) even though for the late Middle Ages historians find evidence for a population of between 8000 and 10,000 (Blouet 2004, 57). The two smaller islands midway in the narrow channel between Gozo and Malta, and an isolated rock off to the south-west of Malta appear to have always been inhospitable, without a sufficient amount of arable land and a perennial water supply.

Presumed predecessors

In academic literature Malta's prehistory is made to start around 5000 BC, coinciding with the earliest secure available evidence of human presence on the island. This stance, however, begs the question as to whether the earliest Neolithic farmers to settle on Malta had been preceded by earlier inhabitants with whom they could relate. Indeed, in 1918 two taurodontic human molars were reported to have been discovered in the previous year in a Mid-Pleistocene level during excavations conducted inside the cave of Ghar Dalam near the south-eastern harbour of Malta (Despott 1918, 220-221; Keith 1924, 254). Arthur Keith of the London Anthropological Society immediately accepted these finds as certain evidence for the presence of a group of Neanderthal men on Malta in the Upper Palaeolithic (Keith 1918, 1924).[2]

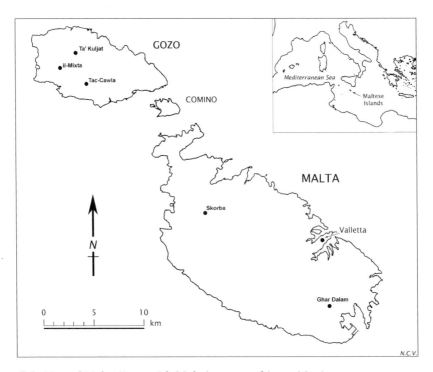

Figure 7.1: Map of Malta (inset with Malta's geographic position)

[2] In 1936 one more human molar with the same characteristics was found in similar contexts in the same cave, in a level mixed with pottery and other, clearly not Pleistocene, cultural material (M.A.R. 1936-37, 19-20).

But already in 1926 a dispassionate and acute examination of the excavation reports, in particular the obviously disturbed layers in which the teeth were found, led the German scholar H. Obermaier to discount peremptorily Keith's claim (Obermaier 1926). The same was done by John Evans who in the 1950s was entrusted with the drawing up of a comprehensive survey of the prehistoric remains of the Maltese islands (Evans 1959, 36; 1971, 19, 208). Even Themistokles Zammit, the Maltese scholar who loomed large in local archaeology in the first third of the 20th century, was no exception. He never accepted this and other finds as amounting to 'a proof of the existence of palaeolithic man in these islands' (Zammit 1952, 25-26). The extraction of two taurodontic molars from a living human by a local dentist in 1962 (Mangion 1962), and the results of biochemical analyses of the Ghar Dalam teeth conducted at the British Museum (Natural History section) which dated them as 'not older than the Neolithic' (M.A.R. 1963, 5; Oakley 1971) sealed the fate of Keith's theory once and for all. Until, that is, it was recently revived in a volume written and published by two Maltese paediatricians (Mifsud and Mifsud 1997).[3]

These authors also took into account claims made on several occasions by Emmanuel Anati that he had identified remains of cave paintings inside Ghar Hasan, a much frequented cave perched on the cliff face of the south-eastern coast of Malta, not far from Ghar Dalam. Anati claimed he could identify animal figures, hand prints and a 'vaguely anthropomorphic shape'. He also made comparisons with other cave paintings normally associated with 'archaic hunting peoples' in Italy, Spain, Romania and even Russia, but stopped short of dating the presumed paintings more precisely (Anati 1990, 1995).

Although the land that now forms the Maltese islands was for several periods during the Pleistocene physically connected with Sicily and the continent as a result of falling sea levels,[4] thus making it possible for human beings to move overland to these high rises, as it was for several animal species like pygmy elephants and hippopotami whose bones were found inside Ghar Dalam, the evidence provided by the Ghar Dalam teeth is far too uncertain to be accepted at its face value. The alleged cave paintings, then, require further investigation before a more positive judgement can be made. In any case, the two sets of evidence are quite distinct and chronologically separated by tens of thousands of years for them to be made to converge towards proving a human presence in Malta during the Palaeolithic.

Whether a human presence on the Maltese landscape in the Palaeolithic is ever proved by further, more stringent evidence, or not, it is unlikely to be found to belong to a permanent settlement, even less so to a fully-fledged *colonisation* process. At most, it would probably be the relic of sporadic use of natural caves for shelter or dwelling as part of the same process as that affecting the northern mainland to which the land was physically attached.

Already at this stage the role of Sicily as an unavoidable route for prehistoric migrations of animals or human beings to Malta is crucial. Although many attempts have been made over the years to push back human activity in that island to as far as the Lower Palaeolithic, conservative academic scholarship has seriously assessed the produced evidence and deemed it of insufficient solidity, at most 'problematic' (Bonfiglio and Piperno 1996; see also Mussi 2001, 90). Thus, even for Sicily, it is still premature to claim human presence prior to the

[3] The authors of this publication have attempted to prove that the results of the scientific analyses of the teeth in question, and of some others from Maltese prehistoric contexts, conducted at the British Museum (Natural History section) in the 1950s, were somehow manipulated to reduce their age.

[4] These periods differ in date according to different glacial denomination systems. According to the classic system, the last fall in sea levels took place around 18,000 years ago.

Aurignacian (30,000 years ago) since radiometric dates are still lacking for these finds and none of them are 'certainly associated with necessarily early palaeontological material' (Leighton 1996; see also Leighton 1999, 21-22).[5]

Pre-colonisation movements

The earliest fully documented human presence on the Maltese islands dates back to the very end of the 6th millennium or the beginning of the 5th millennium BC (c. 5000 BC). This and the following dates are based mainly on radiocarbon determinations produced from samples extracted by David Trump from the site of Skorba in the early 1960s (Trump 1966), calibrated by Renfrew (1972) and confirmed by a series of new determinations produced by the excavation of the underground cemetery of the Xaghra Circle, Gozo, between 1987 and 1994 (Trump 1997).

It has been argued, however, that the permanent settlements of the *Ghar Dalam* phase (5000-4500 BC), such as that documented by the open Neolithic village of Skorba, could not have taken place without a series of visits to the islands from nearby Sicily taking place beforehand (Fedele 1988). The possibility – I would even say, the probability – that such pre-colonisation visits took place exists and needs to be taken into account; but, as yet, we have no tangible proof to sustain it. The evidence of occupation in caves, like that inside the Ghar Dalam and Il-Mixta caves could have resulted from sporadic visitations rather than permanent habitation. The pottery found in them, however, seems locally made, even if inspired by Sicilian (*Stentinello*) wares. As for the open-air habitations, the investment in their structures and domestic equipment – later, also religious equipment – implies permanent settlements.

Malta still lacks archaeological deposits belonging either to Mesolithic or pre-pottery (or pre-farming) Neolithic communities like those discovered in other Mediterranean (albeit larger) islands, like Cyprus (Shillourokambos, Mylouthkia and Khirokitia), Crete (Knossos) and Sicily (the Uzzo cave). The size of the islands makes them more comparable to other small islands, or groups of islands, like the Aeolian and the Balearic islands, which also miss out on such early archaeological evidence (see Cherry 1981, 1984, 1990, 1995). Besides, there are on Malta neither mineral deposits nor any other natural resources, like those of obsidian on the islands of Melos and Lipari, likely to attract early sporadic visits, prior to the farming Neolithic settlements.[6] Therefore, whereas it would not harm anyone to keep looking for such evidence it would still be very much of a surprise, even though not an unwelcome one, if it were ever found.

Environment and resources of the Maltese islands

The present geography of the Maltese islands results from the submersion of the ridge which during the Pleistocene formed an epicontinental land bridge extending southwards from Italy and incorporating Sicily, which permitted the migration of the exotic fauna whose bone remains were found at Ghar Dalam and in other caves and fissures.

[5] According to Margherita Mussi (2001, 327), 'Sicily was, in a way, the 'last frontier' throughout the Palaeo-lithic...The strait of Messina was crossed by human groups manufacturing Aurignacian tools. This early Upper Palaeolithic settlement, however, was a dead-end. Real and permanent colonization only happened much later and was a well established fact by 12.000 bp.'

[6] Such as the Melian obsidian found in the Franchthi cave on the mainland.

Only Malta, with a surface area of 245.7 sq km, and Gozo, with a surface area of 67.1 sq km, appear to have been inhabited in early prehistoric times. Both islands have sheltered inlets suitable for landing and for sheltering fishing boats. The west coast of both islands rises abruptly with high cliffs from the sea, while the north-east coast of Malta drops gently and opens up in various inlets and two extraordinarily deep and sheltered harbours. Fishing resources have been reasonably abundant until they started to be depleted along with those of the rest of the Mediterranean in modern times.

The geomorphology is characterised by articulated hills on the west of Malta and mezas of different sizes scattered all over Gozo – none of which exceeding 250 m in altitude – with small, fertile, sloping plains suitable for agriculture in-between. Softer hills prevail on the east half of Malta with valleys and seasonal watercourses.

The fauna present on the islands at the time of the earliest settlement of Neolithic farmers must have been that which survived the final separation from Sicily (c. 15,000-10,000 years ago) and which was represented by the bone remains in the so-called 'Red Deer Layer' at Ghar Dalam, like bear, wolf, fox and, obviously, the predominant red deer. Some of these might have already gone extinct by the time of the first human settlement. Of these only deer is represented in the bone repertoire of the cultural horizons, and that by only one example in the Temple period. All domesticated animals had to be imported from outside. So did flint and obsidian and other hard stones, like jadeite and serpentinite, that were needed for efficient lithic instruments and personal ornaments of prestige. The islands possessed, on the other hand, abundant deposits of two types of limestone, both excellent for building purposes. Utilised only in its raw state without any manipulation in the first 1500 years of human presence on the islands, this mineral resource later made possible the rise of the extraordinary architecture of the megalithic temples. A geological deposit of clay was used extensively for wattle-and-daub and mud-brick domestic structures, as well as for pottery manufacture.

The islands might have had a discreet tree cover before it was greatly cut down for opening up new arable land.[7] It provided suitable structural material as well as fuel. All domesticated plants had to be imported for cultivation. Unfortunately, proper biological sampling had never been the rule of the day in archaeological excavations until the late 1980s and, as a result, we have no records of floral taxonomies for any period in prehistory. At present, studies are underway of several deep cores in the alluvium at the lower end of the main water course in Malta with the purpose of establishing a sequence of environmental changes based on floral taxa and molluscs extending back to beyond the earliest human presence on the island (Carroll *et al.* 2004).

First Neolithic colonisation

The first people to settle on the Maltese islands appear to have crossed there from the south-eastern coast of Sicily. The stretch of sea that separates the two islands at this point is only 90 km and the islands are mutually visible on the horizon on clear days. Besides, the pottery repertoire of these early inhabitants is almost identical to that of the *Stentinello* culture of this part of Sicily (Matrensa, Stentinello etc.), although closer affinities have been proposed with the predominant *Stentinello* forms at Monte Kronio, near Sciacca, a considerable way further to the

[7] This is mostly presumed, since no environmental samples have been analysed from archaeological horizons prior to the Neolithic (see Hunt 1997 and Schembri 1997).

west on the same south-facing coast. Now that the *Stentinello* ware has been found to extend much further into western Sicily than was thought before, the *Ghar Dalam* people could have departed from any point on the south coast of Sicily, but the geography suggests that the probability increases towards the east, since the distance to be traversed gets shorter and shorter.

A migration is the only possible scenario that can be proposed for the emergence of the first farming communities in Malta, since, as it has already been stated, there were no pre-Neolithic native inhabitants to absorb the new way of life. This movement of people could have taken place under different forms, ranging from a trickle of people gradually filtering in and exploiting readily available cave shelters for temporary dwellings (like that of Ghar Dalam), to a number of families setting out together and taking up residence in organised open villages, like that of Skorba. Whatever the format of this earliest migration into Malta, these farmers had to transport the first specimens of their domesticated plants and animal stocks since these were not available in the wild on the islands. And in order to accomplish this transfer, in particular that of the larger animals, like cattle, they must have been in possession of capacious and sturdy sea-craft and of the necessary navigational skills.

The archaeological deposits belonging to this first phase of Maltese prehistory were first met at Ghar Dalam from which the phase derived its name. This context suggested the use of caves for some sort of occupation, probably for habitation, but even the uppermost layer inside this cave, the cultural deposit, was substantially disturbed and contained archaeological material of later prehistoric phases, as well as later historical ages (Evans 1971, 18-21). For this reason pure, uncontaminated *Ghar Dalam* levels were greatly appreciated whenever they were encountered. The most important of such finds was that of Skorba where pure *Ghar Dalam* levels were discovered in association with domestic huts and with a stretch of thick wall (Trump 1966, 10-11). This wall is still rather enigmatic and has not been properly explained, probably because only a limited section of it was uncovered. It could simply be a boundary wall,[8] but the possibility of a defence wall is not excluded even though the choice of the location of the village would not suggest such a preoccupation (see Trump 1966, 11). The hut remains, however, provide clear indication for the presence of an open village incorporating a cluster of modest huts that was to survive well into the Temple period when two megalithic temples were constructed on part of the village.

The island of Gozo constitutes the first landfall for any vessel approaching the archipelago from the north. Although Gozo does not have any proper natural harbours, it was quite possible for the first scouting visitors to land first in one of its several inlets – referred to as 'well-placed harbours' by the 1st century BC Greek historian Diodorus Siculus – and eventually set up home there, conceivably before they did so on Malta itself. Some of the pottery retrieved in an uncontrolled excavation at Il-Mixta, in one of the caves that surround the plateau of Ghajn Abdun on Gozo (Trump 2002, 28, 31, 186-187), has impressed decorative motifs that make it even closer to pottery of the parent *Stentinello* culture in Sicily than the equivalent impressed pottery from Ghar Dalam, Skorba and other sites on Malta. Unfortunately, further controlled excavations by the Director of the Museum Department in 1969-70 did not confirm the presence of an early Neolithic occupation in the area (M.A.R. 1969, 15-16, 1970, 6).

The only other excavated archaeological site in Gozo that has produced Neolithic material is Santa Verna which was explored in 1911 (Ashby *et al.* 1913, 105-123; Evans 1971, 186-

[8] Like the one at Piano Vento (Leighton 1999, 71, 73).

190). This site, together with a marked concentration of pottery sherds of the *Red Skorba* phase recently identified on the slope of Ta' Kuljat, one of the hills close to Xaghra (Brown 1990, 22), suggest that the settlement pattern on Gozo in the Neolithic was not limited to cave dwelling, but extended also to open villages (De Lucca 1990, 122); the site of Ic-Cnus ta' San Gwann at Ix-Xewkija was mainly a temple period complex and produced only a few sherds of the Neolithic period when Fr Manuel Magri made some trial excavations there (Evans 1971, 191-192; Magri 1906). Claims of evidence of a Neolithic settlement at Tac-Cawla, near Rabat (Veen and van der Blom 1992, 19-26), have also been confirmed, though to a limited extent, by an archaeological investigation made by a research team from Oxford University in April 1995 (Horton 1995). From these scanty finds one gets the impression that these Neolithic inhabitants lived in sparsely scattered sites, natural caves or settlements consisting of a few huts.

What could have motivated these early visitors to set up home in these two remote islands, some distance from the nearest Sicilian landfall? The geological formation of both Malta and Gozo lacks sufficiently hard stone, such as flint, to make really efficient cutting instruments. Certain areas in the islands produce an inferior type of flint, commonly known as 'chert' in archaeological circles, which served a limited range of purposes. So flint and obsidian (which was already in current use among Sicilian early Neolithic farmers) had to be carried along to Malta over a longish stretch of open sea.

The two islands lacked the domesticated range of seeds and animals normally associated with a typical Neolithic economy. These had to be transported over to the Maltese islands in order to start up new stocks. Presumably, new units were occasionally introduced to freshen up the otherwise inbred stocks of animals. Given this dearth of raw materials for a viable economy on the islands it is difficult to guess what might have induced these early settlers to abandon their homes in the larger island to colonise the smaller ones, regardless of all the risks involved. Land hunger and population pressures, given the size and carrying capacity of Sicily, is not high on the list of probabilities. Social tensions or competition could be a possible motivation. Or is it the innate crave for novelty and adventure that drove these people to start a new life in a place that was probably already perceived as being on the 'edge of the visible world' (Malone and Stoddart 2004)? Whatever the motivation, all we see is a duplication of the settlement pattern experienced in Sicily.

Having embarked on a new lease of life on the two major Maltese islands, the new inhabitants appear to have kept their trading and cultural connections with their Sicilian cousins alive. So much so that Sicilian sources of good quality flint and Lipari (and Pantelleria) obsidian continued to provide the Maltese Neolithic farming community with excellent raw materials for efficient lithic instruments, obsidian no doubt reaching Malta via Sicily. This is only an assumption based on a geo-historical reality. Direct sea routes between these islands and Malta must have been much more difficult and less convenient in prehistoric times than ones making use of the intermediary of Sicily. This presumption can only be proved or negated, however, by further scientific studies of imported products in relation to their sources (e.g. Tykot 1996; Tykot and Ammerman 1997). It should be noted that obsidian from either of the two documented sources (Lipari and Pantelleria) reached Malta down the line of exchange through the Sicilian intermediary, and that Malta was at the southernmost edge of that line of exchange.

Even the pottery styles tend to remain to some extent faithful to those prevalent among the communities of the parent island. That of the second phase – *Grey Skorba* (4500-4400 BC;

Table 1) – is rather uninspiring and greatly inferior to the *Serra d'Alto* repertoire prevalent in eastern Sicily in the Middle Neolithic. Both the elaborate handles and the painted decoration of the *Serra d'Alto* ware are absent. This might be taken to imply a relative detachment from the parent culture, possibly an inferior quality of life, even though trade links are still apparent in the imported obsidian and flint. The situation improves greatly, however, in the following *Red Skorba* phase (4400-4100 BC) when the Maltese pottery shows greater affinity to the *Diana* pottery of the Aeolian and Sicilian Late Neolithic, from which it was obviously inspired.

Of all the sites mentioned above the most important so far remains the Skorba settlement. One modest *Ghar Dalam* hut was built of wattle and daub. It might have been re-used in the following (*Grey Skorba*) phase. New ones were built in the last phase. Then, two huts joined by a common cobbled courtyard, belonging to the last phase of the Neolithic (the *Red Skorba* phase, 4400-4100 BC) reveal a different aspect of the life of this Neolithic community. The objects found inside the larger of the two huts suggested a non-domestic, most probably religious, purpose. Fragments of several figurines of the same, overtly feminine, iconography suggest some cultic activity connected with a female divinity probably associated with fertility. This 'religious' activity marks a very important trait of autonomous development of this community with respect to the Late Neolithic ones in neighbouring Sicily and Lipari where no evidence of a similar concern has ever surfaced.[9] On the other hand, the building techniques are similar to those of Sicily.

From the scanty remains recovered from Skorba it appears that the early inhabitants of the Maltese archipelago depended on a simple subsistence farming economy. It is normally assumed that a system of shifting agriculture was practised at the time when the advantages of crop rotation were yet unknown. Clearing land of indigenous vegetation made cultivation possible for a few years, after which the naturally fertile soil was depleted of the nutrients required by the crop. Therefore, new land was cleared, allowing the former to recover its fertility through the natural cycle. This system could not but succeed at the expense of woodland. It marked the beginning of a long process of woodland denudation which reached its peak in early modern times (Schembri 1997). Evidence of crops comes from the Ghar Dalam hut at Skorba; they consisted of barley, wheat and lentils (Trump 1966, 24). As for animal husbandry, bones of ovicaprids, pig and cow were also present. A large quantity of seashells found already in this early phase seems to have been procured for food, only one appearing to be pierced for suspension as ornament (ibid., 24). Pierced more clearly for the same purpose are a cockle and a cowrie (along with a cow incisor) from the second phase horizon (*Grey Skorba* phase, 4500-4400 BC) (ibid., 28). Similar piercing is also noted on individual pieces in the Red Skorba shrine. Even in these last two phases the remaining seashells were a source of food, having no evidence for tool use.

Some hunting seems also to have taken place. This is suggested by the numerous sling-stones found in the cultural layer at Ghar Dalam, as well as those found in the better defined *Grey Skorba* contexts at Skorba (Evans 1971, 210; Trump 1966, 29, pl. XXIIId). Besides birds, hunting could have been directed to any surviving wild fauna from the late Pleistocene, such as wild boar and deer (Evans 1971, 100, 165, 222, 239-241).

In a semi-arid island like Malta, water was clearly an indispensable factor in the lives of these early farmers, both for domestic purposes and for their crops. It must have been,

[9] The single figure from Piano Vento is not enough to denote a religious function (Leighton 1999, 71).

consequently, a determining factor in the choice of the site for a permanent settlement. All Neolithic settlement sites are in fact located in the western part of Malta, and in Gozo; in areas, that is, where the presence of a blue clay stratum in the geological formation produces perennial springs. Only the cave of Ghar Dalam is in the east of Malta where this clay formation is absent. However, the cave perforates the side of a deep *wied* ('river valley'). The formation of the cave itself by water solution suggests the presence in antiquity of a much higher aquifer in the area.[10] Recent studies, using Geographic Information Systems and centuries-old place names, have confirmed the existence of natural water storage systems in the vicinity of prehistoric sites, that have disappeared with the exponential increase in water extraction from both the perched and the lower water tables (Bonanno 2009; Grima 2004). A case in point is Ghar Dalam which coincides with the occurrence of several water-bearing place names like *ghadira* ('pond') documented in the 17th century (Abela 1647, 109) and *menca de gadir, aquae stagnum in contrada gadir ad umectandum linum.* ('a quagmire used for retting flax') documented in a notarial deed of 1522 (Wettinger 2000, 373).

One would expect that the sea was another source of nutrition for people who by the very fact of their transfer to the islands proved they had the means to exploit it even out in the open, like their predecessors had done at Uzzo cave and on the small island of Levanzo (Leighton 1999, 57-58, 81-82). Even though Skorba is two-three kilometres away from the nearest navigable inlets, seashells, but not fish bones, were reasonably common there. Confirmation or otherwise of fish consumption is likely to come when, and if, other sites of the period, including burial ones, are explored.[11] The situation with regard to the diet of the Neolithic inhabitants remained roughly the same through the other two phases of the Neolithic, the *Grey Skorba* (4500-4400 BC) and the *Red Skorba* (4400-4100 BC) phases.

Distribution of labour at this early stage must have been of a very simple type, if at all. There is, however, no evidence for such distribution or for a distinction based on gender and ages. A stone quern found in the Neolithic hut at Skorba shows that this activity took place inside the hut (Evans 1971, 209; Trump 1966, 10). Some weaving was also done, as we can see from the clay spindle whorls found in *Red Skorba* levels at Skorba (Trump 1966, 34, fig. 31a-b). Flint and chert were probably also used in leather working to provide warm clothing for the colder months.

It is not possible to say what degree of specialisation was exercised by these early communities – probably very little – nor whether pottery production was the concern of specialised craftsmen, or an occasional domestic activity. No pottery kiln has yet been identified in Malta for the whole of the Neolithic. What is certain is that the first pottery types were imported from Sicily with the first migration, but thenceforth it continued to be manufactured locally where the raw materials, clay and fire-wood, were readily available.

The purpose of the Ghar Dalam wall discovered at Skorba, datable to this period, is not clear (Trump 1966, 10), but so far we have no other indication of a preoccupation with defence, whereas we find a different situation in Sicily where the early Neolithic settlements are characterised by defensive moats.

[10] The usually accepted model for the formation of the cave is that it formed beneath the river bed, before the latter broke through the cave's ceiling as it wore down through the rock (Zammit Maempel 1989, 27-32).

[11] Burials, which could be a source of human bones for isotope analysis, are strangely absent in the archaeological record for the whole of the Maltese Neolithic.

A change of population?

Around 4000 BC the ceramic repertoire changed completely, suggesting a change of culture without, however, any apparent interruption in the occupation of the Skorba village. It is still not possible to explain this change. The Neolithic population could have been wiped out or forced to leave the island by a natural disaster and replaced by another migration. This is the traditional view, even though there is hardly any evidence to support it other than the absence of any continuity of culture. Alternatively, the same people were for some unknown reason forced to forego their pottery style in favour of a new one derived again from contemporary cultures in eastern Sicily, the *San Cono/Piano Notaro* cultures (McConnell 1992). It is still hard to resist the view of an inflow of a new population carrying with it the new pottery style. Apart from the complete change in the pottery style, however, the rest of the material culture remains virtually unaltered, except that from the very start, along with some huts at Skorba belonging to this phase and the continued occupation of Ghar Dalam, there appears a cultural facet which is not recorded for the previous age: the collective rock-cut tombs that have their counterparts in both Italy and Sicily (Malone 1996).

References

ABELA, G.F. 1647: *Della descrittione di Malta, isola del Mare Siciliano con le sue antichità ed altre notizie* (Malta).

ANATI, E. 1990: Arte preistorica a Malta. *Bollettino del Centro Camuno di Studi Preistorici* 25-26, 166-172.

ANATI, E. 1995: Archaeological exploration in Malta. *Bollettino del Centro Camuno di Studi Preistorici* 28, 103-106.

ASHBY, T., BRADLEY, R.N., PEET, T.E. and TAGLIAFERRO, N. 1913: Excavations in 1908-11 in various megalithic buildings in Malta and Gozo. *Papers of the British School at Rome* 6, 1-126.

BLOUET, B.B. 2004: *The Story of Malta* (Malta, revised edition).

BONANNO, A. 2009: L'acqua nella cultura dei templi megalitici di Malta. *Mare Internum: Archeologia e Culture del Mediterraneo* 1, 25-31.

BONFIGLIO, L. and PIPERNO, M. 1996: Early faunal and human populations. In Leighton, R. (ed.), *Early societies in Sicily: new developments in archaeological research* (London), 21-29.

BROWN, D. 1990: The field survey programme: an interim statement. In Malone, C. and Stoddart, S. (ed.), *Joint Bristol-Cambridge-Malta-York Universities, Museum of Malta, Gozo Project. 1990 Season. Provisional Report* (cyclostyled), 20-23.

CARROLL, F.A., FENECH K., BONANNO A., HUNT C., JONES A.M. and SCHEMBRI P.J. 2004: The past environment of the Maltese Islands: the Marsa cores. In *Exploring the Maltese Prehistoric Temple Culture (2003 Conference in Malta)* (Sarasota, OTSF; available only on CD).

CHERRY, J.F. 1981: Pattern and process in the earliest colonization of Mediterranean islands. *Proceedings of the Prehistoric Society* 47, 41-68.

CHERRY, J.F. 1984: The initial colonisation of the Western Mediterranean islands in the light of island biogeography and palaeogeography. In Waldren, W.H., Chapman, R.,

Lewthwaite, J. and Kennard, R.C. (eds.), *Early settlement in the Western Mediterranean islands and the peripheral areas. The Deya Conference of Prehistory* (Oxford, BAR International Series 229), 7-23.

CHERRY, J.F. 1990: The first colonisation of the Mediterranean islands: a review of recent research. *Journal of Mediterranean Archaeology* 3 (2), 145-221.

CHERRY J.F. (ed.) 1995: Colonization of islands. *World Archaeology* 26 (3).

DE LUCCA, D. 1990: The built environment in Gozo: a historical review. In Cini, C. (ed.), *Gozo. The Roots of an Island* (Malta), 121-159.

DESPOTT, G. 1918: Excavations conducted at Ghar Dalam (Malta) in the Summer of 1917. *Journal of the Royal Anthropological Institute* 48, 214-221.

EVANS, J.D. 1959: *Malta* (London).

EVANS, J.D. 1971: *The prehistoric antiquities of the Maltese islands, a survey* (London).

FEDELE, F. 1988: Malta: origini e sviluppo del popolamento preistorico. In Fradkin Anati, A. and Anati, E. (eds.), *Missione a Malta: ricerche e studi sulla preistoria dell'Arcipelago Maltese nel contesto Mediterraneo* (Milan), 51-90.

GRIMA, R. 2004: The landscape context of megalithic architecture. In Cilia, D. (ed.), *Malta before history* (Malta), 326-345.

HORTON, M.C. 1995: *Assessment of archaeological evaluation by the Museums Department at Tac-Cawla, Rabat, Gozo* (unpublished cyclostyled report to the Ministry of Youths and the Arts, Malta. National Museum of Archaeology).

HUNT, C.O. 1997: Quaternary deposits in the Maltese Islands a microcosm of environmental change in Mediterranean lands. *Geojournal* 41 (2), 101-109.

KEITH, A. 1918: Discovery of Neanderthal Man in Malta. *Nature* 3543 (25 July 1918), 404-405.

KEITH, A. 1924: Neanderthal Man in Malta. *Journal of the Royal Anthropological Institute* 56, 251-260.

LEIGHTON, R. 1996: Research traditions, chronology and current issues: an introduction. In Leighton, R. (ed.), *Early societies in Sicily: new developments in archaeological research* (London), 1-13.

LEIGHTON, R. 1999: *Sicily before History: an archaeological survey from the Palaeolithic to the Iron Age* (London).

MAGRI, E. 1906: *Ruins of a megalithic temple at Xeuchia (Shewkiyah), Gozo, First Report* (Malta).

MALONE, C. 1996: Cult and burial in the Neolithic and Early Bronze Age Central Mediterranean, an assessment of the potential. In Wilkins, J.B. (ed.), *Approaches to the study of ritual* (London), 31-54.

MALONE, C. and STODDART, S. 2004: Towards an island of mind? In Cherry, J., Scarre, C. and Shennan S. (eds.), *Explaining social change: studies in honour of Colin Renfrew* (Cambridge), 93-102.

MANGION, J.J. 1962: Two cases of taurodontism in modern human jaws. *British Dental Journal* 113, 309-312.

M.A.R. 1936-37: *Museum Annual Reports* (Malta).

M.A.R. 1963: *Museum Annual Reports* (Malta).

M.A.R. 1969: *Museum Annual Reports* (Malta).

M.A.R. 1970: *Museum Annual Reports* (Malta).

McCONNELL, B. 1992: *San Cono- Piano Notaro- Grotta Zubbia ceramics in Sicilian prehistory* (1985 PhD thesis, Brown University) (Ann Arbor, Michigan).

MIFSUD, A. and MIFSUD, S. 1997: *Dossier Malta: evidence for the Magdalenian* (Malta).

MUSSI, M. 2001: *Earliest Italy: an overview of the Italian Paleolithic and Mesolithic* (New York).

OAKLEY, K.P. 1971: Malta. In Oakley, K.P., Campbell, B.G. and Molleson, T.I. (eds.), *Catalogue of fossil hominids,* II, *Europe* (London), 263-264.

OBERMAIER, H. 1926: Malta: Paläolithikum. In Ebert, M. (ed.), *Reallexikon der Vorgeschichte* 7 (Berlin), 356-357.

RENFREW, C. 1972: Malta and the calibrated radiocarbon chronology. *Antiquity* 46, 141-145.

RENFREW, C. 1973: *Before civilization: the radiocarbon revolution and prehistoric Europe* (London).

SCHEMBRI, P.J. 1997: The Maltese islands: climate, vegetation and landscape. *Geojournal* 41 (2), 115-125.

TRUMP, D.H. 1966: *Skorba* (London).

TRUMP, D.H. 1997: Radiocarbon dates from Malta. *Accordia Research Papers* 6 (1995-96), 173-177.

TRUMP, D.H. 2002: *Malta: prehistory and temples* (Malta).

TYKOT, R.H. 1996: Obsidian procurement and distribution in the central and western Mediterranean. *Journal of Mediterranean Archaeology* 9 (1), 39-82.

TYKOT, R.H. and AMMERMAN, A.J. 1997: New directions in central Mediterranean obsidian studies. *Antiquity* 71, 1000-1006.

VEEN, V. and VAN DER BLOM, A. 1992: *The First Maltese* (Haarlem).

WETTINGER, G. 2000: *Place-names of the Maltese islands ca. 1300-1800* (Malta).

ZAMMIT, T. 1952: *Malta: the Maltese islands and their history* (Malta, 3rd edition).

ZAMMIT MAEMPEL, G. 1989: *Ghar Dalam. Cave and deposits* (Malta).

Islands from the South: an Oceanian perspective on island colonisation

Atholl Anderson

Introduction

Much of what happened prehistorically on islands is common currency between the Mediterranean and the Pacific. We have, for example, a mutual interest in the timing and nature of human impact on island biotas, by destruction and introduction (e.g. Alcover 1998, 2000; Anderson 2002). So, although my research is primarily in the Pacific, I have visited Corbeddu Cave, Sardinia, with Paul Sondaar and Cueva de Moros on Mallorca, with Antonio Alcover, to inspect stratigraphic evidence concerning the extinction of *Prolagus* and *Myotragus* respectively. Another common theme, in some respects related, is colonisation of the insular landscape, and it is aspects of that which are discussed here. An obvious place to begin is with variation in the effect of geometry and scale, notably between the Mediterranean and the Pacific, and their significance for understanding remoteness. In discussing these I use a broad tripartite division of island proximity by simple map distance across the sea. These matters then command discussion of the role of seafaring as an agent of amelioration in distance and thereby in the construction of remoteness or isolation. Following from that is the role of climatically-induced change in the parameters of the insular landscape, particularly as those might from time to time have affected the efficacy of seafaring. Lastly, I turn to one of those elusive desiderata of the research field, which is how prehistoric islanders themselves, in this case Polynesians, understood or internalised the appropriation of newly-found islands.

The concept of landscape is as useful in insular as terrestrial regions to express spatial relationships in historical perspective. As is apparent, however, I prefer 'insular landscape' to the term currently in vogue, 'seascape'. The latter has no necessary connotation of islands. It is used to imply a familiarity with the geography of the sea which sustained connectivity between islands (Gosden and Pavlides 1994) that can only have been partly true in colonising phases, and seldom in remote situations, and it bears another kind of aesthetic meaning which is generally not intended in archaeological use.

Contrasting cultural geographies

In several ways the Mediterranean and the Pacific represent the widest possible divergences in island archaeology. There is, of course, a massive difference in scale; the Pacific Ocean is more than 70 times the size of the Mediterranean Sea, and that has important implications to which I shall return. The Mediterranean is commonly regarded as including its coasts as well as its islands in a coherent region that is fairly well-defined climatically, geographically, and in some historical characteristics of connectivity (Braudel 1972). Much like the ancient Near East, to which it was intimately connected, the Mediterranean also achieved at times a significant donor status, as in the dissemination of key elements of Neolithic and classical civilisations.

The Pacific, in contrast, is a more elusive landscape. The ocean extends from the Bering Straits to Antarctica and from the coast of the Americas to eastern Australia, Sumatra and mainland Asia, but not all the islands in that vast area (181 million sq km) had been inhabited prior to European discovery so 'the Pacific' in archaeological terms is rather smaller. Along the western and northern peripheries lies a series of seas, each more or less enclosed by island chains, but none strictly comparable to the almost land-locked Mediterranean, although they are sometimes regarded analogically as other 'mediterranean seas' (Leier 2001, 26). The Banda, Java, Celebes and Sulu Seas, together with the South China Sea, define the region of 'Island South-East Asia'. To the north are the East China Sea (including the Yellow Sea), bordered by the Ryukyu Islands, then the Sea of Japan, the Sea of Okhotsk, and the Bering Sea. In each case these regions tend to look archaeologically toward their adjacent mainlands, or laterally along island chains, rather than out into the wider Pacific. The 'island continent' of Australia, far from the Asian mainland, is also perceived fairly introspectively as encompassing both a continental and an insular status. Once those regions are abstracted, we are left with 'Oceania', the essential archaeological Pacific and an exclusively insular and borderless region of 40-50 million sq km.

Occasional and specific arguments to the contrary (e.g. Denham *et al.* 2003), Oceania is perceived as culturally marginal, the recipient of diffused aspects of the coastal and offshore island cultures of eastern Asian and the Americas. In addition, from the earliest European observations, the descriptive emphasis was upon climatic and biogeographical variety and on cultural diversity. This was represented, for instance, by the 18th century racial systematics of Charles de Brosses and Johann Forster, and then in 1832 by the enduring Malaya-Melanesia-Micronesia-Polynesia schema of Dumont D'Urville (Clark 2003; Tcherkézoff 2003).

As a theatre of human colonisation, Oceania resembles the Mediterranean in one respect, which is that its islands are concentrated toward one side. The southern half of the Mediterranean is almost empty of islands; so too is the eastern Pacific (where the Galapagos is by far the largest outlying group). But there the resemblance ends. The landscape geometry of these insular regions is very different. The Mediterranean islands, all located relatively close to the mainland, directly or through other islands, sketch a cultural geography of multiple and approximately parallel instances of similar proximity relationships. Colonising sources and subsequent interactions, leaving aside those between islands, could originate anywhere along the entire northern coastline, extending about 3700 km as the crow flies, a situation reinforced by prevailing winds from the northerly quarter. In contrast, the Oceanic islands stream away as a broad band from the eastern archipelagos of South East Asia and reach far into the Pacific, towards the prevailing south-easterly trade winds. The main island band originates on a comparatively narrow base, about 500 km wide from the Bismarcks to mainland New Guinea and this, although it is only the breadth of the southern Aegean Sea, constituted by far the principal colonisation routeway of people, plants and animals into Oceania throughout the late Quaternary. Once Micronesian atolls became habitable in the late Holocene there was some additional contact with the western margins, but it was comparatively limited. In short, while Mediterranean island cultures could each be involved continually with local mainland sources (Broodbank 2000, 9), most cultural and biotic infusions came down the line to Oceanic islands through a single and comparatively narrow conduit.

That brings us back to the effects of distance. Not only are the Oceanic islands situated at right angles to their main biological and cultural sources in Island South-East Asia, they also extend an immense distance across the ocean, measuring some 11,000 km west to east, not to

mention additional distances north and south to Hawai'i and South Polynesia (the New Zealand region). Looking from the west, islands in the main band become progressively smaller, biogeographically simpler and increasingly further apart. Their geometric relationships describe degrees of geographical remoteness that far exceed those of any other region. Remoteness, of course, is a cultural rather than a purely geographic quality. For people with no effective watercraft, islands a mere 10 km offshore could be unattainably remote, as were most of the Bass Strait islands for post-glacial Tasmanians, and Tasmania for all other Australian Aboriginals, yet islands hundreds of kilometres distant were reached rather easily and often by recent Micronesians in their flying proas. But while various means, including the nature of watercraft – in its various senses – could ameliorate the challenge of sheer distance across the sea, there is some merit in looking first at the general problem in simple distance terms.

Within insular regions, and at that scale of analysis, differences in proximity were often culturally significant, as in variable ages of initial colonisation and differing patterns and frequency of exchange relations, but viewed at a worldwide scale, most of these recede into insignificance. The basic proximity relationships of prehistorically-inhabited saltwater islands during the Holocene can be divided into three broad groups. The largest group includes islands that lie within a few hundred kilometres of others, or of mainland coasts. Here, they are placed in the category of 'offshore' islands (Figure 8.1). Distances between them or to the mainland are shortest in the Mediterranean. Vessels running or reaching under sail could generally move between them with no more than a night or two at sea and mostly without moving far beyond visibility. A second group includes islands in the North Atlantic and the western archipelagos of Remote Oceania (eastern Solomons, Vanuatu, New Caledonia, South Polynesia) which are located at about 200-800 km apart – here regarded as 'outlying' islands. Passages between these could seldom rely on constant fair winds, were dependent on good sailing and seakeeping skills and were mostly outside visibility limits, requiring some skills in navigation.

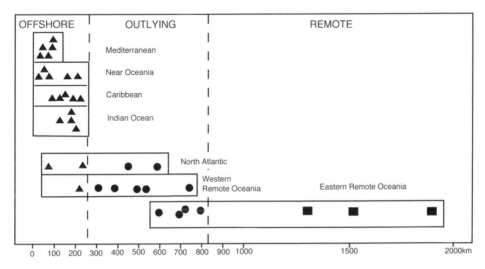

Figure 8.1: The distribution of islands into three groups by minimum distance to the nearest landmass (note: as some passages bypassed intervening islands, they were longer than the minimum distances shown here)

Only in eastern Remote Oceania (Fiji to Easter Island, and also Hawai'i and South Polynesia), were dispersals required to cross open seas of up to 2000 km – these are 'remote' islands, to which voyages might expect to be at sea more than a month, even several months, with commensurate demands on all kinds of seafaring expertise. Beyond them again, and also in high latitude seas, were islands that were never reached prehistorically. In Oceania, these included Lord Howe Island, 900 km south-west of the western margin of East Polynesian habitation on Norfolk Island (Anderson 2003a), and 550 km from Australia, and the Juan Fernandez group, 3000 km from Easter Island but tantalisingly close to South America (Anderson *et al.* 2002a). These cases do not indicate that Oceanic travellers never reached the continental margins – in fact there is possible evidence to the contrary (Anderson 2003b; Ramirez-Aliaga 1992) – but they do suggest that the exploratory effort was becoming significantly diminished towards the known margins of prehistoric island habitation.

Considerable variability in the remoteness of islands has a theoretical implication which ought to be noted here. Models of the process of initial island settlement have attempted to grapple with defining it archaeologically by proposing that discovery was different from colonisation, and that again from more established settlement (e.g. Graves and Addison 1995; Patton 1996, 36-47). I disagree for various reasons (Anderson 1995, 2003b), including those summarised by Cherry (1990, 198), but the point worth making here is that in practice there was probably something like a 'concertina' effect correlating with remoteness. Offshore islands might well have proceeded through the various stages because of the ease of access. It was not necessary to settle islands close by to use their resources until the balance of long-term settlement desirability between mainland and island favoured migration to the latter. Remote islands, on the other hand, were often found only a few times, perhaps only once, and at relatively great cost. Discovery, colonisation and the beginnings of established settlement were thus more or less coincident. It is often suggested, and plausibly, that Polynesian voyagers accommodated this reality by sailing with everything they needed in search of new islands, in the expectation that they might never be able to fetch something that was missing and, in fact, the patchy distribution of transported biota and commodities in eastern Oceania seems to underline that assumed apprehension (Anderson 2009). An important corollary to this general argument is, of course, that where interaction was low or absent, the circumstances of colonisation were much more important in the history of settlement sequences than was otherwise the case, and it is at least partly for that reason that much of the interest in Oceanic archaeology focuses on the colonising eras.

Remoteness and seafaring

It ought to go without saying that seafaring is fundamental to thinking about island colonisation and subsequent interaction, but in fact and except in a general sense, it is often rather taken for granted (Anderson 2004a). Broodbank (2000, 341-349), however, discusses changes in seafaring as the principal agent in cultural change in the Cyclades and elsewhere at the transition from the Early to the Middle Bronze Age, about 4000 BP. I have argued similarly (Anderson 2000a, 2001a, 2004b), that changes in maritime technology, notably in the arrival of the sail and in subsequent important innovations in hulls and rigging, underlie the pattern of Oceanic migration. Some points are pertinent here.

In discussing the difference in required passage lengths between the Mediterranean and Oceania, Broodbank (2000, 105) ponders the very relevant issue of travelling time and

suggests the introduction of scaling ratios to take account of asserted sailing speeds in the Pacific of four to eight times those derived experimentally in the Aegean. As he points out, if this ratio held generally, then the Aegean would have been approximately the same size, measured by travel time, as virtually the entire Lapita region. The implications are profound in terms of exchange, social networks and island isolation, but they depend critically on the basic data, and on the Oceanic side these are open to question.

The assertion that long-range Oceanic sailing vessels could average about 170-250 km in a 24 hour run (Irwin 1992), is a key point in the neotraditional hypothesis of Oceanic voyaging which asserts that sailing capabilities were greater in antiquity than at the advent of European observation. This is an idea derived from the traditionalist belief that the works of the ancestors exceeded those of their descendants. It still underlies some indigenous perspectives (e.g. Hau'ofa 1994), as it had done widely in ethnological scholarship up to the mid-20th century and in prehistory perhaps universally. It was described by Dening (1963) as the principle of degeneration in indigenous Pacific history.

The particular passage speeds come primarily from sailing the Hawai'ian experimental canoe, *Hokule'a*. They are not supported by ethnographic data which indicate much slower speeds overall and the data are compromised by conceptual and technical deficiencies in the Oceanic experimental sailing programmes, including in computer simulation voyaging (see discussion in Anderson 1996, 2000a, 2001a, 2003b, 2003c, 2004a, 2004b, 2008). The *Hokule'a* programme embraced two worthy objectives; first, to test the sailing capabilities of reconstructed Polynesian voyaging canoes, perceived by Finney (1979, 1994) as having been denigrated by Andrew Sharp (1957), an acerbic critic of traditionalism, and second, to raise the self-esteem of modern Polynesians by engaging them in a practical project of long-distance sailing along the sea paths of their ancestors. In the course of development, the objectives became fused, so that the experimental vessels were built to safeguard the success of the second objective at the expense of authenticity in the first. *Hokule'a* is built in modern materials, to fail-safe standards, with twice the sail area of historical double canoes. Not surprisingly it travels with about the capability to windward and at the same average speed as a modern cruising yacht.

Reference to historical data suggests, conversely, that East and South Polynesian voyaging canoes had almost no windward capacity. The running stay rig would allow some reaching in light airs but at normal tradewind velocities (15-25 knots), the absence of shrouds precluded shaping the sail fore-and-aft to go to windward. Vessels were thus propelled by a mix of sailing and paddling, as Finney (1979) has observed. Their average speeds on long passages probably did not exceed a knot or two (Anderson 2000a). That is comparable to the travelling speeds estimated for Aegean longboats (Broodbank 2000). Oceanic distances, consequently, were indeed very substantial.

An additional factor to take into account is that at least some of the passage distances in Oceania were probably considerably greater than is shown in Figure 8.1, which probably underestimates the distance differential between offshore and remote islands in general. In the case of offshore islands, minimum map distances between islands, or from the mainland, must often have approximated actual passages, because those were able to be made in conditions of inter-island visibility, including by raising a destination before losing sight of a point of origin. Over longer distances there are often hypothetical map routes which could break the full passage into stages by deviations to islands either side of the most direct route, but the existence of these potential staging posts, if they were known at all, must often have been

established after exploration had succeeded; i.e. as exploration is, by definition, a venture into the unknown, the voyaging utility of intervening islands is only apparent, and their discovery more probable, once a route is established to a new destination.

This appears to be the case in Oceania, where archaeological evidence indicates that mainland New Zealand was found before the intervening Kermadecs which were colonised from it (Anderson 2000b). Consequently, early passages from East Polynesia to New Zealand must have been at least 2600 km, not 1900 km as shown. Similarly, there is a theoretical island-hopping route from Tahiti to Hawai'i, in which the longest passage is about 1500 km from the Line group to Hawai'i Island, but archaeological data indicate that the Line Islands were colonised later than Hawai'i (Anderson *et al.* 2002b) where the early material culture, furthermore, is indicative of a Marquesan origin, requiring a passage of about 3000 km. This would have been the longest single passage in prehistoric island colonisation but most of it was potentially downwind, on the south-east trades. In the North Atlantic, Eirik the Red's Saga suggests that his first voyage to Greenland took a route west and then a coasting south (Thorsson 2000, 655), but at least some of the early passages sailed directly to the Eastern Settlement area, a passage of some 1200 km.

Putting sailing capability and probable passage length together, it is apparent that some Oceanic islands were very remote indeed. That point is poorly captured in the conventional terminology (Pawley and Green 1973) of 'Near Oceania' (the New Guinea-Solomons region): 'Remote Oceania' (eastern Melanesia, Micronesia and Polynesia). This is more an expression of the chronology and origins of island occupation in archaeology and historical linguistics (as in the Austronesian – non-Austronesian languages dichotomy) than it is an implied measure of proximity or remoteness. In 'Remote Oceania' few western islands are more than several hundred kilometres apart, but many of the eastern islands are up to an order of magnitude more remote. That difference is not always sufficiently appreciated in Oceanic archaeology, with some authorities tending to generalise from the circumstances of the western Pacific (e.g. Rainbird 1999; Terrell 1999), and in doing so to underestimate the implied potential for real isolation in much of the inhabited eastern region.

I do not want to dwell on this matter (see discussion in Anderson 2003b) except to point out that archaeological investigations so far have failed to show any sign of interaction between (or amongst) most of the more remote eastern archipelagos and the central archipelagos of Polynesia. There is evidence of dispersal from central to peripheral islands in the form of transported adzes and other artefacts of basalt or obsidian, but no sign in the former islands of commodities returned, even from such important sources of diverse and high quality lithics as Easter Island and New Zealand (Anderson 2000c, 2008; Weisler 1997). Interaction in these cases remains no more than an assumption and one which is quite possibly wrong. Total isolation extending over hundreds of years, in other words over the greater part of the prehistoric sequence in East and South Polynesia, appears a more plausible interpretation of the current data for remote cases.

Rather than attempt to argue that propositions of interaction, in greater or lesser degree, can be held as generalisations in island archaeology, it would be better, in my opinion, to recognise that there is greater variability in access relationships than that position assumes. At times in deep prehistory, some inhabited islands were entirely isolated for millennia, as Tasmania remained across almost the entire Holocene, and right up until the arrival of European shipping virtual or total isolation was also true of remote eastern Oceanic islands and archipelagos.

The potential impacts of climatic change

Now, I need to address the apparent contradiction that is emerging in this argument. If Oceanic sailing vessels in prehistory had virtually no windward capacity, as I contend, and therefore such little ability to make substantial eastward distance against the south-easterly trades that many islands remained totally isolated from others for centuries at a time, and in some cases throughout their prehistory, then how could Oceania have been settled at all, let alone in phases of very rapid and extensive dispersal?

One potential answer is suggested by Dickinson (2001; and see Kerr 2003). This is the argument, often conjectured but now presented in satisfactory quantitative detail, that drawdown of sea levels by 1-2 m in the late Holocene allowed the emergence and eventual habitability of numerous coral atolls which then became potential stepping-stones in Oceanic migration. Instead of attempting to battle for weeks against head winds, vessels could take advantage of brief periods of fair winds to go eastward in incremental short passages. While continuous dispersal eastward would seem the logical consequence, Dickinson points out that the pattern of atoll emergence was staged, with coral islands becoming available, for eustatic reasons, much later (after 2000 BP) in the central Pacific than they did in the west (4000-3000 BP). This hypothesis is consistent, therefore, with two widely-agreed conclusions about initial migration patterning in the late Holocene; that it began in the west before 3000 BP and that there was no significant movement beyond the range of Lapita settlement – i.e. no movement from West into East Polynesia – until somewhat later than 2000 BP.

There is, however, a flaw in the hypothesis as an explanation of migration patterning in late Holocene Oceania. As noted above, the migration route taken during the Lapita expansion was through Melanesia and no atolls emerged in the critical passage between the main Solomon Islands and Santa Cruz. That is, the minimum passage distance and direction was virtually the same in 3000 BP as at any other time during the Holocene. The potential direct passages from West Polynesia to East Polynesia, similarly, were hardly changed by the emergence of Palmerston Atoll relatively close to the eastern side, and no atolls emerged between East and South Polynesia. The main areas of atoll emergence were in Micronesia, where they almost certainly were significant in the initial settlement of the eastern region, and in the Tuamotus, facilitating movement to the Marquesas from Tahiti, but they can have had no significant impact on accessibility along the major routes of migration.

A more plausible explanation might lie in the influence of climatic change upon wind patterns, since vessels with insignificant windward capacity required relatively long periods of fair winds to make substantial passages; either that, or they had to remain at sea without losing too much to leeway in adverse conditions between periods of fair winds. The periodicity of westerly winds, on which migration could proceed east, was consequently a critical factor (Anderson 2004b; Anderson *et al.* 2005). In tropical Oceania, the prevailing south-easterly trades are interspersed with occasional westerlies, but long or frequent periods of westerlies are closely related to the incidence of El Niño conditions. Various measures of El Niño frequency have been used to show that there were considerable frequency differences on a millennial scale, indeed that there is a certain cyclicity of high and low frequency (and intensity) with an amplitude of 1500-2000 years. For example, Moy *et al.* (2002) show that El Niño variability was not significant until after about 7000 BP and first reached a substantial peak of frequency at about 4700-5000 BP, then again at 3300-2700 BP, 2500 BP, 1100-1600 BP, 200-900 BP (Figure 8.2). There is an intriguing degree of correspondence between

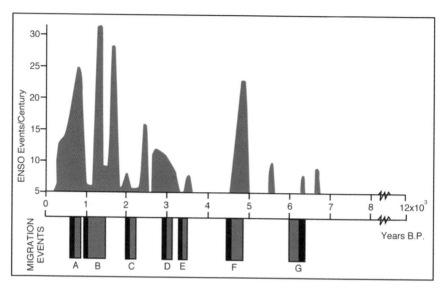

Figure 8.2: Frequency of ENSO events (after Moy et al. 2002) in comparison with periods of Pacific migration (in each case the most likely part of the period for migration, based on archaeological data, is shown in black): A= South Polynesia; B= East Polynesia; C= Marginal West Polynesia and eastern Micronesia; D= eastern Lapita; E= western Lapita; F= Neolithic expansion into Near Oceania; G= possible arrival of Neolithic in Taiwan

major peaks and substantial eastward migration, notably during the 3300-2700 BP Lapita era (Anderson 2001b, 2004b; Anderson *et al.* 2005) and the East Polynesian dispersal, about 1100-900 BP (Anderson and Sinoto 2002). There might also have been an additional impetus involved. El Niño creates frequent droughts in the western Pacific, to which small island populations are especially susceptible. Crop failure places an increasing emphasis on the use of marine resources and islanders often seek to migrate (Bourke 2000). Correspondingly more humid conditions in the central and eastern Pacific, moved the regional balance of resource productivity eastward at such times and people may have followed.

The role of climatic change in island colonisation generally might be more influential than is generally thought, although not necessarily in the Mediterranean. Broodbank (2000, 338) thinks that significant drought at the end of the Early Bronze Age had relatively little impact on the Cyclades. On the other hand, I have suggested (Anderson 2004b) that prehistoric movements onto the western Indian Ocean islands, perhaps also the Maldives, and into the Caribbean islands, seem to correlate with periods of significant drought in adjacent mainland areas during the later Holocene when shifts in the Atlantic sector of the Intertropical Convergence Zone and the Indian Ocean dipole appear to co-vary with high periodicities in El Niño. In other words, it can be conjectured that, at least in the tropics, oceanic climates at a millennial scale changed more or less together with similar consequences. Drought on the mainland, or on inhabited offshore islands, prompted greater mobility in search of new habitats, and that probably included maritime migration in search of new islands to settle.

Inside island territoriality

How did prehistoric island colonists arrange the construction of a new social landscape? In some respects this is a question open to archaeological investigation, as through the analysis of settlement patterns, material culture distributions, relations of communication and other aspects of what Patton (1996) has called 'island sociogeography' in relation to Mediterranean studies. It is exemplified especially well, on a small scale, by Broodbank's (2000) close analysis of interaction patterns and inferences of status relationships in the early Cyclades. It is a developing field of interest in Oceania as well. On Easter Island, for example, the distribution of different types of ceremonial platforms or *ahu* has been studied in relation to traditional evidence of land boundaries (Martinsson-Wallin 1994; Rounds-Beardsley 1990). The most recent study, by Stevenson (2002) used cluster analysis to distinguish an apex group of elaborately constructed *ahu* which were found to associate closely with remains of elite villages where the formal *hare paenga* houses were built, the correlation suggesting that there were eleven centres of substantial social groups. Similar analyses in Hawai'i have shown that plotting the distribution of settlement units at different levels of complexity provides a strong correlation with historically-mapped land boundaries (e.g. Graves *et al.* 2002), that represented the traditional *ahupua'a* territorial system. Implications of territorial dominance have been drawn from the size and distribution of monumental architecture in variable Oceanic environments by Graves and Sweeney (1993) and territorial signification can be read into the burial of very fine objects in early colonisation sites, as in the abundant and finely-crafted adzes, necklaces and other objects at the Wairau Bar cemetery in New Zealand (Duff 1956), or the immense and intricately decorated bowls discovered recently at the eponymous Lapita site in New Caledonia (Sand 1997). The great Tahitian double canoes, which were not used for voyaging, but were moved into squadrons at the arrival of Europeans were also, I think, primarily objects of status display and implied territorial intimidation – mobile megadendrons instead of fixed megaliths.

In Oceania, however, there is another level to this matter that is accessible, if somewhat precariously, by recourse to recorded indigenous traditions. Amongst Polynesians, various oral narratives, in most cases interstitial to extensive genealogies, were recorded quite early by European visitors. They came from such mutually-isolated islands, including New Zealand, Hawai'i and Easter Island, as to engender some confidence that they represented a body of tradition common to the region prior to widespread dispersal about 1000 years ago. The traditions describe a common mythological homeland, the attributes and functions of deities, the activities of mythological figures, and so on. From them, can be derived an approximate template of the terms in which ancient Polynesians conceived island colonisation (Anderson 2003d).

The central figure in the narratives is the fish. Islands did not emerge over the horizon into the gaze of the hopeful voyager. They existed first as fish, concealed in the ocean depths. Deities and culture-heroes, to which Polynesian populations traced their genealogies, travelled about the ocean and caught the fish, brought them to the surface and in the course of subduing their struggles, slashed and bludgeoned them into the broad shapes of the historical topographies. The clever and devious Maui often figures in these narratives; thus New Zealand's North Island was called 'Te Ika a Maui', Maui's fish. Similarly Tahiti, and Mangaia in the southern Cook Islands, were each, 'visualised as a fish, as the 'fish of Rongo'[a Polynesian deity]... The fish lay with its head to the east and its tail to the west'

(Goldman 1970, 91). It is tempting to expand this idea into a perception of island-fish as swimming upstream, into the tradewind-driven currents. At any rate, the fish pointed to the east, to the life-giving sunrise, and swam away from the afterworld and mythological homeland in the west.

The division of the fish was connected closely to status relationships. In traditionally ramified Polynesian societies, genealogical proximity to the main line of the agreed clan or tribal ancestor, ranked almost everybody, and each family or clan, in a scale of seniority; in Maori, for example, every relationship from the point of reference is either with *tuakana* (senior) or *teina* (junior) persons or groups. One affect of this was the common division of islands or island territories into senior and junior halves. On Niue, these were given names which reflected status and recalled the image of the fish; matafonua (the front or senior lands) and mulifonua (the back or junior lands), also called uluhiku, meaning the tail of the fish. In New Zealand the cognate 'murihiku' was the tail of the South Island 'fish', just as muriwhenua, cognate of mulifonua in Niuean, represented the tail of the North Island, in this case Northland, the large peninsula extending north of Auckland. A drawing in 1793 by Tuki, a northern Maori chief, depicts Northland, and to some extent the North Island in general, as divided longitudinally. The main line of division, he said, was a common pathway along which the spirits of the dead could proceed unhindered to the north-western headland, there to enter the underworld by slipping into the sea. On Easter Island, there was a division between the senior west, occupied by the Mata-nui ('great clans') where the Orongo bird-man cult and village became located, and the junior east occupied by the Mata-iti ('lesser clans'), while in Manihiki-Rakahanga (northern Cooks), a stone marker in the single village divided the lagoon-side territories allocated to the senior line, from the seaside lands of the junior line (Anderson 2003d).

Island moieties were then divided again, according to seniority. In tradition, Mangaia was colonised by three grandsons of the god Rongo who had arrived from Tahiti, 'and was thought of as having been divided longitudinally into a right-hand and left-hand side and in three portions going from east to west, as head, body and tail' (Goldman 1970, 91). These were allocated by seniority. For Hawai'i, Sahlins (1992, 17) refers to the 'segmentation of each of the larger islands into six principal divisions, or multiples of six, which are also territories of high chiefs…'. Traditional accounts from Easter Island describe the founding ancestor, Hotu-matua (literally, 'founding parent'), dividing the land amongst his six sons according to their birth-order. The oldest, Tu-maheke, got the 'royal lands' on the north coast and the second-born, Miru, a desirable neighbouring territory, whereas the least-favoured eastern side of the island went to the youngest son, Hotu-iti (Thomson 1891).

Coupled with this geography of status by rank, was another of status by gender. Mountains were of high status and associated with males, mythology and the sacred. They were places of concealment, appropriate to ritual behaviour, and regarded as relatively close to the mythological heaven or to points of entry to the afterworld. Conversely, valleys and lower inland slopes were of low status, secular and associated with females (Campbell 2001; Weisler and Kirch 1985). Land-holding groups required access, of course, to both kinds of lands.

On high islands generally, and to a lesser extent on atolls, the final resolution of these territorial considerations was usually manifested as a radial pattern of wedge-shape districts, each expanding from the central interior to encompass one or two valleys, and adjacent lowlands and lagoon out to the reef. While this ensured that each land-holding group had similar access to the same range of resource opportunities, it is apparent that the considerations involved in

the territorial pattern were far more complex and diverse than exclusively economic. They also had an important implication for understanding colonisation processes.

The hostility inherent in status relationships drove social fragmentation and consequent geographical dispersal at rates much faster than subsistence pressures or population growth demanded, even if these tended to operate in the same direction – as in early and wholesale depletion of fragile native faunal resources. Polynesian traditions are replete with accounts of movement to new districts or new islands, or simply of sailing off into the unknown, by losers in status competitions, often quite early in settlement sequences (Anderson 2006a). This might be seen as a phenomenon cognate to the ecological imperative of continual movement at low population densities by island colonists intent on maintaining high levels of resource access (Keegan 1995). Both processes reflect the intolerance of initial or early colonists to decline in expected standards of living, in the broadest sense. The result seen archaeologically is very rapid and extensive dispersal. In Remote Oceania, the early Lapita dispersal may have taken little more than a century; East Polynesian dispersal perhaps a little longer but not by much and the dates of earliest settlement throughout New Zealand, and between all of the South Polynesian islands, fall more or less on top of one another (Anderson 2000b, 2006b). I do not doubt that subsistence imperatives (Anderson 1996), autocatalysis (Keegan and Diamond 1987) and the exercise of specialist powers in seafaring (Thomas 2001), amongst other factors, were involved in colonisation, but in reading the Polynesian traditions it is difficult to avoid the conclusion that there was also a profoundly socio-political impetus to the rapidity of dispersal episodes. Similar rapidity is evident in the early colonisation episodes of the Caribbean and north Atlantic islands, quite possibly for similar reasons.

Conclusions

The idea of islands as laboratories in its more literal interpretation is out of favour these days. Still, the intellectual appeal remains in the experimental facility of islands to separate, multiply and highlight packages of data which can be brought to bear on archaeological problems. Islands have become rhetorical laboratories, regardless of where archaeologists stand on the significance of insularity.

I have canvassed here several of the common issues of insularity in colonisation phases, largely as they are applicable to outlying and remote Oceania, but with reference here and there to the Mediterranean Islands. As I see it, the main point to take is that Oceania was not simply a scaled-up version of the Mediterranean or of any other insular landscape. It was a wholly insular region in which prehistoric exploration barely touched the continental margins. Distance really did matter in Oceania, and it created levels of remoteness or isolation beyond any which can be comprehended sensibly in propositions of insularity as relative interactivity. Oceania also differs from other insular regions in the late survival and subsequent recording of extensive traditions about island colonisation. These offer an insight into the appropriation of island territories and episodes of rapid dispersal, through endemic status competition.

If there is a general point underlying these it is that while island archaeology has much in common in its interests and methods, island landscapes are highly variable around the world and are difficult to comprehend within a single set of conclusions about their internal and external relationships.

References

ALCOVER, J.A. 1998: The extent of extinctions of mammals on islands. *Journal of Biogeography* 25, 913-918.

ALCOVER, J.A. 2000: Vertebrate evolution and extinction on western and central Mediterranean islands. *Tropics* 10, 103-123.

ANDERSON, A.J. 1995: Current approaches in east Polynesian colonization research. *Journal of the Polynesian Society* 104, 110-132.

ANDERSON, A.J. 1996: Adaptive voyaging and subsistence strategies in the early settlement of East Polynesia. In Akazawa, T. and Szathmary, E. (eds.), *Prehistoric Dispersal of Mongoloids* (Oxford), 359-374.

ANDERSON, A.J. 2000a: Slow boats from China: issues in the prehistory of Indo-Pacific seafaring. In O'Connor, S. and Veth, P. (eds.), *East of Wallace's Line: studies of past and present maritime cultures of the Indo-Pacific region* (Rotterdam), 13-50.

ANDERSON, A.J. 2000b: The advent chronology of south Polynesia. In Wallin, P. and Martinsson-Wallin, H. (eds.), *Essays in honour of Arne Skjolsvold 75 Years* (Occasional Papers of the Kon-Tiki Museum 5), 73-82.

ANDERSON, A.J. 2000c: Implications of prehistoric obsidian transfer in south Polynesia. *Bulletin of the Indo-Pacific Prehistory Association* 20, 117-123.

ANDERSON, A.J. 2001a: Towards the sharp end: the form and performance of prehistoric Polynesian voyaging canoes. In Stevenson, C.M., Lee, G. and Morin, F.J. (eds.), *Pacific 2000: Proceedings of the Fifth International Conference on Easter Island and the Pacific* (Los Osos), 29-36.

ANDERSON, A.J. 2001b: Mobility models of Lapita migration. In Clark, G.R., Anderson, A.J. and Vunidilo, T. (eds.), *The archaeology of Lapita dispersal in Oceania: papers from the Fourth Lapita Conference, June 2000, Canberra, Australia. Australia (Terra Australis 17)* (Canberra), 15-23.

ANDERSON, A.J. 2002: Faunal collapse, landscape change, and settlement history in Remote Oceania. *World Archaeology* 33, 375-390.

ANDERSON, A.J. 2003a: Investigating early settlement on Lord Howe Island. *Australian Archaeology* 57, 98-102.

ANDERSON, A.J. 2003b: Initial human dispersal in remote Oceania: pattern and explanation. In Sand, C. (ed.), *Pacific archaeology: assessments and prospects* (Noumea), 71-84.

ANDERSON, A.J. 2003c: Entering uncharted waters: models of initial colonization in Polynesia. In Rockman, M. and Steele, J. (eds.), *Colonization of unfamiliar landscapes* (London), 169-189.

ANDERSON, A.J. 2003d: *Kin and border: traditional land boundaries in East Polynesia and New Zealand with particular reference to the northern boundary of Ngai Tahu* (Evidence to Waitangi Tribunal, Wai-785, Department of Justice, New Zealand).

ANDERSON, A.J. 2004a: Islands of ambivalence. In Fitzpatrick, S.M. (ed.), *Voyages of discovery: the archaeology of islands* (Westport), 251-274.

ANDERSON, A.J. 2004b: *Taking to the boats: the prehistory of Indo-Pacific colonization* (Canberra, National Institute for Asia and the Pacific Public Lectures, NIAP Publications).

ANDERSON, A.J. 2006a: Islands of exile: ideological motivation in maritime migration. *Journal of Island & Coastal Archaeology* 1, 33-48.

ANDERSON, A.J. 2006b: Retrievable time: prehistoric colonization of South Polynesia from the outside in and the inside out. In Ballantyne, T. and Moloughney, B. (eds.), *Disputed histories: imagining New Zealand's pasts* (Dunedin), 25-41.

ANDERSON, A.J. 2008: Traditionalism, interaction and long-distance seafaring in Polynesia. *Journal of Island & Coastal Archaeology* 3, 240-250, 268-270.

ANDERSON, A.J. 2009: The rat and the octopus: initial human colonization and the prehistoric introduction of domestic animals to remote Oceania. *Biological Invasions*, DOI 10.1007/s10530-008-9403-2.

ANDERSON, A.J., and SINOTO, Y.H. 2002: New radiocarbon ages of colonization sites in east Polynesia. *Asian Perspectives* 41, 242-257.

ANDERSON, A.J., HABERLE, S., ROJAS, G., SEELENFREUND, A., SMITH, I.W.G. and WORTHY, T. 2002a: An archaeological exploration of Robinson Crusoe Island, Juan Fernandez Archipelago, Chile. In Bedford, S., Sand, C. and Burley, D. (eds.), *Fifty years in the field: essays in honour and celebration of Richard Shutler Jr's archaeological career* (Auckland, New Zealand Archaeological Association Monograph 25), 239-249.

ANDERSON, A.J., MARTINSSON-WALLIN, H., and WALLIN, P. 2002b: *The prehistory of Kiritimati (Christmas) Island, Republic of Kiribati: excavations and analyses* (Oslo, Occasional Papers of the Kon-Tiki Museum volume 6).

ANDERSON, A.J., CHAPPELL, J., GAGAN, M. and GROVE, R. 2005: Prehistoric maritime migration in the Pacific islands: an hypothesis of ENSO forcing. *The Holocene* 16, 1-6.

BOURKE, R.M. 2000: Impact of the 1997 drought and frosts in Papua New Guinea. In Grove, R. and Chappell, J. (eds.), *El Niño – history and crisis* (Cambridge), 149-170.

BRAUDEL, F. 1972: *The Mediterranean and the Mediterranean world in the age of Phillipe II* (London).

BROODBANK, C. 2000: *An island archaeology of the early Cyclades* (Cambridge).

CAMPBELL, M. 2001: *Settlement and landscape in late prehistoric Rarotonga, Southern Cook Islands* (Unpublished PhD thesis, University of Sydney).

CHERRY, J.F. 1990: The first colonization of the Mediterranean islands: a review of recent research. *Journal of Mediterranean Archaeology* 3, 145-221.

CLARK, G. 2003: Dumont D'Urville's Oceania. *Journal of Pacific History* 38: 155-161.

DENHAM, T.P., HABERLE, S.G., LENTFER, C., FULLAGAR, R., FIELD, J., THERIN, M, PORCH, N. and WINSBOROUGH, B. 2003: Origins of agriculture at Kuk swamp in the Highlands of New Guinea. *Science* 301, 189-193.

DENING, G. 1963: The geographical knowledge of the Polynesians and the nature of inter-island contact. In Golson, J. (ed.), *Polynesian navigation: a symposium on Andrew Sharp's theory of accidental voyages* (Wellington), 102-131.

DICKINSON, W.R. 2001: Paleoshoreline record of relative Holocene sea levels on Pacific islands. *Earth-Science Reviews* 55, 191-234.

DUFF, R.C. 1956: *The Moahunter period of Maori Culture* (Wellington).

FINNEY, B.R. 1979: *Hokule'a: the way to Tahiti* (New York).

FINNEY, B.R. 1994: *Voyage of rediscovery: a cultural odyssey through Polynesia* (Berkeley).

GOLDMAN, I. 1970: *Ancient Polynesian Society* (Chicago).

GOSDEN, C. and PAVLIDES. C. 1994: Are islands insular? Landscape vs. seascape in the case of the Arawe Islands, Papua New Guinea. *Archaeology in Oceania* 29, 162-171.

GRAVES, M.W. and ADDISON, D.J. 1995: The Polynesian settlement of the Hawaiian archipelago: integrating models and methods in archaeological interpretation. *World Archaeology* 26, 380-399.

GRAVES, M.W. and SWEENEY, M. 1993: Ritual behaviour and ceremonial structures in eastern Polynesia: changing perspectives on archaeological variability. In Graves, M.W. and Green, R.C. (eds.), *The evolution and organisation of prehistoric society in Polynesia* (Auckland, New Zealand Archaeological Association Monograph 19), 106-125.

GRAVES, M.W., O'CONNOR, B. and LADEFOGED, T.N. 2002: Tracking changes in community-scaled organisation in Kohala and Kona, Hawai'i island. In Ladefoged, T.N. and Graves, M.W. (eds.), *Pacific landscapes: archaeological approaches* (Los Osos), 231-254.

HAU'OFA, E. 1994: Our sea of islands. *Contemporary Pacific* 6, 148-161.

IRWIN, G.J. 1992: *The prehistoric exploration and colonisation of the Pacific* (Cambridge).

KEEGAN, W.F. 1995: Modelling dispersal in the prehistoric West Indies. *World Archaeology* 26, 400-420.

KEEGAN, W.F. and DIAMOND, J.M. 1987: Colonization of islands by humans: a biogeographical perspective. In Schiffer, M.B. (ed.), *Advances in archaeological method and theory, vol. 10* (San Diego), 49-92.

KERR, R.A. 2003: Geological Society of America meeting: Pacific migration arrested by meltdown's high waters. *Science* 302, 1888-1889.

LEIER, M. 2001: *World atlas of the oceans* (Ringwood).

MARTINSSON-WALLIN, H. 1994: *Ahu – The ceremonial stone structures of Easter Island: analysis of variation and interpretation of meanings* (Uppsala, AUN 19).

MOY, C.M., SELTZER, G.O., RODBELL, D.T. and ANDERSON, D.M. 2002: Variability of El Niño/Southern Oscillation activity at millennial timescales during the Holocene epoch. *Nature* 420, 162-165.

PATTON, M. 1996: *Islands in time: island sociogeography and Mediterranean prehistory* (London).

PAWLEY, A. and GREEN, R.C. 1973: Dating the dispersal of the Oceanic languages. *Oceanic Linguistics* 12, 1-67.

RAINBIRD, P. 1999: Islands out of time: towards a critique of island archaeology. *Journal of Mediterranean Archaeology* 12, 216-34; discussion and debate 12, 235-258.

RAMIREZ-ALIAGA, J.-M. 1992: Contactos transpacificos: un aceramiento al problema de los supuestos rasgos polinesicos en la cultura mapuche. *Clava* 5, 41-74.

ROUNDS-BEARDSLEY, F. 1990: Spatial analysis of platform ahu on Easter Island (Unpublished PhD thesis, University of Oregon).

SAHLINS, M. 1992: Historical Ethnography. Volume 1 of *Anahulu: The Anthropology of History in the Kingdom of Hawaii,* Kirch, P.V. and Sahlins, M. (eds.) (Chicago).

SAND, C. 1997: *Lapita: collection de poteries du site de Foué* (Noumea).

SHARP, A. 1957: *Ancient voyagers in the Pacific* (Harmondsworth).

STEVENSON, C.M. 2002: Territorial divisions on Easter island in the sixteenth century: evidence from the distribution of ceremonial architecture. In Ladefoged, T.N. and Graves, M.W. (eds.), *Pacific landscapes: archaeological approaches* (Los Osos), 213-229.

TCHERKÉZOFF, S. 2003: A long and unfortunate voyage towards the 'invention' of the Melanesia/Polynesia distinction 1595-1832. *Journal of Pacific History* 38, 175-196.

TERRELL, J.E. 1999: Comment on Paul Rainbird, "Islands out of time: Towards a critique of island archaeology." *Journal of Mediterranean Archaeology* 12, 240-245.

THOMAS, T. 2001: The social practice of colonisation: re-thinking prehistoric Polynesian migration. *People and Culture in Oceania* 17, 27-46.

THOMSON, W.J. 1891: *Te Pito o te Henua, or Easter Island* (Washington).

THORSSON, Ö. (ed.) 2000: *The Sagas of the Icelanders* (New York).

WEISLER, M.I. 1997: *Prehistoric long-distance interaction in Oceania: an interdisciplinary approach* (Auckland, New Zealand Archaeological Association Monograph 21).

WEISLER, M. and KIRCH, P.V. 1985: The structure of settlement space in a Polynesian chiefdom: Kawela, Molokai, Hawaiian Islands. *New Zealand Journal of Archaeology* 7, 129-158.

The small worlds of the (pre-)Neolithic Mediterranean

Chris Gosden

People are social animals and this is nowhere more obvious than in situations in which they have to collaborate in order to achieve their ends. Operating a boat of any size requires more than one person, whether this is a raft to be paddled or a log or plank boat to be sailed. To cross even small stretches of water requires knowledge of matter and energy, time and space. Human groups are operating in two dimensions at once: dealing with the social demands of collaboration on the one hand and with the practical exigencies of wind, current, tide and distance on the other. The combination of social and material challenges are not unique to seafaring, being found in hunting, herding, farming, large building projects, warfare and so on. But it can legitimately be said that seafaring poses social and material challenges in particular ways, quite new to those undertaking them for the first time, as they have no exact analogues in other areas of action on which to draw. For the analyst, seafaring offers exciting possibilities for looking into human material and social engagement in new ways. Obviously, for the prehistoric periods covered by this book we cannot see people at sea, nor can we ask them what they did and why they did it. It is, of course, possible to look at the effects of seafaring in terms of when landmasses were first reached by people and when travel across various stretches of water became routine. The incorporation of new islands or island groups into cycles of regular interaction changed local cognitive geographies fundamentally, making the mainland seem a different place, as well as the islands.

Notions of knowledge are changing fast at present from an older view in which propositional knowledge was primary and then drove the actions of the body to the opposite idea in which motor knowledge influences sensory perception and appreciation which in turn gives rise to ideas in the form of stated propositions. The primacy of motor knowledge derives from our fundamental physical engagement with the material world. This often takes the form of cooperative action – rowing a boat being a perfect example in which joint rhythms and coordinated action in a changing sea are key. Each cultural form has its own stock of fundamental routines, which in Neolithic society would comprise digging, sewing, weeding, harvesting, cooking and eating; the skills needed to nurture, herd, kill and butcher animals; the skills in building, potting, weaving etc.; but also moving around the landscape singly or in groups. This is a minimal list, but few of these skills would have been directly transferable to a seafaring context (building and some forms of performative action such as dance?) making this an arena of considerable social and material innovation. Perhaps because of the complex demands of social and material engagement involved in operating at sea, some of the best studies in the emerging material engagement approach to human intelligence involve studies of navigation at sea in both 'traditional' and technologically-assisted situations (Hutchins 1983, 1995).

As Farr (2010) has noted navigation involves an appreciation of time, as well as space – motion involves movement through time and space. When the medium through which one is moving is also in motion, which is always the case with the sea, then estimations of direction, distance and duration are complex, involving (possibly) reckoning through sight of land, the stars, moon or sun, the flight of birds and so on. Constant adjustments need to be made to the course, which also involve adjustments in the coordinated actions of the sailors. Journeys are made and groups are constituted simultaneously.

Not only are individual groups brought together in the processes of seafaring, but also larger cultural areas. When looking at larger units we need to be aware of anachronism or of imputing an overly-essentialised unity. In their different ways, Herzfeld (2005) and Horden and Purcell (2000) warn against too great a stress on unity. Herzfeld worries that 'Mediterraneanism' might rank alongside Said's Orientalism as creating a unified and reified category, which does not do justice to the diversity and complexity of Mediterranean life, encompassing as it does the north African coast, the Middle East, the European founts of civilisation in Greece and Italy, as well as the Iberian west. Horden and Purcell's concerns are slightly more pragmatic in that they feel scholarship on the Mediterranean has grown so big as to make it impossible to produce a singular narrative of the region which does not do violence to local variability. They start from the bottom up, looking at micro-ecological differences throughout the coast and islands and the imperative variability and uncertainty that the Mediterranean ecology imparts to human life, making necessary links between local regions to even out differences in the availability of key resources. Horden and Purcell posit a 'cabotage model', which makes for some unity out of diversity through constant low level interactions.

The present volume, focusing as it does on the earliest periods of island occupation, raises different problems in assuming or positing too much Mediterranean unity. As we have seen from the papers collected here and documented well in the overview by Dawson, island occupation occurs for the first time between the Younger Dryas and the late Neolithic. By the 3rd millennium BC all the major islands and groups see permanent occupation and in many cases this already has a history of several thousand years. The late Neolithic and early Bronze Age show people everywhere on islands and mainland in a way that has never been true before. The needs of metal trade, bringing together the components of bronze, then tie together island groups (Cyprus and Sardinia for instance) in novel ways. There is an internationalism from the Bronze Age onwards that makes it possible to talk about the Mediterranean in a manner never possible before (not forgetting the dangers of that term). Prior to the Bronze Age we are looking at a set of more localised connections and considerable variations within those localised regions. As threads to follow, the early distribution of obsidian from the earliest use of the sources on Melos some 12,000 years ago, and the much later distributions of bronze show two different worlds. Our view of *the* Mediterranean is so shaped by the situation from the Bronze Age onwards that it is hard to excise this from our imagination and think more locally.

This volume provides the raw material for thinking locally rather than globally. Of course, in the very long time spans dealt with here there are no singular local regions. The long history of Cyprus shows this, as Simmons' paper demonstrates. The slow shift from hippo hunting to cow herding sees also a change from impermanent to more fully insular populations, coming out in the Khirokitia cultural form. The Cyclades are settled in a complicated manner and as Phoca-Cosmetatou emphasises we should not see permanent settlement as an inevitable

outcome of island visitation and use, especially when islands are small and with variable resources. The linked networks moving people, plants, animals and materials around gradually crystallise out into individual island settlement. The pre-Bronze Age settlement is starting to become clearer, but more work of the type Phoca-Cosmetatou has carried out is needed to show how a long knowledge of these islands was drawn on in the process of settlement to create viable forms of animal husbandry and crop management.

The manner in which island occupation may re-orient cognitive geographies is indicated by Forenbaher and Kaiser's work on Palagruža, which, once occupied, may have provided the possibility of direct links across the Adriatic, carrying Adriatic impressed ware from west to east, rather than the much longer route round the coast. Given the rugged nature of the eastern Adriatic coast, sea transport may well have been favoured, constituting a new set of cultural connections and forms.

The Aeolian Islands and especially the obsidian from Lipari allow Castagnino Berlinghieri to chart one of these Neolithic networks in which varying areas, even on the same island, may be characterised by diversity. Connections can facilitate difference as well as sameness. Her attempts to use ethnographic parallels from Australia and the Pacific were intriguing, rather than totally convincing. This is because the central Mediterranean groups she focused on were in the process of becoming new cultural forms through colonisation and the movement of materials. All cultures are always in a process of becoming, but newly establishing groups become themselves in dramatic ways which alter both island ways of life and those on adjacent mainlands. Indeed, the links between the Sicilian islands and their big neighbour, Malta, show conjoined histories through the movement of both flint and obsidian. The earliest settlement there around 5000 BC, as Bonanno discusses, is likely to have been influenced by a longer period of visitation (presumably from Sicily) for which there is little good evidence at present. The dramatic changes in material culture that Bonanno documents around 4000 BC are hard to explain and may well have involved new people from, or connections with, Sicily bringing with them pottery in the styles of the San Cono/Piano Notaro groups. The stability of most other aspects of material culture may indicate that pottery was used in particular contexts that linked Malta and Sicily in new ways and for a limited period of time. Changing and unstable social and cognitive geographies are again an aspect of this Neolithic world. The local was redefined in Malta in 4000 BC but may still have been more important than the wider sets of links that become more obvious later.

While most central and eastern Mediterranean islands maintain some support for claims of really early occupation, perhaps going back to 120,000 years ago, the smaller islands of the west, such as the Balearics, exhibit a shrinking prehistory. This western island group looks quite different from the larger islands of Corsica and Sardinia, as well as exhibiting considerable differences to the connectivity of Sicily, the Aeolian Islands and Malta. The Small Worlds of the Neolithic are each different and distinct.

Anderson looks at a very large world, that of the Pacific. Just as I have emphasised differences between various parts of the Mediterranean prior to the Bronze Age, Anderson stresses the differences between the Pacific and the Mediterranean. As Anderson points out, useful contrasts can be drawn when looking at the world's sets of islands in the major seas and oceans – the Pacific, Indian and Atlantic Oceans (the last of which has sub-sets in the form of the Caribbean and the north Atlantic) and the Mediterranean. The Mediterranean covers a large area compared with the Black or Caspian Seas, but is very small in comparison with the major oceans. The question of size is to a large degree relative to the speed of movement across it,

which depends in turn on the technology of seafaring in various areas. As it turns out Anderson's estimates of speed of movement of prehistoric craft and those of Broodbank (2000) are fairly similar, making travelling times the same and emphasising the vastness of the Pacific, especially east Polynesia. Polynesian culture, as Anderson brings out, is also very unified in terms of material culture, language and mythology and this unity probably goes back to the first settlement of many of the larger island groups. The implication of the papers here is that diversity both within and between local regions is key to the earliest settlement of the Mediterranean. The melting-pot Mediterranean only came about from the Bronze Age onwards, being especially prominent in our minds through the spread of Greek and especially Roman culture in the 1st millennium BC.

I started by discussing embodied intelligence and the manner in which the world becomes intelligible to people through engagements and connections. The cognitive geographies of the earliest use of islands (whenever that was) through to the start of the Bronze Age were very different from those subsequently. No one would have entertained the notion of the Mediterranean as a physical or cultural region. Instead, the various Small Worlds of island groups (the Cyclades, Sicily – Aeolian Islands – Malta, Palagruža and its shorelines, the Balearics, etc.) or larger islands like Cyprus or Crete would have been centres of gravity in which much of life was lived and identities carved out. More work needs to be carried out at a conceptual level today to understand the changing nature of these worlds, which were not cultures in any obvious sense, but part of a mosaic of forms of life in which the individual tesserae were more important than any overall pattern. This volume is an important one in bringing out the special nature of these early worlds and showing the growing richness of information for island life over at least the last 12,000 years. Older frameworks of explanation, not least that of biogeography, do not provide a full explanation for the process of initial colonisation and subsequent ways of life. New forms of thought are starting to appear, representing in their own way exploration of poorly charted regions of human history.

References

BROODBANK, C. 2000: *An island archaeology of the early Cyclades* (Cambridge).

FARR, H. 2010: Measurement in navigation: conceiving distance and time in the Neolithic. In Morley, I. and Renfrew, C. (eds.), *The archaeology of measurement* (Cambridge), 19-26.

HERZFELD, M. 2005: Practical Mediterraneanism: excuses for everything, from epistemology to eating. In Harris, W. V. (ed.), *Rethinking the Mediterranean* (Oxford), 45-63.

HORDEN, P. and PURCELL, N. 2000: *The corrupting sea: a study of Mediterranean history* (Oxford).

HUTCHINS, E. 1983: Understanding Micronesian navigation. In Gentner, D. and Stevens, A. (eds.), *Mental models* (Hillsdale), 191-225.

HUTCHINS, E. 1995: *Cognition in the wild* (Cambridge).